Lawrence
ALMA-TADEMA

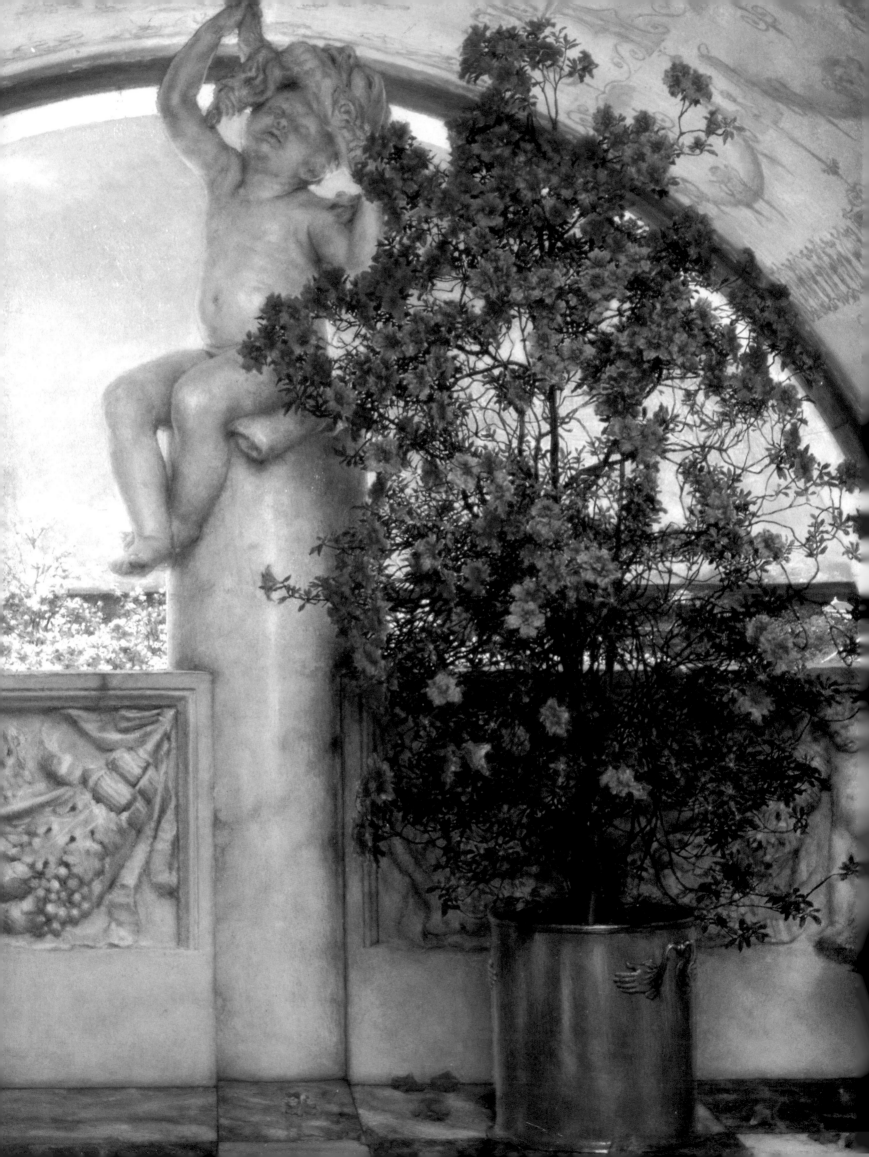

Lawrence
ALMA-TADEMA

Edmund Swinglehurst

ThunderBay
P·R·E·S·S

ACKNOWLEDGEMENTS
P. 6, Private Collection/Bridgeman Art Library, London. Topham Picturepoint: P. 7, Private Collection/Bridgeman Art Library: P. 8, The Leger Gallery, London/Bridgeman Art Library: P. 10, Private Collection/Bridgeman Art Library: P. 11, Galleria degli Uffizi, Florence/Bridgeman Art Library: P. 12, Private Collection/Bridgeman Art Library: P. 13, The Royal Academy of Arts, London/Bridgeman Art Library: P. 14, Russell-Cotes Art Gallery and Museum, Bournemouth, UK/Bridgeman Art Library: P. 15, Private Collection/Bridgeman Art Library: P. 16–17, Private Collection/Bridgeman Art Library: P. 17, Bonhams, London/Bridgeman Art Library: P. 18, Private Collection/Bridgeman Art Library: P. 19, Victoria & Albert Museum/Bridgeman Art Library: P. 20, Hackley Art Gallery, Michigan, USA/Bridgeman Art Library: P. 21, Russell-Cotes Art Gallery and Museum, Bournemouth, UK/Bridgeman Art Library: P. 22, The Fine Art Society/Bridgeman Art Library: P. 23, Christie's Images, London/Bridgeman Art Library: P. 24, Private Collection/Bridgeman Art Library: P. 25, Fine Art Society/Bridgeman Art Library: P. 26–27, Private Collection/Bridgeman Art Library: P. 28, Private Collection/Bridgeman Art Library: P. 30, Private Collection/Bridgeman Art Library: P. 32, Roy Miles Fine Paintings/Bridgeman Art Library: P. 34, Private Collection/Bridgeman Art Library: P. 36–37, Birmingham Museum and Art Gallery, UK/Bridgeman Art Library: P. 38, Private Collection/Bridgeman Art Library: P. 39, Private Collection/Bridgeman Art Library: P. 40–41, The Guildhall Art Gallery, Corporation of London/Bridgeman Art Library: P. 42–43, The Guildhall Art Gallery, Corporation of London/Bridgeman Art Library: P. 44, Private Collection/Bridgeman Art Library: P. 46–47, Milwaukee Art Center, Wisconsin/Bridgeman Art Library: P. 48, The Fine Art Society/Bridgeman Art Library: P. 49, Towneley Hall Art Gallery and Museum, Burnley, UK/Bridgeman Art Library: P. 50–51, Private Collection/Bridgeman Art Library: P. 52, Birmingham Museum and Art Gallery, UK/Bridgeman Art Library: P. 53, British Museum, London/Bridgeman Art Library: P. 54–55, Private Collection/Bridgeman Art Library: P. 56, Muséed'Orsay, Paris/Bridgeman Art Library. Roger-Viollet, Paris: P. 57, Cecil Higgins Art Gallery, Bedford, UK/Bridgeman Art Library. P. 58, Victor Hammer Galleries, New York/Bridgeman Art Library. P. 60, Private Collection/Bridgeman Art Library: P. 61, Private Collection/Bridgeman Art Library: P. 62, Trustees of the Royal Watercolour Society, London/Bridgeman Art Library: P. 63, Private Collection/Bridgeman Art Library: P. 64, Private Collection/Bridgeman Art Library: P. 65, Private Collection/Bridgeman Art Library: P. 66, Private Collection/Bridgeman Art Library: P. 68–69, Private Collection/Bridgeman Art Library: P. 70–71, National Gallery of Victoria, Melbourne, Australia/Bridgeman Art Library: P. 72, Art Gallery of New South Wales, Sydney, Australia/Bridgeman Art Library: P. 73, Dick Institute, Kilmarnock, Scotland/Bridgeman Art Library: P. 74–75, Ashmolean Museum, Oxford, UK/Bridgeman Art Library: P. 76, Private Collection/Bridgeman Art Library: P. 78–79, Private Collection/Bridgeman Art Library:P. 80–81, Sterling and Francine Clark Art Museum, Massachusetts/Bridgeman Art Library: P. 82–83, Private Collection/Bridgeman Art Library: P. 84–85, Hamburger Kunsthalle, Hamburg, Germany/Bridgeman Art Library: P. 86, J. Paul Getty Museum, Malibu, Cal./Bridgeman Art Library: P. 88, Private Collection/Bridgeman Art Library: P. 89, Private Collection/Bridgeman Art Library. Chris Beetles, London: P. 90–91, The Guildhall Art Gallery, Corporation of London/Bridgeman Art Library: P. 92, Private Collection/Bridgeman Art Library: P. 93, Private Collection/Bridgeman Art Library: P. 94–95, The British Museum, London/Bridgeman Art Library: P. 96–97, Private Collection/Bridgeman Art Library: P. 98–99, Private Collection/Bridgeman Art Library: P. 100–101, Private Collection/Bridgeman Art Library: P. 102–103, Laing Art Gallery, Newcastle upon Tyne, UK/Bridgeman Art Library: P. 104–105, The Maas Gallery, London/Bridgeman Art Library: P. 106, The Royal Pavilion Libraries and Museums, Brighton & Hove, UK/Bridgeman Art Library: P. 108–109, Bristol City Museum and Art Gallery, UK/Bridgeman Art Library: P. 110, Private Collection/Bridgeman Art Library: P. 112, Private Collection/Bridgeman Art Library: P. 113, Private Collection/Bridgeman Art Library: P. 114, Private Collection/Bridgeman Art Library: P. 115, Private Collection/Bridgeman Art Library: P. 116, Private Collection/Bridgeman Art Library: P. 118, Private Collection/Bridgeman Art Library: P. 119, Private Collection/Bridgeman Art Library: P. 120–121, Private Collection/Bridgeman Art Library: P. 122–123, Private Collection/Bridgeman Art Library: P. 124–125, Private Collection/Bridgeman Art Library: P. 126, Private Collection/Bridgeman Art Library: P. 128–129, Private Collection/Bridgeman Art Library: P. 130, The Maas Gallery, London/Bridgeman Art Library: P. 132–133, Private Collection/Bridgeman Art Library: P. 134, Private Collection/Bridgeman Art Library: P. 136–137, Private Collection/Bridgeman Art Library: P. 138, Private Collection/Bridgeman Art Library: P. 140–141, Private Collection/Bridgeman Art Library: P. 142–143, Private Collection/Bridgeman Art Library.

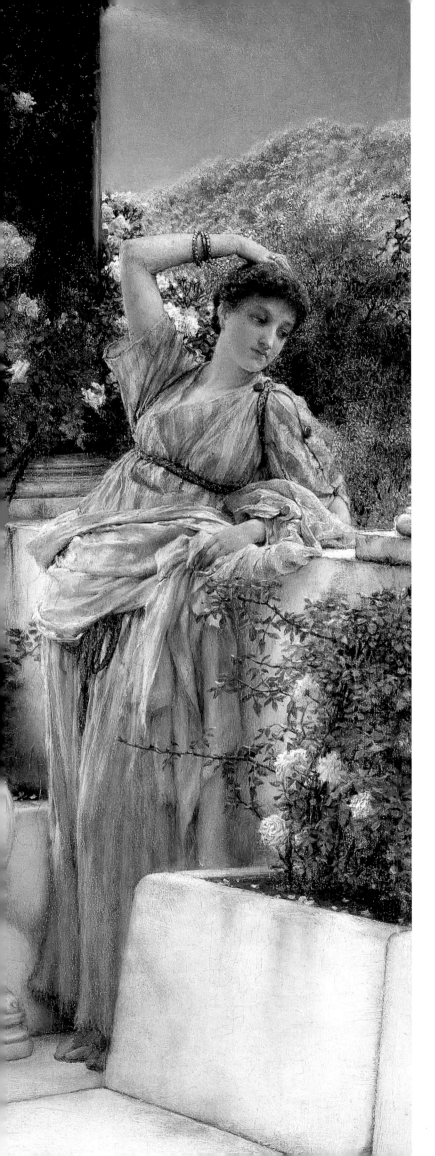

Contents

THE YOUNG DUTCHMAN

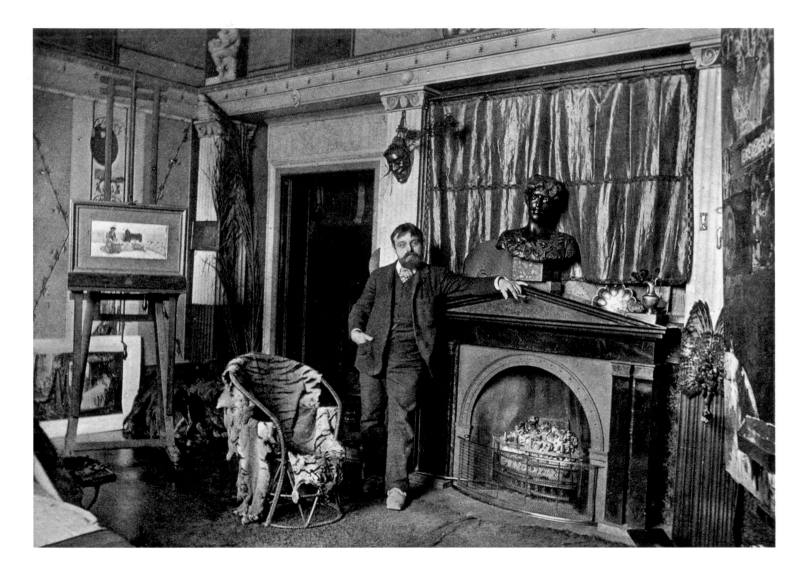

Photograph of Alma-Tadema (1884)
Private collection.

Sir Lawrence Alma-Tadema, one of Victorian England's favourite artists, was in fact Dutch. Although he was already an established artist when he settled in England in the 1870s, he became so successful a part of the English art establishment that he is always known by his anglicized name, which is used throughout this book.

He was born Lourens Alma Tadema in Dronryp, Friesland on 8 January 1836. His family were Mennonites, a strict and disciplined community of Baptists, whose origins could be traced to the time when the Dutch were fighting to free themselves from the Catholic Empire of Charles V and Philip II of Spain. The rigours of their struggle made the Netherlanders a tough and rugged people with a dedication to order, hard work and with a determination to succeed – traits very visible in the character of the young Lourens Alma Tadema.

By 1884, photography was becoming a new window on the world and Alma-Tadema agreed to have his picture taken in his studio in Grove End Road, St John's Wood, London. One of his most frequently used props, a tiger skin rug, lies on a chair and on the the easel are the beginnings of a painting, *Expectations* (p. 96), which he exhibited at the Royal Academy the following year. The photographer was J.P. Mayall and the photograph was destined for the 'Artists at Home' series.

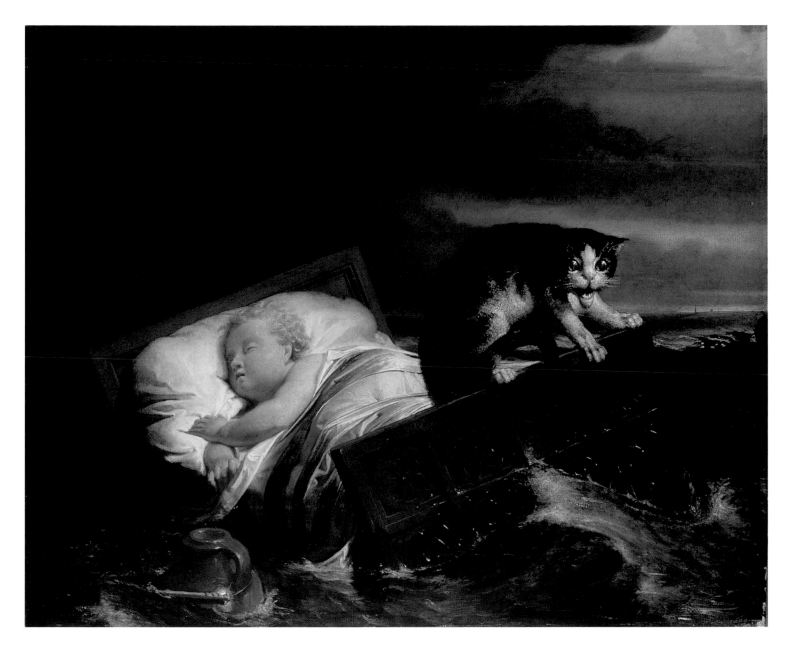

The Inundation (1856)
Oil on canvas. 21$\frac{1}{2}$ x
25$\frac{1}{2}$in (54.6 x 64.8cm).
Private collection.

This dramatic scene was
most probably a
recollection of Alma-
Tadema's youth, when
the River Biesbosch broke
its banks and flooded the
flat Dutch countryside – a
not uncommon
occurrence where land
had been largely
reclaimed from the sea.
The sleeping child and the
terrified cat suggest that
the artist either
experienced the event
himself or heard about it
in a vivid account of the
incident from neighbours.

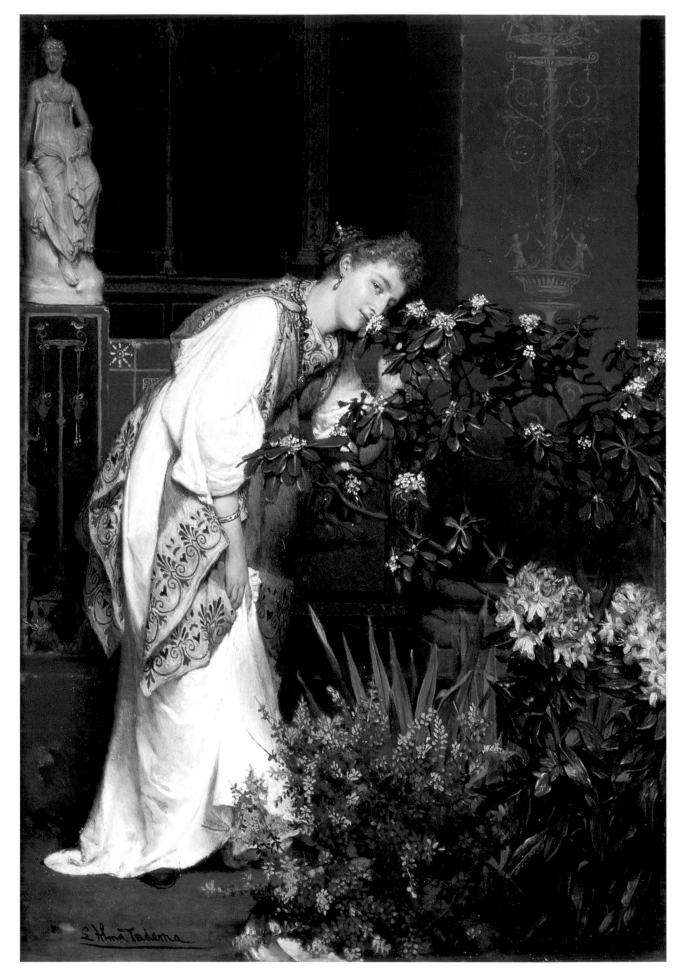

In the Peristyle (1866)
Oil on canvas. 23 x 16in
(58.4 x 40.6cm).
The Leger Gallery,
London.

A peristyle consists of a
row of columns
surrounding a space
within a building, such as
a courtyard or internal
garden, and was an

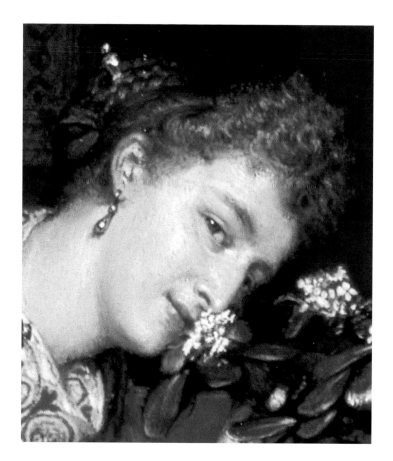

architectural device
popular with the Greeks
and Romans in their villas.
This is a portrait of Alma-
Tadema's first wife,
Marie-Pauline Gressin de
Boisgirard, a
Frenchwoman, and she is
shown standing in a
Pompeian courtyard filled
with flowering plants and
shrubs.

His father was a notary who died in 1840 and the boy
was brought up by godparents who did nothing to encourage
his ambition, expressed from an early age, to be an artist.
Lourens, who had been raised to be respectful and obedient,
complied with their wishes and attended school, although he
was not particularly interested in academic work and continued
to explore the world of painters and painting in secret.
However, the conflict caused by this hidden passion led to a
breakdown in health which persuaded the godparents to let the
boy have his own way and he was sent to an art school.

He had actually been painting on his own for many years,
his earliest known work being a picture of a vase of tulips
dating from 1846, when he was ten years old; by 1849 he had
also produced a portrait of his sister, Artje.

By 1852, Lourens' obvious talent as a painter won him a
place at the Royal Academy of Antwerp, whose principal was
the celebrated Baron Gustav Wappers, and who favoured the
style of Rubens, Jordaens and Van Dyck. He was not Wappers'
pupil for long, however, and his next teachers, Joseph
Dyckman and Nicaise de Keyser, introduced him to the work
of the French Romantic painters, Delacroix and Géricault, and
to the English painter, Richard Parkes Bonington, a painter of
landscapes and historical subjects, who stirred in him an

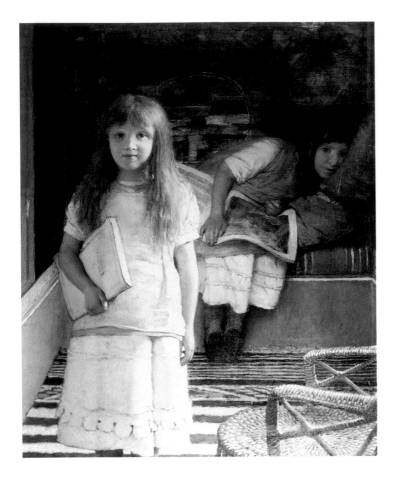

LEFT
This Is Our Corner (1873)
Oil on canvas. 22¼ x 18½in (56.5 x 47cm). Private collection.

The subjects of this charming domestic scene are Alma-Tadema's daughters, Laurence and Anna, and the affection and pride he felt for his family shines through. It has the conventional sombre background of his early style, though the black-and-white rug and rattan chair appear surprisingly modern. The two girls have evidently been surprised in their own secret world, where they have been reading and exchanging childish confidences. Both girls lived on into the 1940s and died unmarried.

interest in architecture as a subject for paintings. Another important influence at the time was Professor Louis Jan de Taye, a member of the Cercle Artistique et Litteraire d'Anvers and an expert on historical costume.

Armed with a formidable knowledge of the painting traditions of his own country and the techniques of the great masters of the past, Alma-Tadema began to develop his own versions of their work, though his choice of subject was original. Although he painted portraits and landscapes, his real passion was for the history of the Merovingian kings, whose Frankish dominions had encompassed the Low Countries and whose ruthless and colourful lives, filled with feuds and fired by rapacity and revenge, read like adventure stories.

His canvases, therefore, began to reflect Merovingian themes, as in *The Destruction of the Abbey of Terdoest*, a painting which did not please him and which he gave to his mother, who used it as a tablecloth, and *The Education of the Children of Clovis* (p. 38), in which the boys are learning to wield the weapons with which they will avenge their father's death. Alma-Tadema's work did not lay solely in the Merovingian period, however, and he ventured into other periods with such dramatic subjects as *The Death of Cleopatra*

OPPOSITE
Self-Portrait (1896)
Oil on canvas. 25½ x 20¾in (64.7 x 52.7cm). Galleria degli Uffizi, Florence.

It was the custom for painters invited to become members of the Royal Academy to contribute a work, usually a self-portrait. Alma-Tadema painted a rather formal one with the intention of presenting it to the Uffizi and later painted a more informal one of himself wearing a straw hat. Whether this was inspired by Van Gogh's self-portrait, in which he is wearing a similar hat, is not certain; but since they were both Dutchmen, and Van Gogh's work was becoming better known following his death in 1890, it is a possible explanation.

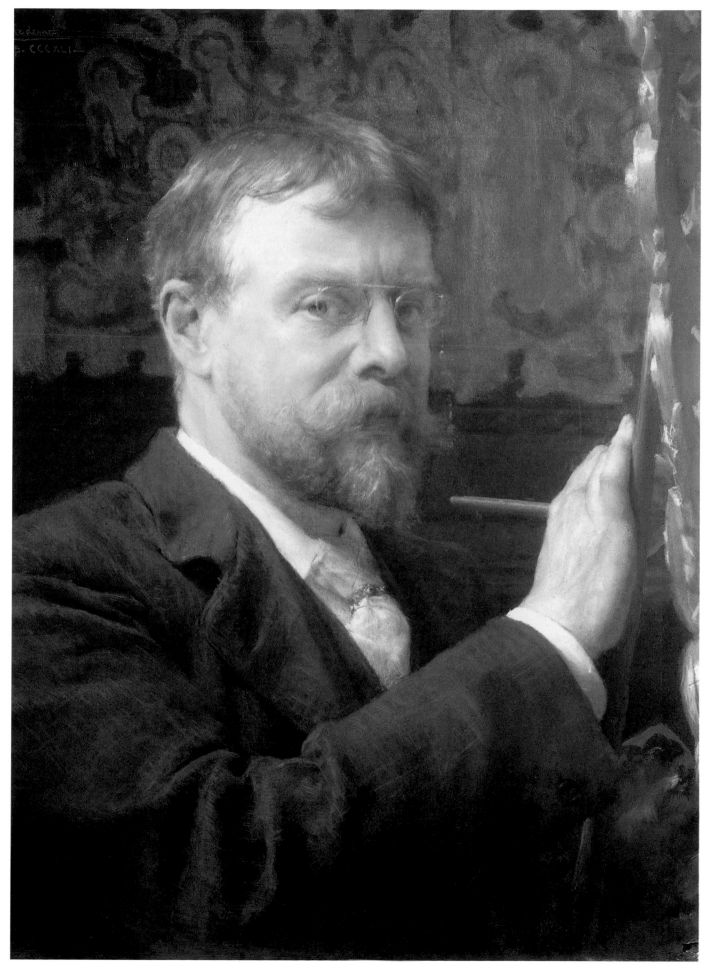

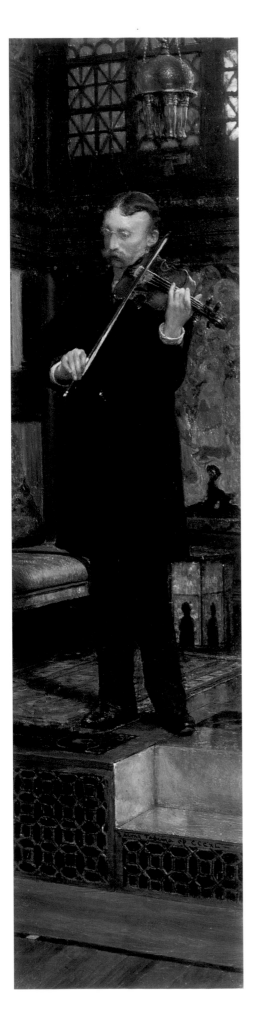

Maurice Sens (1896)
Oil on canvas. 20 x 5in
(50.8 x 12.7cm).
Private collection.

This is a commissioned
portrait of the violinist
who was a friend of Alma-
Tadema and sometimes
played at the artist's
Tuesday evening musical
soirées: it is probable that
Alma-Tadema gave the
finished work to the
musician in gratitude for
his performances. The
setting of the portrait, in a
corner of Alma-Tadema's
studio, was probably
intended as a souvenir of
the pleasurable gatherings
attended by many of the
celebrities of the time,
including Alma-Tadema's
London artist friends, and
such European luminaries
as Enrico Caruso and
Eleonora Duse.

and a local disaster, *The Inundation* (p. 7), in which a child
is shown asleep, while a terrified cat attempts to wake it as
flood waters advance. This latter gives a foretaste of the vein
of sentimentality which ran through much of Alma-
Tadema's later work, once he had become a dedicated
father and devotee of the domestic life, though many
paintings on the theme were transferred to Roman settings;
no doubt, Alma-Tadema wished to inject a little culture
into the lives of the newly-emerging *nouveaux riches*.

At about this time, Alma-Tadema persuaded his mother
and sister to join him in Antwerp where they set up house
together, establishing the quiet, ordered domesticity that
was essential to his peace of mind. He was not a bohemian,
an iconoclast rebelling against the status quo and ever
searching for new and original techniques; he was a
hardworking artist-craftsman in the style of his Dutch
predecessors and, like them, worked conscientiously to
satisfy his public and earn a living.

With a mother, sister, house and studio to finance,
Alma-Tadema, having found work as an apprentice at the
studio of Baron Hendrick Leys, was spurred to even greater
efforts. His first commission was to help the Baron with
the decorations of the Antwerp Town Hall, which more

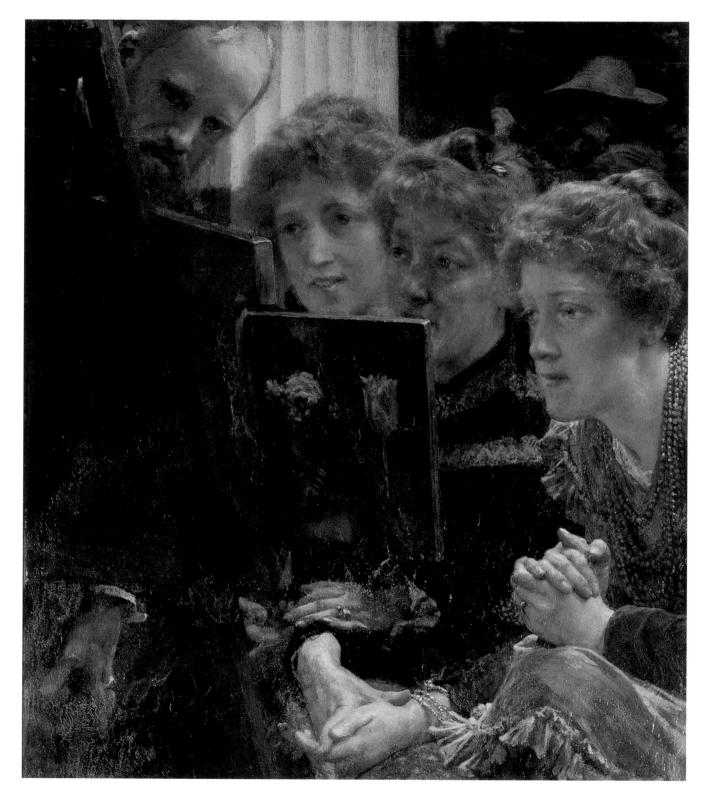

A Family Group (1896)
Oil on panel. 12 x 11in
(30.5 x 28cm).
The Royal Academy of
Arts, London.

This is a small painting of
the Epps family, Alma-
Tadema's in-laws. Epps
was a homeopathic
doctor and an importer of
cocoa, a business which
had made him a wealthy
man. Laura, Alma-
Tadema's young second
wife, had reddish hair like
her mother and is next to
her at the centre of the
picture. Her sister, Ellen,
who married Edmund
Gosse, famous for his
great book *Father and
Son*, and a librarian at the
British Museum and later
the House of Lords, is on
the right. On the left is
Washington Epps, Laura's
brother. The painting on
the easel is a triptych
which Alma-Tadema and
his wife had painted for
their wedding in 1871.

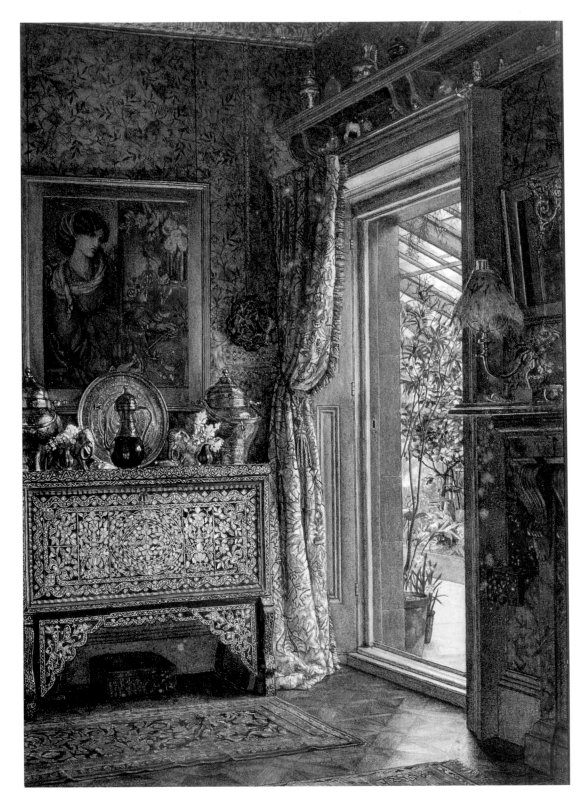

**Master John Parsons
Millet** (1889)
Oil on canvas. 11½ x
7½in (29.3 x 19cm).
Private collection.

John was the son of an
American, Frank Millet,
who lived in the
Cotswolds and knew all
the artists who lived and
worked around Broadway,
a location that had
become a popular centre
for artists, for it was a
tranquil and beautiful
place studded with small
villages built of honey-
coloured Cotswold stone.
Millet was a close friend
of Alma-Tadema and of
the other Cotswold
painters, which included
Frederick Barnard, Alfred
Parsons, Edwin Austin
Abbey, and occasionally
John Singer Sargent.
Unfortunately, Frank
Millet died in the *Titanic*
disaster.

ABOVE
**Drawing Room, Holland
Park** 1887 (Anna Alma-
Tadema, 1865–1943)
Watercolour. 11¾ x 8in
(29.8 x 20.3cm).
Russell-Cotes Art Gallery
and Museum,

Bournemouth, England.

This London room was
painted by Alma-Tadema's
talented daughter, Anna.
It probably belonged to
the Alma-Tademas' artist
friend, Albert Moore, and

provides a glimpse of the
opulent middle-class
residences of the time.
The French window leads
into a conservatory in
which were kept
evergreen plants, such as
ferns, aspidistras and,

occasionally, caged birds.
These glassed-in spaces
were intended to
encompass nature, albeit
in a tame, domesticated
form, which the Victorians
believed they could
master.

than satisfied the Baron when he realized that he had a talented young assistant at his disposal. His one criticism of his apprentice's work was that he managed to make marble look like cheese. This, however, did not dismay Alma-Tadema, but encouraged him to do better: his typical response was always to confound his critics by improving his technique, so much so that in later years he was known as the 'master of marble'.

The death of Alma-Tadema's mother in 1862 was a serious blow and it may be that he went to London in an attempt to relieve his sorrow. He visited the recently opened Victoria & Albert Museum and encountered the Elgin Marbles in the British Museum, as well as superb artefacts from Ancient Egypt and the classical Greek and Roman worlds. These were all destined to supersede the Merovingian influence as the main inspiration for Alma-Tadema's work.

In 1863, and possibly to re-create the happy home environment that he had enjoyed with his mother and sister, he married Marie-Pauline Gressin de Boisgirard, the daughter of a French journalist. Their honeymoon was spent in Florence and Rome, where it was Alma-Tadema's intention to study Renaissance subjects and early Christian churches. He was rather more fascinated, however, by the remains of classical Rome, and the archeological explorations at Pompeii and Herculaneum, began in 1763, that were still yielding finds.

Alma-Tadema was entranced. He had found the subject on which he could focus his life's work, a subject already popular in the art markets of Europe: the Latin language, with Greek, was already an important part of the education of cultivated Europeans and Roman history was particularly fascinating to the British, both nations having links to an imperial past.

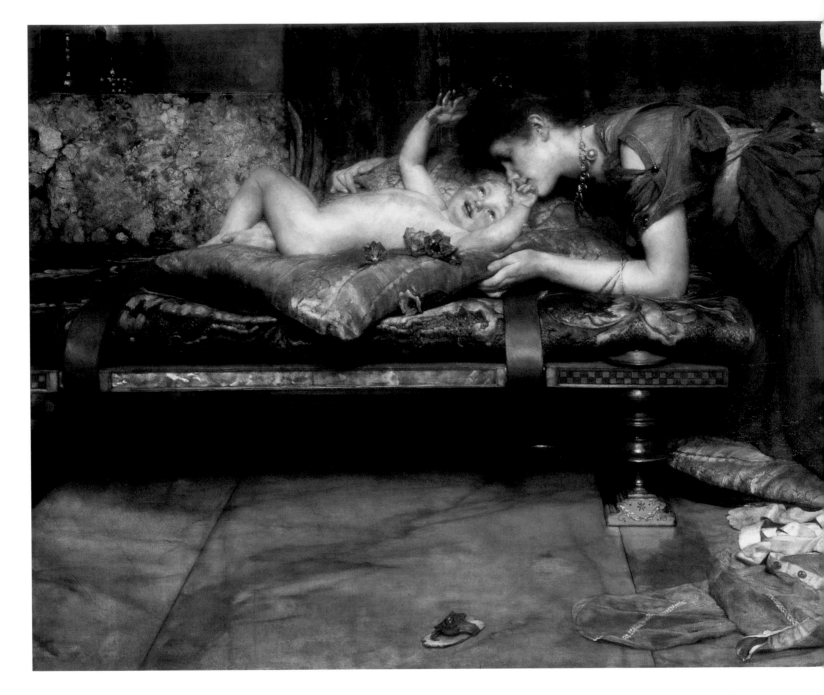

An Earthly Paradise
(1891)
Oil on canvas. 34 x 65in
(86.4 x 165.1cm).
Private collection.

The warm, sentimental side of the artist's nature is expressed in this painting of a mother and child. For him, paradise was a comfortable home with children, supervised by a loving wife who, no doubt, was tolerant of his practical jokes, his endless entertaining, and his passion for working all hours of the day and night. Alma-Tadema was a typical Victorian paterfamilias, a gentle tyrant who was easily angered when things did not go his way and especially when other artists received awards he considered rightfully his.

Alma-Tadema did not immediately begin painting Roman subjects, however; his increasing reputation as an artist with a respectable list of patrons was based on his skill as a painter of the Middle Ages. Gradually, however, new subjects began to appear in his catalogue and in 1863 he painted *Pastimes of Egypt*, a picture for which the Emperor Napoleon III offered 3000 francs. Despite Nelson's defeat of the French fleet at Aboukir Bay in 1798, the French interest in Egypt had remained strong, thanks to the large body of scholars that had accompanied the first Napoleon on his Egyptian adventure.

The Alma-Tademas had moved to Paris in the 1860s, and work was going well. But their small son, Eugène, died of

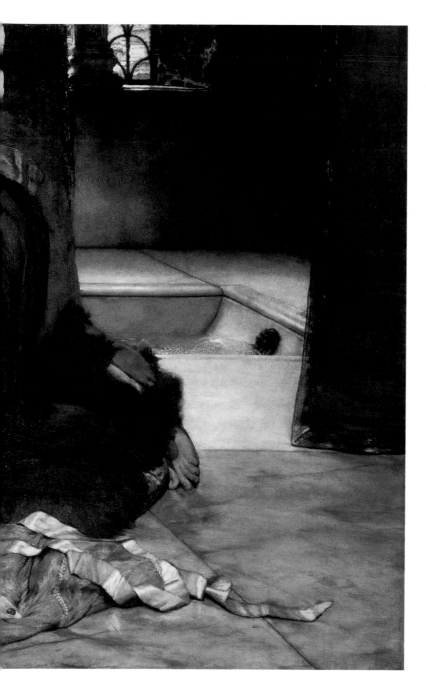

smallpox in 1865 and his wife, Pauline, in 1869, leaving her husband with two young daughters, Laurence and Anna, to bring up on his own.

In 1865 Alma-Tadema had had a fateful encounter in Paris with Ernest Gambart, an art dealer with connections in many parts of Europe. The story of their meeting has something of a legendary quality: according to some, the encounter was plotted by Alma-Tadema's friends, while others claim it was accidental. The facts are that Gambart was misdirected as he set off for another artist's studio and found himself instead at Alma-Tadema's door where he was confronted by a large painting with an Egyptian theme; he was so taken with it that he ordered a dozen of the same – 'as if,' Alma-Tadema later wrote, 'they were bales of cotton.'

Whatever he may have secretly thought, Alma-Tadema knew that he would be insane to refuse such a request, and persuaded Gambart to take six of his Merovingian paintings and six on Egyptian themes.

Encouraged by Gambart and confident that his future was now assured, Alma-Tadema moved to Brussels, where he became friendly with his landlord, another art dealer called

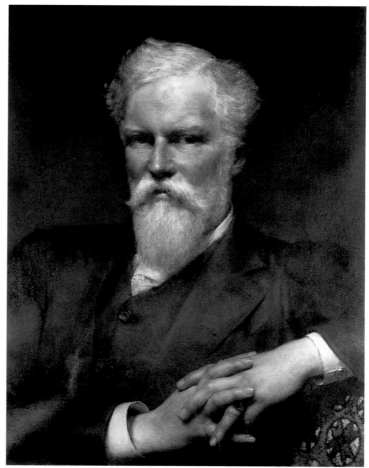

RIGHT

Portrait of Sir Alfred Waterhouse (1891)
Oil on canvas. 26 x 21in (66 x 53.3cm).
Bonhams, London.

This portrait of a typical Victorian gentleman is of Alfred Waterhouse (1830–1905), an English architect knighted for his services, whose designs

included the Manchester assize courts (1859) and Town Hall (1869–77), for which Ford Madox Brown painted a mural of Hadrian building his great wall, and the Natural History Museum in London (1873–81).

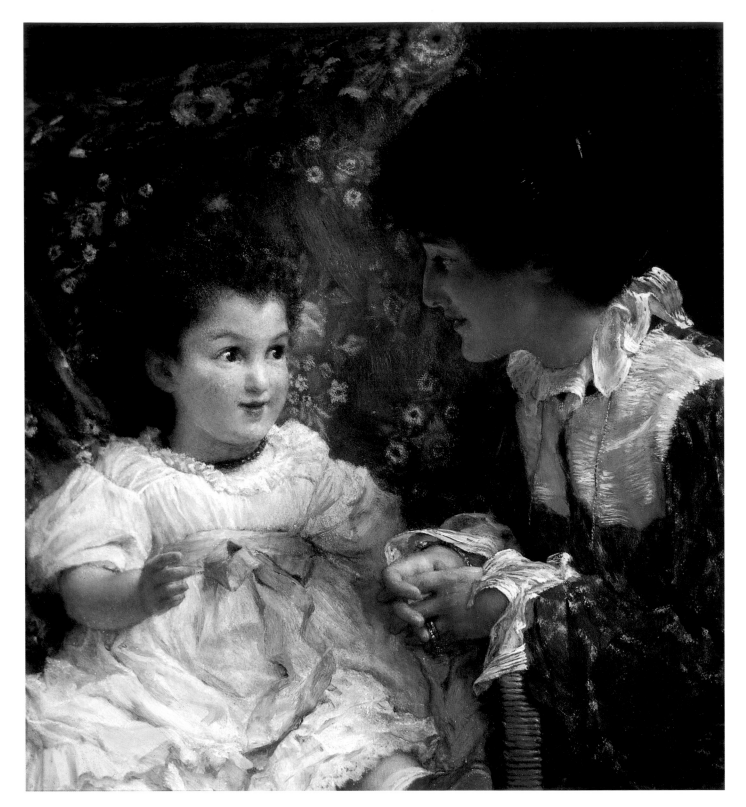

Mrs George Lewis and Her Daughter Elizabeth
(1899)
Oil on panel. 9³/4 x 8³/4 in (24.8 x 22.2cm). Private collection.

Although the painting is of both mother and daughter, the artist has in fact concentrated on the child, whose face is brightly illuminated while the mother's is in shadow. Alma-Tadema painted many portraits featuring his friends and relations – some commissioned. But all of them were produced in a straightforward and truthful academic manner. However, Alma-Tadema did not set himself up solely as a portrait painter, for his interests lay in other directions. Mrs Lewis was the wife of the artist's solicitor and the cost of the portrait may have been set against legal fees.

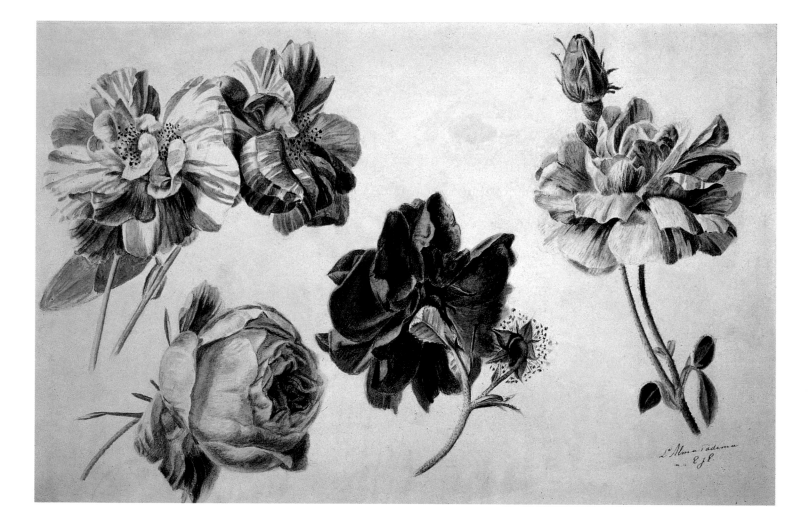

Roses (Undated)
Watercolour. 7³/₄ x 11²/₃in
(19.7 x 29.6cm).
The Victoria & Albert
Museum, London.

Throughout his life, Alma-
Tadema produced
thousands of studies of
flowers, artefacts and
fragments of architecture,
which he used as
components of his later
compositions. He was
also an avid collector of
objects brought back from
his travels and which he
used to decorate his
house and studio. In this
way, he never ran short of
subjects to paint when he
needed them.

Félix Mommen, and they became lifelong friends. In Brussels
a change came over Alma-Tadema's painting when he decided
to abandon his Merovingian fantasies, which had been
painted in a dark-walled studio; to help him make the
transition towards the classicism of his Victorians in Roman
guise, he painted his new studio pale green and began to use
a palette of far lighter colours.

The Brussels art world readily took to the new painter in
their midst and liked his pictures of domestic life set in
opulent Roman villas. These were still indoor scenes with full-
length figures, though he began to introduce tantalizing
glimpses of gardens and flowers seen through windows and
porticoes.

Pleased with his protégé's progress, Gambart invited
Alma-Tadema to London so that he could attend a large
party that the art dealer was giving on Derby Day, 1866, and
where he could introduce him to prospective clients for his
pictures.

Gambart's house had recently had gas pipes fitted and on
the day after Alma-Tadema and his wife arrived, a servant,

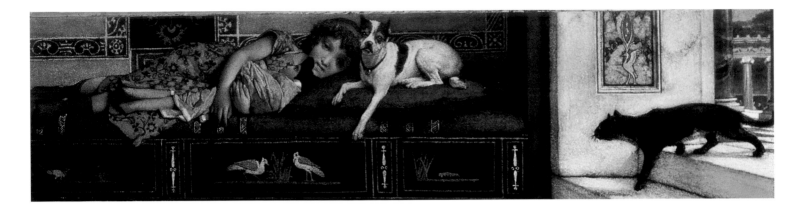

Good Friends (1873)
Oil on canvas. 4½ x 7¼in
(11.4 x 18.4cm).
Hackley Art Gallery,
Michigan.

The title becomes
ambiguous when one
notices that the black cat
is entering with an
aggressive air, or it is
possible that it is jealous
and may attack the dog.
The Victorians loved
sentimental animal
pictures, and Edwin
Landseer was the most
famous exponent of the
genre for the almost
human expressions he
gave to his subjects.
Alma-Tadema, however,
did not continue in this
vein, but concentrated his
curiosity on everyday life
as the ancient Romans
may possibly have lived it.

becoming aware of the smell of escaping gas, went into the
billiard room, which she guessed to be the source of the leak,
and lit a match. The resulting explosion blew Gambart's
guests, including the Alma-Tademas, out of their beds and
badly damaged the house. Fortunately, no one was hurt.

The following day, two of Alma-Tadema's paintings were
exhibited at the French Gallery in London and received
praise from the critics, a sign that his work was as acceptable
in Britain as it was on the continent of Europe. But the
disaster in Gambart's house left the Alma-Tademas too upset
to enjoy their visit to London; Pauline, especially, suffered
extreme shock from which she never fully recovered.

Gratified by Alma-Tadema's London debut, Gambart
now planned to send his painter's work to Paris, where the
market for classical and mythological subjects executed in the
academic tradition was still strong, despite the challenge
already coming from the young artists who, in the 1870s,
would become known as the Impressionists. Gambart entered
13 of Alma-Tadema's paintings at the Exposition Universelle
of 1867.

In Paris, the glamorous Second Empire of Napoleon III
was at its peak. The Emperor and his wife, Eugènie, had
transformed Parisian society, as had the Emperor's architect
Baron Haussmann, who had transformed the medieval city by
creating great boulevards crossing its centre and replacing
ancient and crumbling houses with splendid mansions. The
boulevards, with cafés and restaurants situated along their
tree-lined lengths, through which the carriages of the
affluent processed, soon become the hub of social life. The
Empress gave the lead in matters of fashion and dress houses
sprang up along the Faubourg St-Honoré and great
department stores alongside the Louvre. The cultured classes
attended all the great social occasions, from the opera to the

Always Welcome (Laura
Alma-Tadema, 1887)
Oil on canvas. 14½ x
21½in (37 x 54.6cm).
Russell-Cotes Art Gallery
and Museum,
Bournemouth, England.

This was painted by Alma-
Tadema's second wife,
Laura Epps, who was a
talented painter in her
own right. Indeed, when
she first met her
husband, he used the
excuse of advising her on
painting in order to begin
courting her. This is a
typical Victorian domestic
scene intended to touch
the heart of the viewer
and appears to be a
period piece, perhaps
Tudor or Elizabethan.

highly influential annual Salon, while everyone, whatever their class, patronized the more plebeian but lively dance halls such as the *bals musette* and the Moulin Rouge. In a few years Paris had been transformed from a dowdy post-revolutionary city into the very centre of the civilized world of culture, fashion, art and entertainment.

Confident that he would soon be successful in the wider world beyond The Netherlands, Alma-Tadema worked harder than ever, following Gambart's advice and producing pictures with a classical theme. From his studio came works with titles such as *A Collection of Pictures at the Time of Augustus* (p. 30), *A Dealer in Statues* (p.32), *Phidias and the Frieze of the Parthenon* (p. 36–37), which he hoped to send to London's Royal Academy, now at Burlington House, in 1868, and *A Roman Art Lover* (p. 46–47) .

In the event, Alma-Tadema exhibited *A Roman Art Lover*, as well as *The Pyrrhic Dance* (p. 40–41) at the Royal Academy in 1869. The renowned art critic John Ruskin, was not impressed by the latter painting. He remarked that the warrior figures circling around each other were like 'a small detachment of black beetles in search of a dead rat'. Ruskin was in the minority, however, for most of the London critics viewed Alma-Tadema's paintings with approval.

Exhausted by work – for he had produced eight paintings in four months – Alma-Tadema visited London to see a specialist, Sir Henry Thompson, and found that he needed an operation (possibly for a prostate problem, for there were no further children of his later, second marriage). While in London he was entertained by Sir Johnstone Forbes Robertson and Ford Madox Brown, who invited him to a party where he met Laura Epps, the 17-year-old daughter of Dr Epps, a cocoa importer, businessman and homeopathic doctor. Laura was to become Alma-Tadema's second wife and an accomplished painter in her own right.

CHAPTER TWO
ROMANCE
AND HISTORY

In 1870, Alma-Tadema decided to move his studio from Paris to London, taking his daughters with him. His wife had died the year before and Paris – and indeed, all of France – was beginning to look very much threatened by the military ambitions of Prussia. The London that Alma-Tadema – and numerous French artists, including Monet and Pissarro – decided inhabit, if only for a time, was enjoying considerable prosperity at this mid-way point in the reign of Queen Victoria. There was a thriving middle class, becoming much enriched by Britain's leading role in the new industrial world and from the pickings of imperial expansion, and they were eager to fill their houses with paintings, sculptures, stylish furniture and other trappings of wealth.

The expression of this spirit of optimism in the world of the arts was guided by high-minded people like John Ruskin who, in commenting on a painting by Frederick Leighton, *Cimabue's Madonna Carried in Procession*, which was exhibited at the Royal Academy in 1855 and later bought by Queen Victoria, wrote: 'This is a very beautiful painting. It has sincerity, grace and is painted on the purest principles...' Thus, morality had become a requisite of good art and honest craftsmanship, as expressed in the work of William Morris.

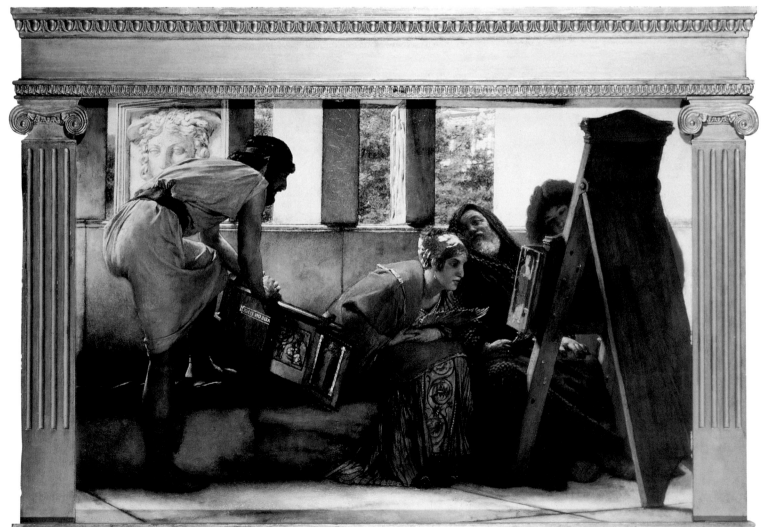

OPPOSITE
A Roman Studio
(Undated)
Oil on canvas. 25$\frac{1}{2}$ x
37$\frac{1}{2}$in (64.7 x 95.3cm).
The Fine Art Society,
London.

Alma-Tadema produced
several paintings of artists
showing their work in
their studios. This one is
more unusual because
the studio is evidently
well lit by a portico
through which a garden
with statuary can be
seen. The picture on view
appears to be a wooden-
framed triptych, for one of
its panels is folded back
over the edge of the
easel. Similarly, the frame
which the artist is holding
also has a painting in it.
An alternative title for the
painting is *Antistius
Labeo*, who was a jurist
living at the time of
Augustus who died
around AD 22, and with
whom Alma-Tadema
identified; this is why he
made the hooded
Roman's face a self-
portrait and included
members of his family as
viewers.

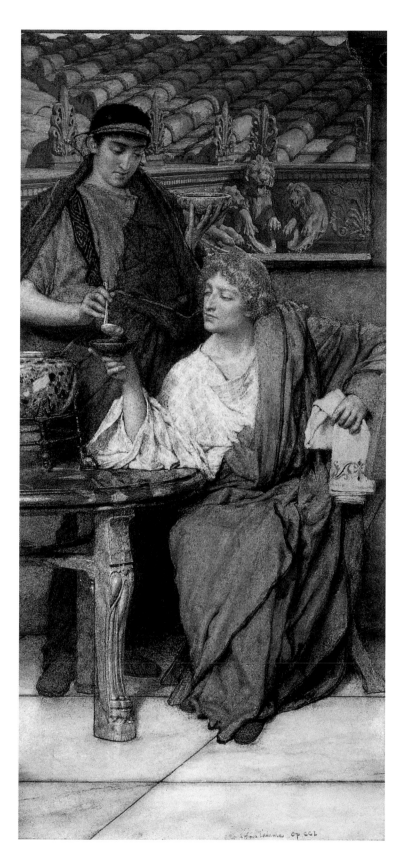

LEFT
**The Roman Wine
Tasters** (1861)
Oil on canvas. 50 x 69$\frac{2}{3}$in
(127 x 176.8cm).
Christie's, London.

This is an early Alma-
Tadema Roman scene in
which he has suggested a
Mediterranean location by
using terra cotta tiles on a
house across a narrow
street from a roof terrace
where two friends are
tasting wine. One has
scooped up a ladleful of
wine from an
earthenware vessel on
the marble table and is
pouring it into a shallow
tasting cup, which
became known as the
taste-vin in France and
was often made of silver
or pewter.

RIGHT
A Roman Scribe (1865)
Oil on panel. 21 1/2 x
15 1/2 in (54.5 x 39.2cm).
Private collection.

RIGHT
A Roman Scribe (1865)
Oil on panel. 21 1/2 x
15 1/2 in (54.5 x 39.2cm).
Private collection.

The scribe, in his bright
red toga, presents an
impressive figure and
Alma-Tadema has painted
him with all the verve of a
Van Dyck portrait. The
sombre ambience
suggests a corner of the
artist's own house,
though he has introduced
a tiled floor to suggest a
Roman villa. Scribes,
when literacy was a
qualification of the few,
held an important position
in Roman society.

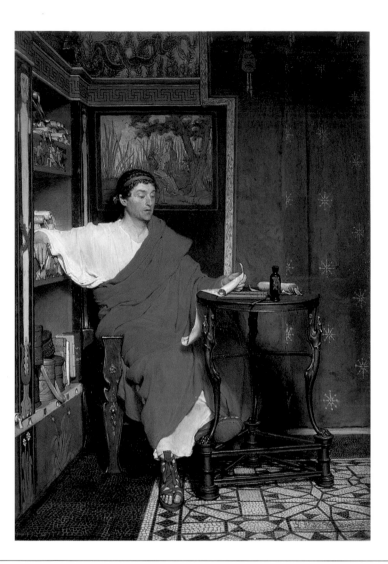

OPPOSITE
A Picture Gallery (1866)
Oil on canvas. 16 1/8 x 23in
(41 x 58.3cm).
The Fine Art Society,
London.

Wealthy Romans resembled
wealthy Victorians in that
they liked to accumulate
possessions as a mark of
their status in society.
Victorians were especially
acquisitive, the more so if
they had become rich
through success in trade
and the new industries of
the late 19th century.
Hanging paintings in their
houses also made them
appear cultured when
perhaps they were not. This
picture is one of several on
the subject.

Alma-Tadema, a businessman sensitive to market trends, fitted neatly into the requirements of English society. His passion for the domestic details that existed in historical subjects was well in tune with the family-based domestic virtues approved of in the court of Queen Victoria, and emulated by the middle classes of Britain. Therefore, he was ready to follow artistic pathways previously travelled by other artists, such as Frederick Leighton, who had already been exploring the artistic applications of the classical world.

Public interest in the ancient world, ignited in the 18th century by works such as Edward Gibbon's *Decline and Fall of the Roman Empire*, completed in 1778, and the first discoveries at Pompeii, had been fuelled in the 19th century by the archaeological discoveries of the post-Napoleonic period. The railway boom and the advent of the steamship allowed increasing numbers of travellers to discover for themselves the ancient splendours of Egypt, Greece and Italy, while interest at home led to enormous success for books

such as Bulwer Lytton's *The Last Days of Pompeii* (1834) and Wilkie Collins' *Antonina: or The Fall of Rome* (1850).

Artists, always watchful for subjects that would interest buyers, were quick to seize on classical subjects. In 1819, just four years after Napoleon had been defeated at Waterloo, J.M.W. Turner was travelling in Italy. Out of his visit came works such as *Rome: The Colosseum*, painted in a romantic and atmospheric style, and *Forum Romanum*, *Caligula's Palace and Bridge* and *Rome from Mount Aventine*, while John Martin, an artist specializing in catastrophic events, painted *The Destruction of Pompeii and Herculaneum* in 1822.

After Turner and Martin came a procession of painters who scoured the classical world for subjects, including Ford Madox Brown, who painted a mural of Hadrian building his great wall, for the Manchester Town Hall, and William Bell Scott who used the same subject for Wallington Hall, Northumberland. It was not long before Alma-Tadema had

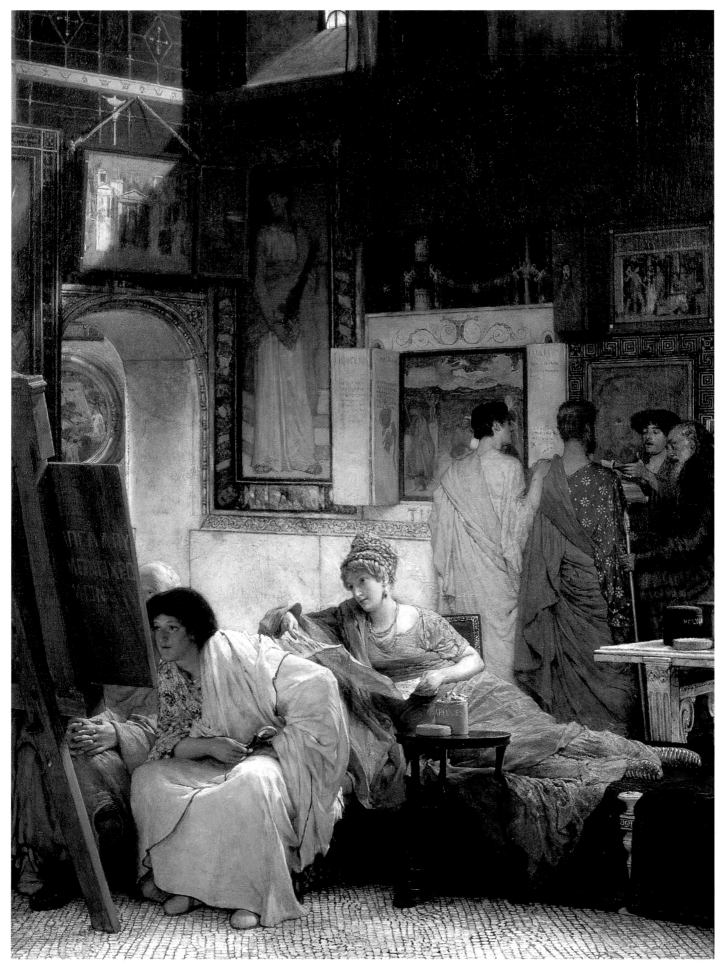

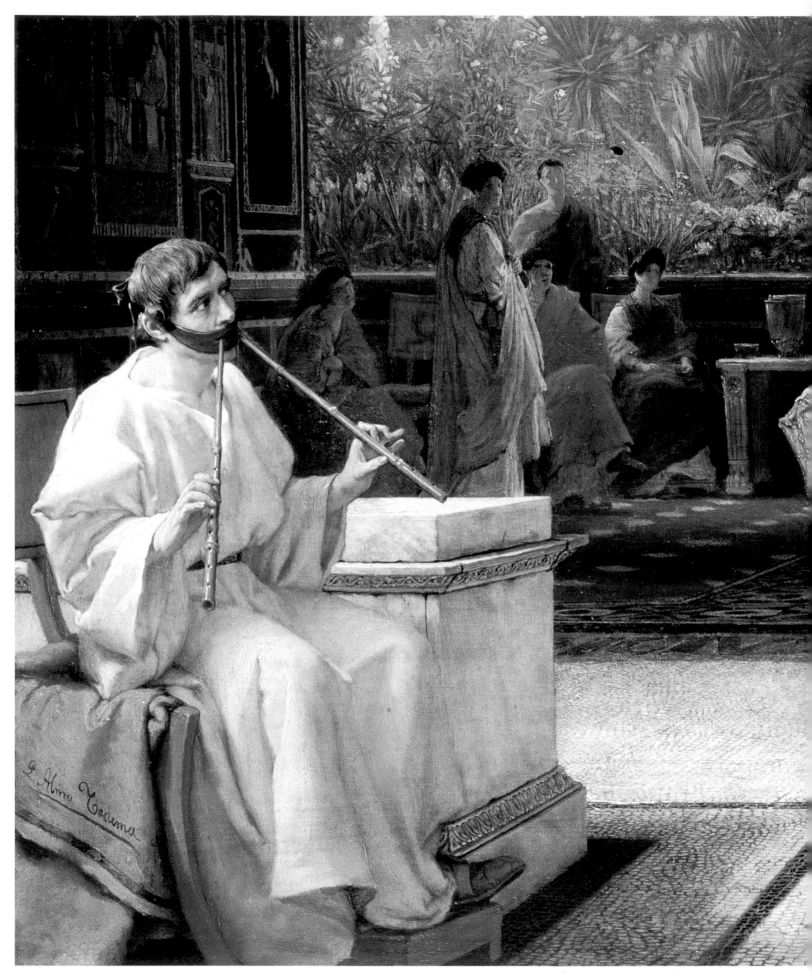

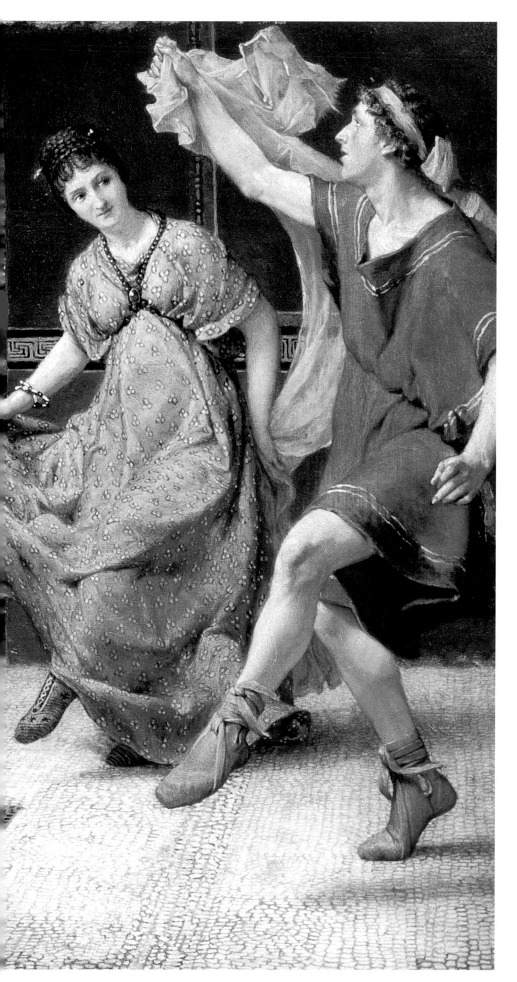

A Roman Dance (1866)
Oil on panel. 16$\frac{1}{8}$ x 22$\frac{1}{8}$in (41 x 56.3cm). Private collection.

In this picture, Alma-Tadema has chosen to portray the decorous and cultured side of Roman life. The family which inhabits this house is not the kind to patronize the violent and bloody combats in the arenas but prefers to be entertained at the theatre by the tragedies of Sophocles or the comedies of Aristophanes. While the young couple dance to the music of the pipes, others are in the peristyle, wandering among the flowering shrubs.

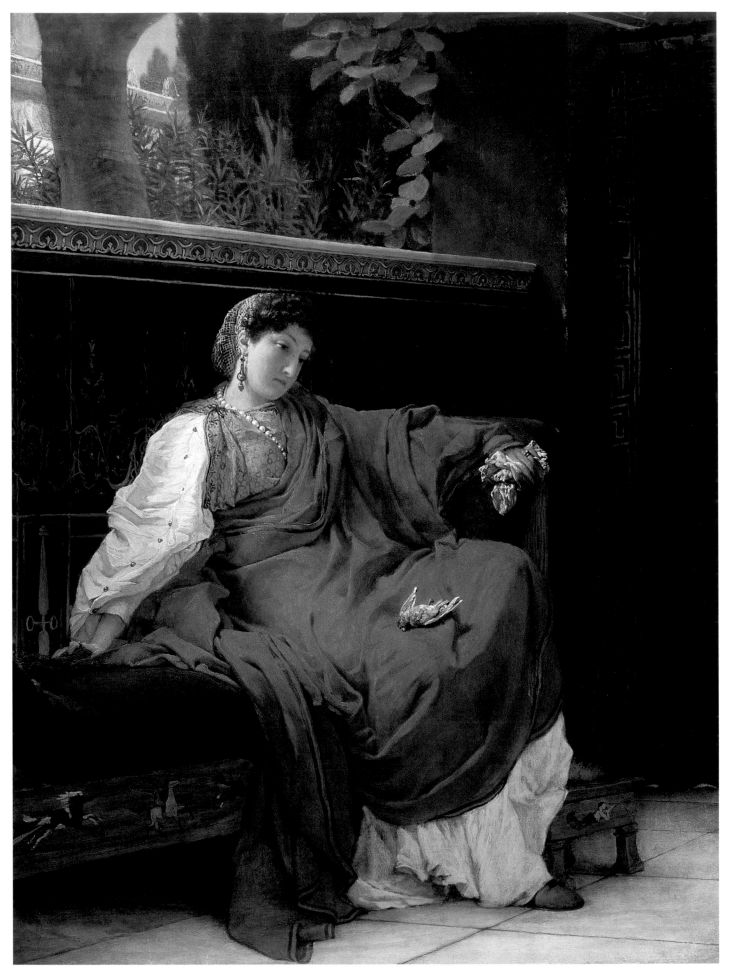

Lesbia Weeping over a Sparrow (1866)
Oil on panel. 25 x 19in
(63.5 x 48.3cm).
Private collection.

Victorian sentiment attached itself to all experiences of life, and particularly where animals were concerned. It was a subject, like a modern tear-jerker, that was guaranteed to touch the hearts of a large public

audience. Paintings of this genre were therefore very saleable, and even more thousands of cheap prints and engravings were made from the originals. Alma-Tadema's ventures into this field were few, but here he has exploited the subject with its religious allusions to the value of life – even a sparrow's – although the subject is a classical one.

not only joined this select band, but had also become the leading exponent where depicting the public, domestic and artistic lives of the ancient Romans was concerned.

From the beginning of the 1870s, Alma-Tadema had been a man in a hurry and England, in contrast to France and the rest of Europe, seemed a peaceful country, overflowing with opportunities for artists.

Moving to London in September 1870, Alma-Tadema rented a house in Camden Square, an unpretentious quarter in the north of the city. Having settled his daughters there, he began to re-establish connections with people he had met on his previous visit, most notably the Epps family, who received him hospitably. His main purpose was to present himself as a suitor for the hand of 17-year-old Laura Theresa Epps; as a widower of 35, with two daughters, he knew this would be no easy task.

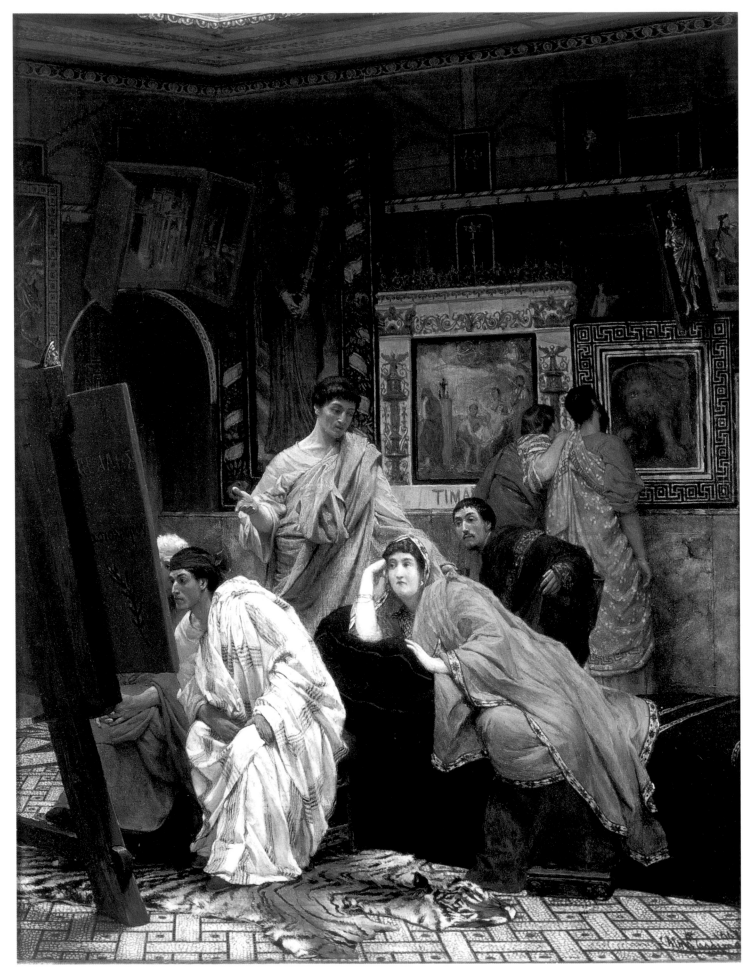

A Collection of Pictures
(1867)
Oil on panel. 28 x 18^1/$_3$in
(71 x 46.5cm).
Private collection.

Alma-Tadema produced several other paintings of Roman picture galleries besides this one – all showing the artist, or perhaps he is the buyer, wearing a white toga and seated or leaning towards an easel on which a picture is placed. In one, a woman reclines on a couch, looking at the paintings (p. 25), while another (p. 49) has a woman in a pink dress. Both the paintings have different background figures. The full title of this work is *A Collection of Pictures at the Time of Augustus* in order to differentiate it from the others.

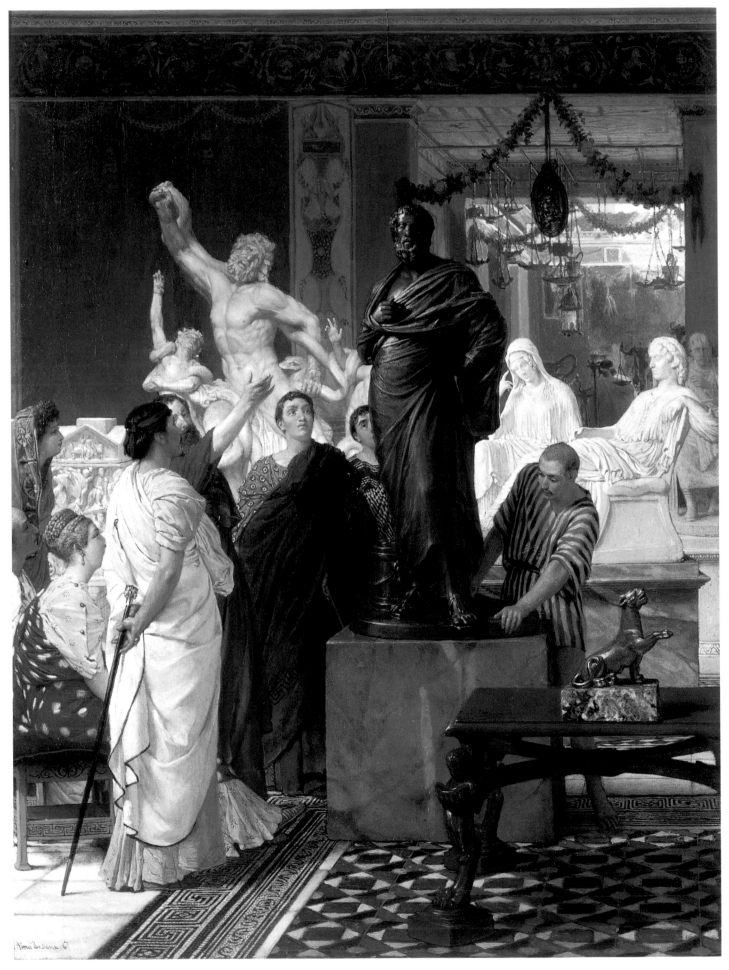

A Dealer in Statues

(1867)

Oil on panel. 24¹/₂ x 18¹/₂in (62.2 x 47cm). Private collection.

A statue is being shown by a dealer, who is expounding on its virtues while it is being turned by a servant so that the potential customer can see it to advantage. The central noble figure in bronze is of Sophocles, the tragic poet and dramatist. In the

background is a marble of Laocoön, a masterpiece of the Pergamene school and the work of three Rhodian sculptors, the original of which is now in the Vatican museum. The seated figure is of Agrippina, who was murdered by her son, Nero. As is often the case with Alma-Tadema's works, this painting also has another title – *A Sculpture Gallery in Rome at the Time of Augustus*.

With not a little guile, he approached the young Laura by discussing her two sisters' painting skills and asking why he had not yet seen her work. Her reply that she was a musician rather than a painter was not encouraging, neither was it true, for she had had lessons from three painters, including Ford Madox Brown. But Alma-Tadema was not to be deterred. He had noticed an unpainted screen in the Epps house on a previous visit and suggested that it could be used as the canvas for a family portrait.

The idea was well received and Alma-Tadema roughed in the drawing for the girls to fill in. Thus he grew closer to Laura, who was amused by his jocular manner. There were six sections of screen to be painted, the people to be included being the extended Epps family including all the daughters, husbands and children. The work was somewhat slow to progress and, indeed, was never finished. However, it lasted long enough for Alma-Tadema to bring his courtship of Laura to the point where he could propose marriage.

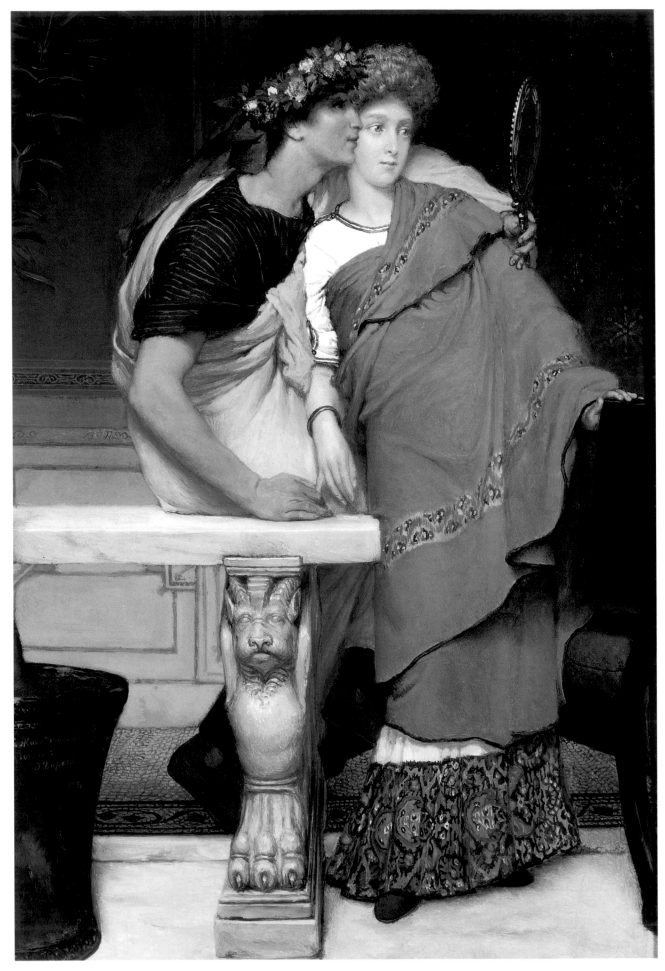

The Honeymoon (1868)
Oil on panel. 14 x 9½in
(35.5 x 24cm).
Private collection.

A young couple wearing
flowery headdresses are
gazing into a mirror which
the man is holding up.
Are they honeymooners
or are they narcissists,
vainly admiring

themselves? This painting
is also called *The Mirror*,
so either connotation
could be correct. The rich
garments that they are
wearing, and the elegant
marble table, suggest that
they are patrician
Romans, the equivalents
of the upper-class
Victorians who may have
bought a picture like this.

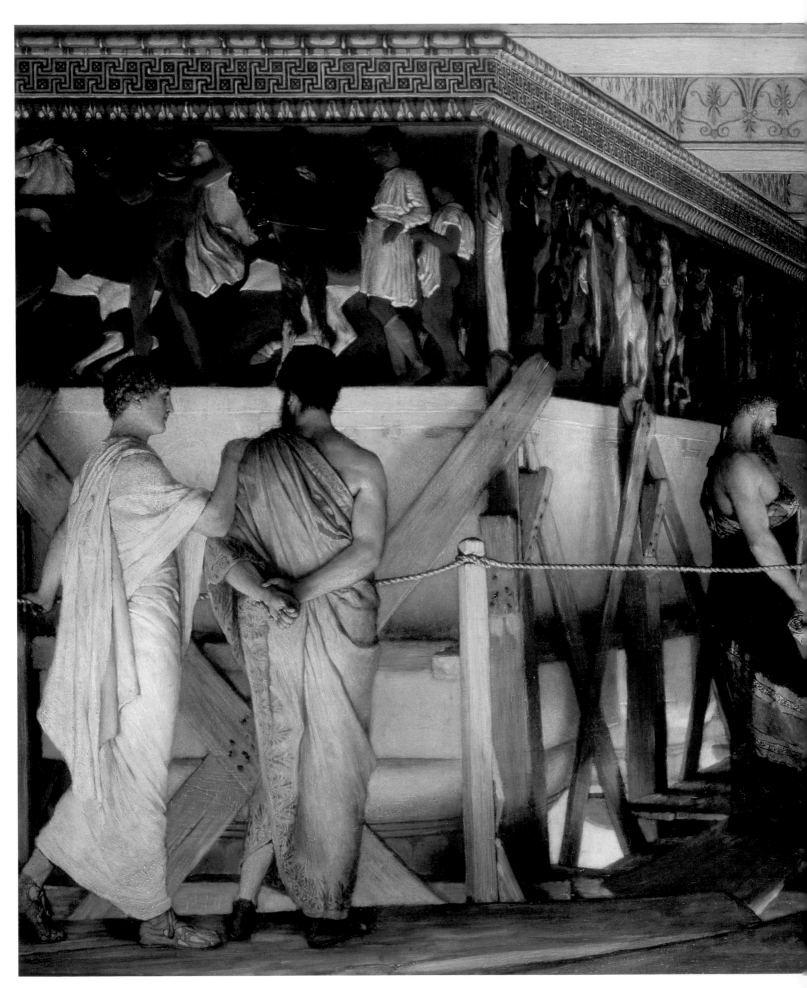

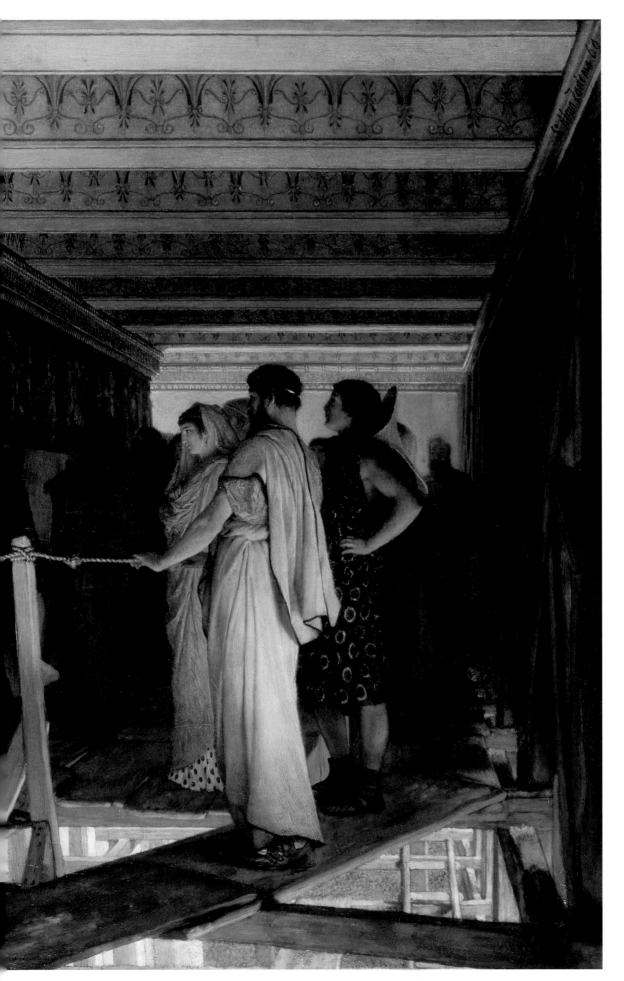

Phidias and the Frieze of the Parthenon, Athens
(1868)
Oil on panel. 29²/₃ x 42¹/₃in (75.3 x 107.5cm).
Birmingham Museums and Art Gallery, England.

In this ingenious composition, Alma-Tadema depicts Phidias showing off his frieze, already in position on the Parthenon. The sculptor and his visitors are standing on the scaffolding erected for the completion of the work, and segments of the pillars of the front of the building, and a ladder, can be glimpsed through gaps in the planking. Alma-Tadema's painting was inspired by the fact that Lord Elgin had brought back fragments of the original frieze to Britain in 1812, which were bought for the nation in 1816, so the artist had plenty of opportunity to study them in the British Museum.

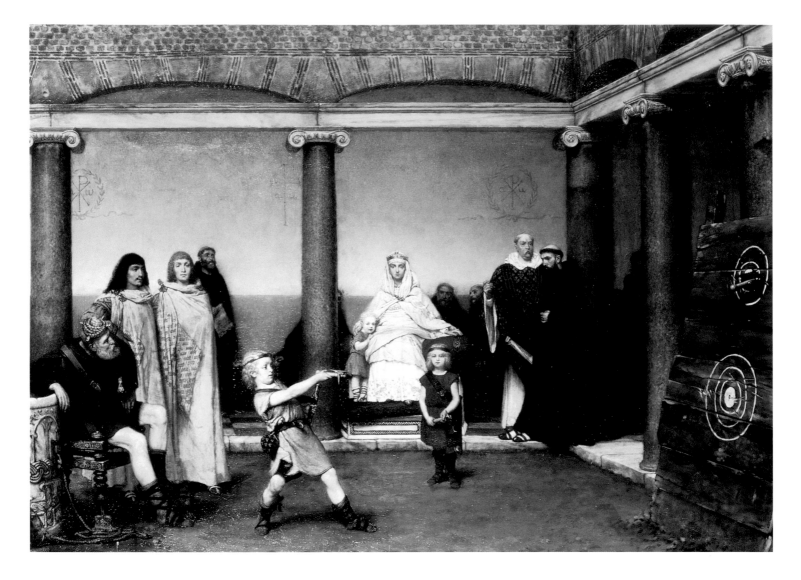

Her father did not reject the idea out of hand, but he was reluctant to agree because of his daughter's extreme youth. There was also resistance from an unexpected quarter: Ernest Gambart, by now determined to launch Alma-Tadema onto the London scene through the Royal Academy, feared that a marriage would diminish his protégé's creative powers.

He need not have feared. Now the artist had a greater incentive than ever to succeed and even increased his work rate, getting up at 4 am on his wedding day in order to complete a painting.

The marriage took place in the spring of 1871. A few weeks later, Alma-Tadema sent two paintings, *Proclaiming Claudius Emperor* (p. 66), which shows Claudius reluctantly allowing himself to be proclaimed Emperor by the Imperial Guard, and *The Grand Chamberlain of Sesostris the Great*, to the Royal Academy.

After a honeymoon spent in The Netherlands, where Alma-Tadema introduced his wife to the scenes of his youth, the couple returned to England, the artist full of energy and enthusiasm to further his career. He established a base at the elegant Townshend House, in Regent's Park, which soon became a popular meeting place for London's artistic establishment.

It was at about this time that he anglicized his christian name to Lawrence and began to use his middle name, Alma, as part of his surname, his reasoning being that 'Alma' would get him much nearer the top of art catalogues than 'Tadema'. He himself never hyphenated the two parts of his surname; it was the socially-snobbish English writers, critics and art dealers who gave him the hyphen.

By now, he had met Frederick Leighton, later Lord Leighton, who had seen in Alma-Tadema an ally in his promotion of the genre of classical painting that would make them both so rich and successful, and had also found friends among the Pre-Raphaelites, including Watts, Millais and Rossetti, to whom he had been introduced by Gambart.

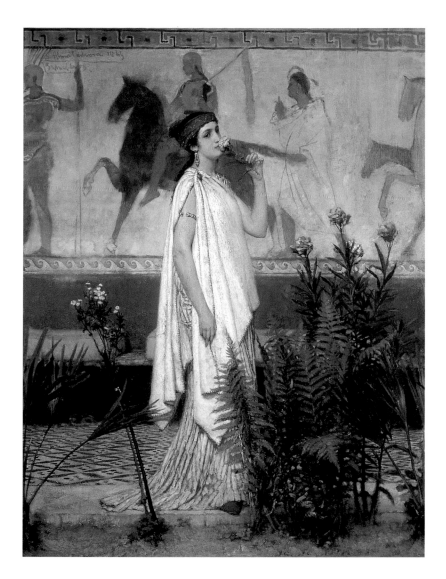

OPPOSITE
The Education of the Children of Clovis (1868)
Oil on canvas. 50 x 69²/₃in (127 x 176.8cm). Private collection.

In this Merovingian painting, Alma-Tadema shows the children of Clovis, King of the Franks, receiving a lesson in knife-throwing. Their mother looks on calmly and encouragingly as her children prepare to avenge the death of their murdered father. Alma-Tadema's interest in historical subjects was encouraged by his teacher, Hendrick Leys, but his own love of narrative and drama ensured that he continued to pursue this interest for the rest of his life.

ABOVE
A Greek Woman (1869)
23⁷/₈ x 18¹/₂in (60.7 x 47.1cm). Private collection.

The background to this picture resembles the decoration on a Greek vase, and the painting in its entirety has the appearance of a manufactured scene. As with much of his work, Alma-Tadema probably completed the painting in his studio. There is a mystery attached to the painting for, in a photograph dated 1906, the background is blank. It is not known if there was a later version or whether the artist painted out the background at a later date.

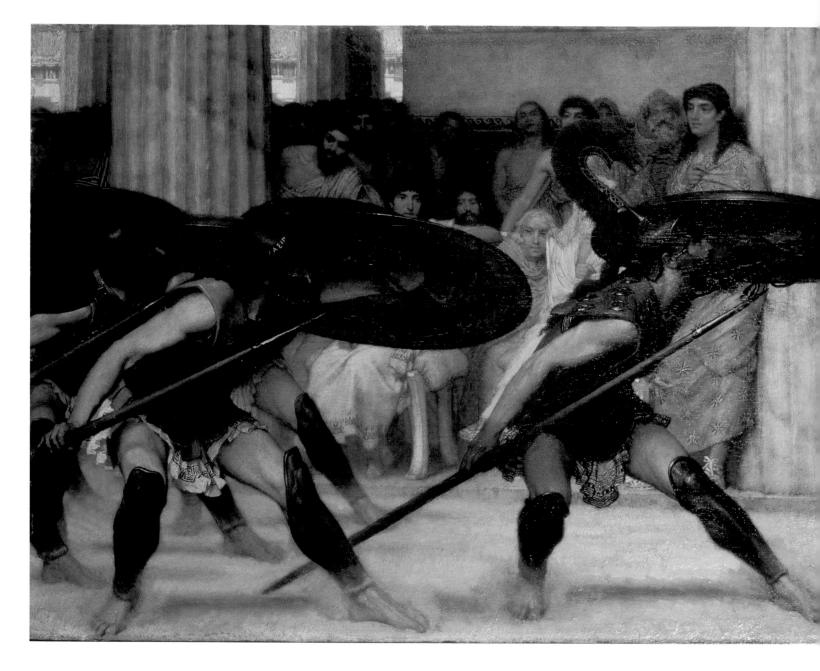

The Pyrrhic Dance (1869)
Oil on panel. 15¹/₈ x
30¹/₄in (38.4 x 76.8cm).
The Guildhall Art Gallery,
London.

The dancers are
performing a war dance
which dates back to the
time that Pyrrhus, King of
Epirus, invaded Italy in
280 BC as an ally of the
Tarentines in their fight
against the Romans.
Although Pyrrhus twice
defeated them, his losses
were so great that he
could hardly have claimed
to have had an overall
victory – hence the term
'pyrrhic victory' – a term
used to this day to
describe a victory won at
too great a cost.

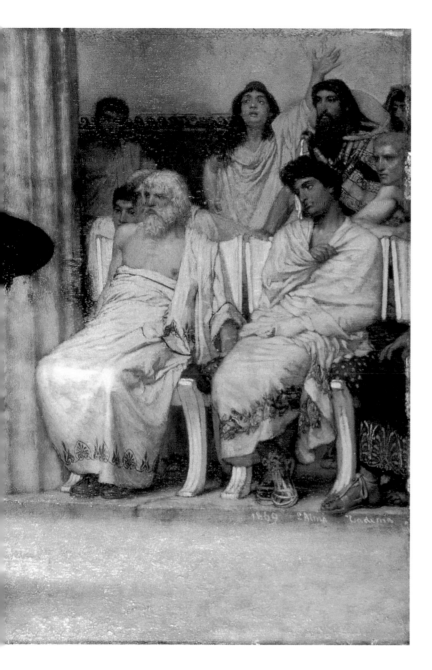

By nature and instinct, Alma-Tadema adhered to the narrative style in art, preferring to paint pictures which illustrated a story. In this he was a kindred spirit with Leighton and Sir Edward Poynter, another artist immersed in the Greek and Roman worlds and whose works were described by Whistler as 'five o'clock tea antiquity'.

Already a member of this fraternity, Alma-Tadema was soon on his way to becoming fully accepted into the London artistic scene, assisted by his painter friends who did not see him as a rival, for his work had a unique architectural quality which he had perfected over the years. Alma-Tadema's art achieved an appealing intimacy in its depiction of the Roman scene, an intimacy which depended more than a little on the fact that Alma-Tadema made Roman women look exactly like English ladies: as was said of him more than once, Alma-Tadema painted Victorians in togas.

This struck a chord in the British who, possessing the largest empire since the time of the Romans, felt themselves to have inherited the mantle of civilization which the Romans had assumed before them. Victorian Britons had a sense of mission, which was zealously adhered to by businessmen, missionaries and teachers abroad, and many of them tried to match their domestic lives to the high standards of Caesar's wife.

From the time he first began to paint, Alma-Tadema had kept a catalogue of his work, giving each one as he listed it a Latin description: thus the first portrait of his sister was listed as 'Op. I' or Opus (Work) I. Moreover, in 1872 Alma-Tadema borrowed an idea from Whistler and, instead of dating his work, began to write the Opus number in Roman numerals beside his signature on the paintings themselves.

This painter of Britons in togas now decided to become one himself. Britain was now his home and he had come to share the beliefs and ideals of his new compatriots. In 1873, he submitted his request and was granted naturalization, the occasion bringing with it a personal letter from Queen Victoria. His acceptance was quickly followed by his first step up the ladder of the British art establishment when he was elected an Associate of the Royal Society of Painters in Watercolours.

By now, his work was also being accepted by the Royal Academy. In 1874/5 he had three paintings on show: *The Picture Gallery* (p. 49), *A Dealer in Statues* (p. 32) and *Joseph,*

Alma-Tadema's genial good spirits and fondness for jokes, as well as his unintentionally amusing malapropisms, endeared him to all who knew him in his adopted country.

As for his work, there were critics, of course, partisans of other forms of art, who did not hesitate to attack him. To John Ruskin, who had compared his Pyrrhic Dancers to beetles, Alma-Tadema's work lacked high moral tone and to Thomas Carlyle, an admirer of the Japanese prints that were flooding Europe, Alma-Tadema's compositions lacked style and elegance. Carlyle embraced the same stream of artistic thought as James McNeill Whistler, which came to be known as the Aesthetic Movement, owing much to Pater and Wilde, and which led eventually to the idea of 'Art for Art's Sake' and laid the foundations for later excursions into abstract art.

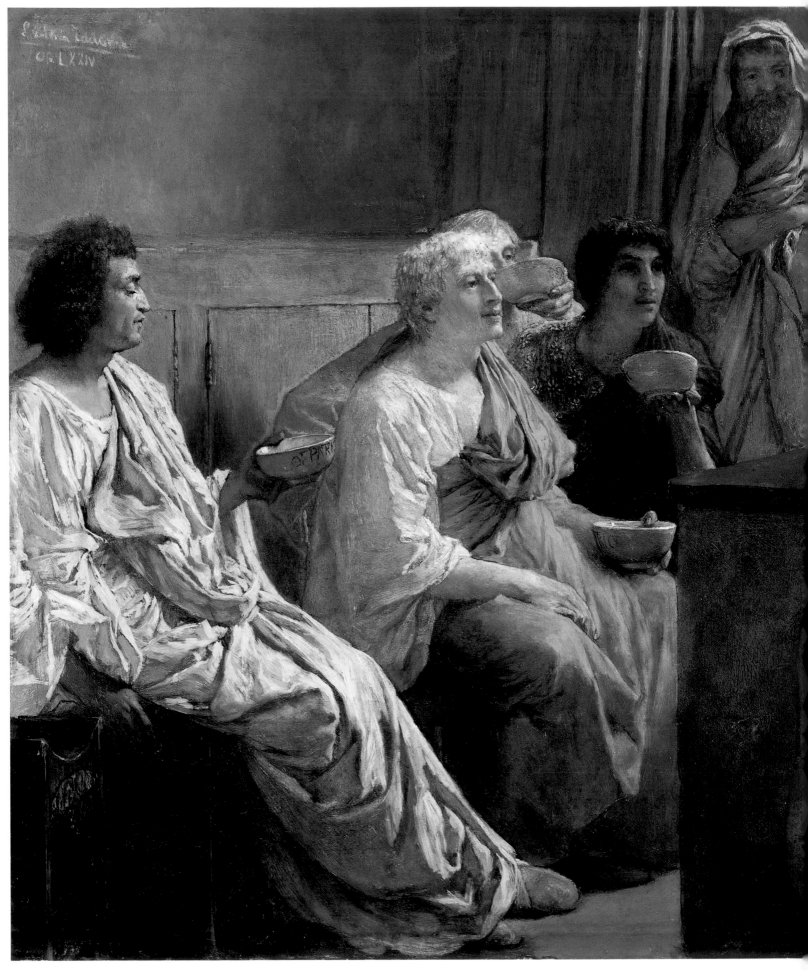

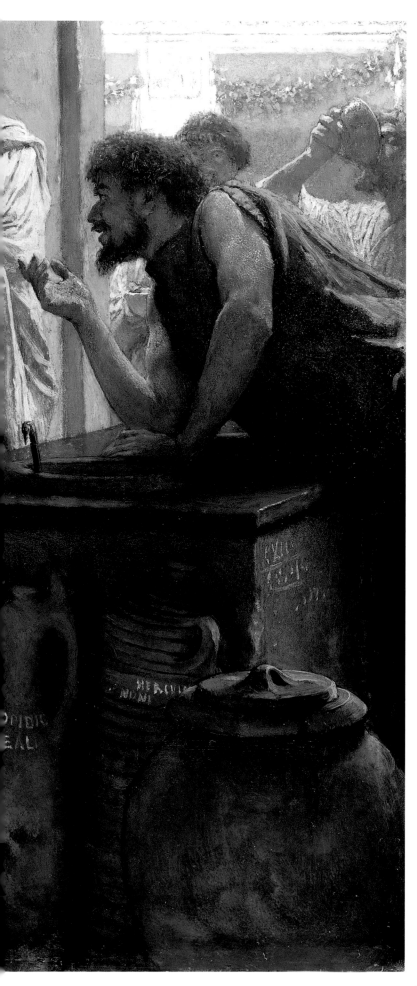

The Wine Shop (1869)
Oil on panel. 15 x 19in
(38.1 x 48.2cm).
The Guildhall Art Gallery,
London.

This Roman wine shop
depicts a scene which,
but for the togas, could
easily be a genre painting
of a Dutch tavern. The
dark tones and the effect
of chiaroscuro are within
the tradition of northern
painting of which
Rembrandt was the
master. The costumes
and artefacts are as
authentic as the
meticulous Alma-Tadema
could make them, and
the cellarer, promoting
his wines, has a distinctly
Rubensesque look about
him.

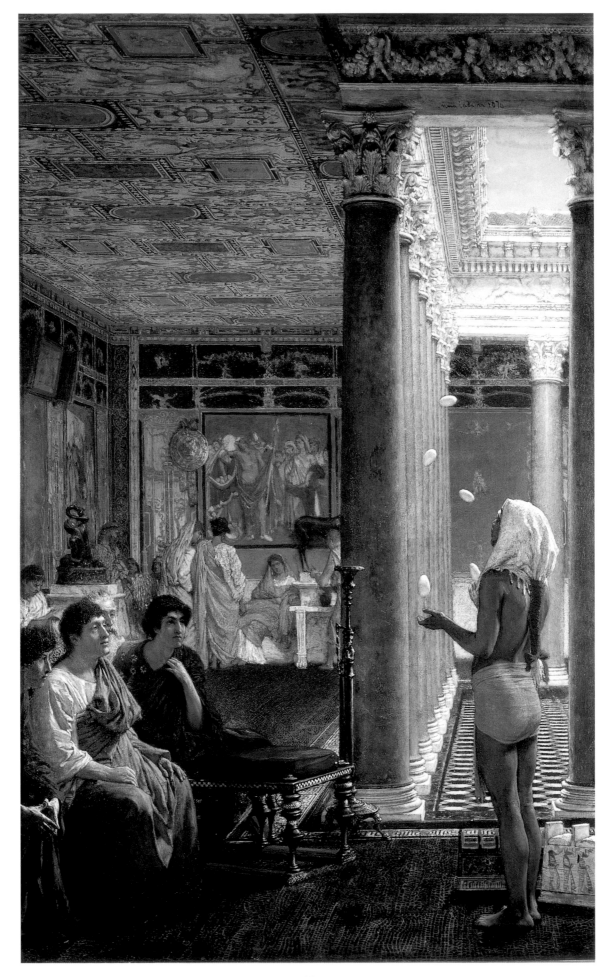

An Egyptian Juggler
(1870)
Oil on canvas mounted on
a panel. 31 x 19¼in (78.7
x 48.9cm).
Private collection.

This scene is set in a
wealthy Roman's villa,
perhaps in Pompeii,
which was a popular
holiday destination, not
only for the Romans but
also for Alma-Tadema,
who went there to draw
and study the ruins. As
with modern holiday
venues, Pompeii provided
plenty of entertainment,
including itinerant
musicians and jugglers
who performed for rich
patrons. With his usual
eye for detail, Alma-
Tadema has furnished the
room adjacent to the
peristyle with *objets d'art*
such as the bronze of the
infant Hercules, wrestling
with a serpent, and a
bronze stag, now in the
Naples Archaeological
Museum.

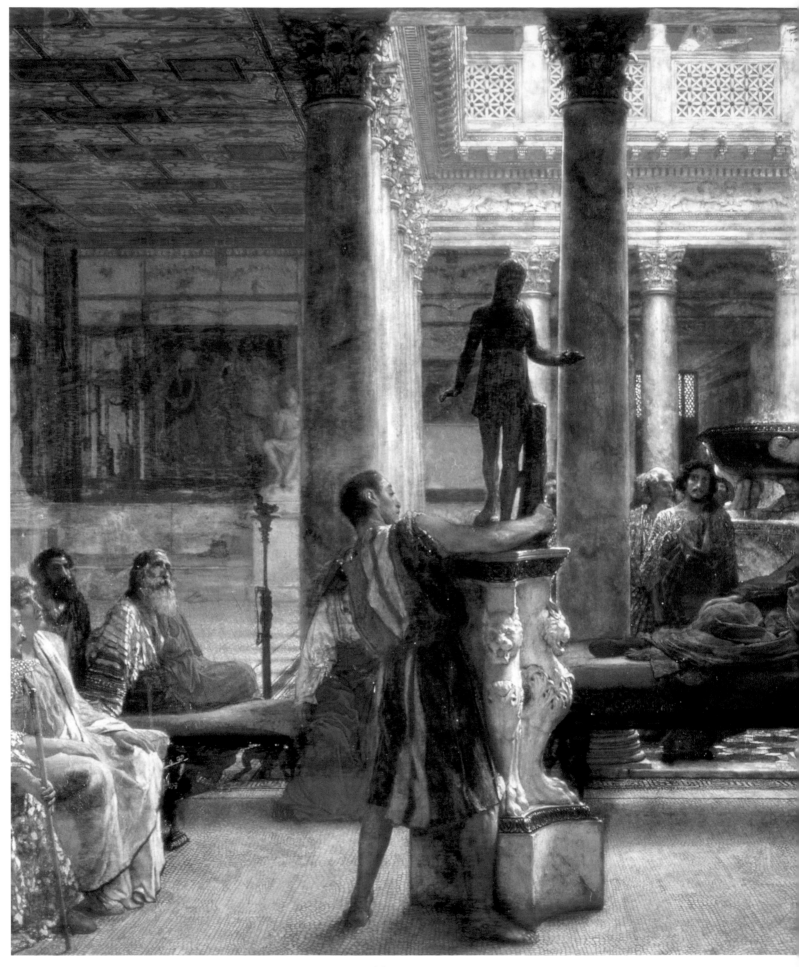

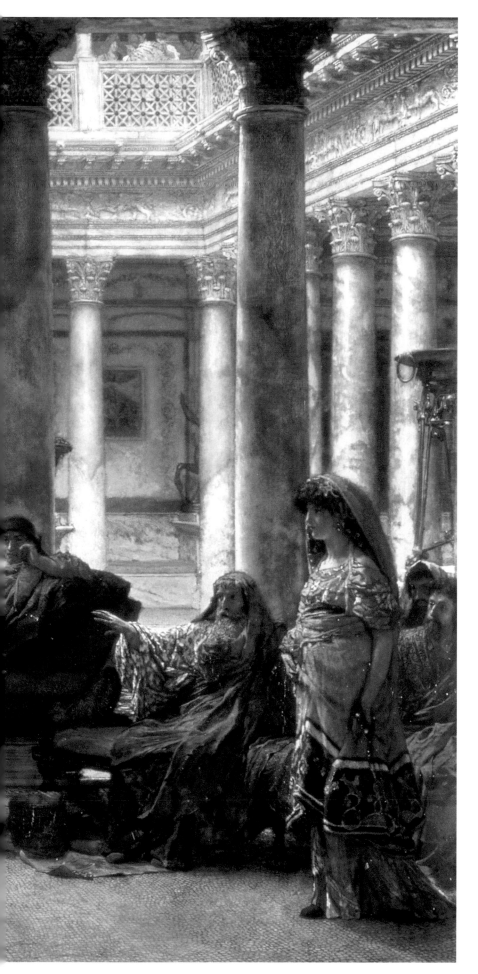

A Roman Art Lover
(1870)
Oil on panel. 29 x 40in
(73.5 x 101.6cm).
Milwaukee Art Center,
Wisconsin.

This handsome work,
showing a group of art
lovers sitting by an atrium
from which sunshine
filters into the peristyle,
reveals Alma-Tadema's
mastery of architectural
forms. The backlit figures
in the foreground are
looking at a bronze statue
of an athlete, *The Amazon
Runner*, which is being
examined as a potential
addition to other statues
in the peristyle which
wealthy Romans often
turned into open-air art
galleries.

RIGHT

Woman with a Vase of Flowers (1872)

Oil on panel. 18 x 15in (45.5 x 37.9cm). The Fine Art Society, London.

This painting, also called *The Last Roses*, shows a woman gazing at roses arranged in a vase. It is obviously autumn and Alma-Tadema intended the underlying theme to be the inexorable passage of time, expressed in a poem: 'Like the garland of flowers thou shalt bloom and fade.' This was a sentiment often voiced by romantic poets.

OPPOSITE

The Picture Gallery (1874)

Oil on canvas. 86 x 65½in (218.4 x 166.4cm). Towneley Hall Art Gallery, Burnley, England.

The largest of Alma-Tadema's picture gallery paintings, and the most accomplished. The man in the white toga, and the woman in pink sitting by his side and holding a white fan, are skilfully highlighted. The tension of their poses is well observed, giving an excellent sense of their alert interest as they come to a conclusion as to the painting's worth.

Overseer of Pharaoh's Granaries (p. 50–51). Their success led to his election as an associate of the Royal Academy in 1876 and he was made a full Royal Academician three years later.

All this success might never have been, for in 1874 the Alma-Tadema family was very nearly a victim of an explosion for a second time. Alma-Tadema and his wife Laura had left their daughters, Laurence and Anna, in the care of their nurse at their Regent's Park home, while they visited friends in Scotland. On their way back, they were told of the explosion of a barge carrying gunpowder on the Regent's Canal. The damage to houses in the neighbourhood was extensive, with those nearest the explosion being virtually destroyed. By great good fortune, although Townshend House was badly damaged, the girls, though shaken, were not hurt and were immediately taken to Laura's mother's house.

The Illustrated London News, reporting the catastrophe, noted that 'To the ordinary householder such a disaster would be a very serious blow, but it could scarcely fail to fall more heavily on any artist for, almost invariably, he furnishes his home and painting room with references more or less to his professional pursuits.' The article went on to say that 'Most fortunately, [Alma-Tadema's] paintings were not

injured … He has borne his loss with manly fortitude and has been working away with undiminished energy in a makeshift atelier.' In fact, Alma-Tadema took his family to Italy for the winter while his house was being repaired.

The Illustrated London News report reflected the great esteem in which the new Briton was now held. The incident spurred Alma-Tadema on to an even greater flow of work, most of it watercolour, an easier medium to deal with under the circumstances.

In 1875 Laura's sister, Ellen Epps, married Edmund Gosse, the poet, critic and later biographer of Alma-Tadema. The newly married couple were invited to stay at Townshend House while it was being repaired. In the meantime, Alma-Tadema, while touring Europe, took the opportunity to buy large numbers of photographs as references for his paintings and began the collection of portfolios which eventually ran to 168 volumes.

He also made notes and sketches for paintings that he would complete in London which included *An Audience at Agrippa's* (p. 73), which was exhibited at the Royal Academy the following year, and *Flora* (p. 89), a picture of Laura gathering flowers in the Villa Borghese gardens. As an

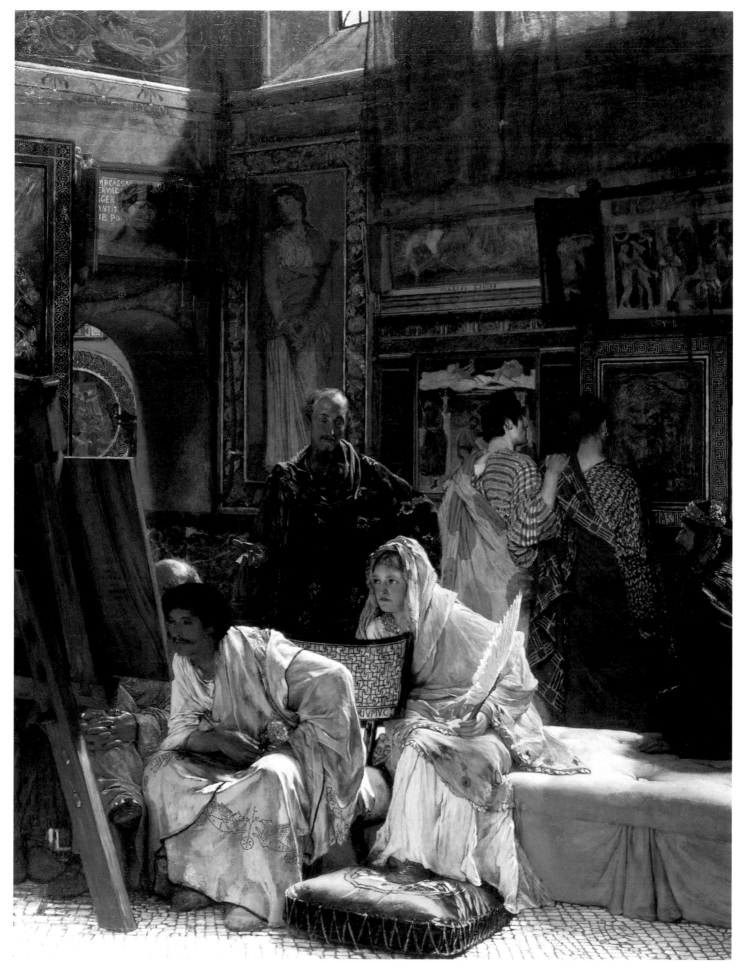

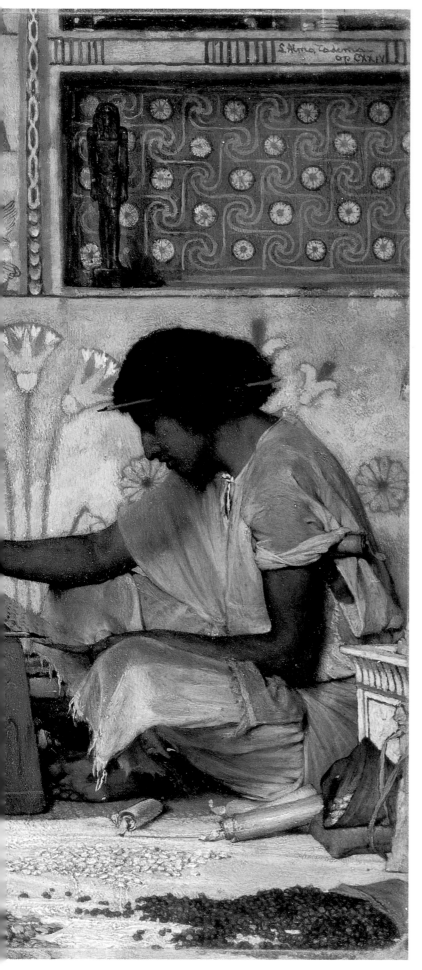

Joseph, Overseer of Pharaoh's Granaries
(1874)
Oil on panel. 13 x 17in (33 x 43.2cm). Private collection.

The Bible tells how Joseph, the favoured son of Jacob and Rachel, was sold into slavery by his jealous brothers because of his many-coloured coat and the fact that he was a talented dreamer. He eventually arrived in Egypt where he became an influential member of Potiphar's court. Through his skill at interpreting pharaoh's dreams, he was eventually made governor of Egypt and while overseer of the granaries rescued his family from famine. Alma-Tadema has chosen to show Joseph, a scribe in attendance, engaged in his work and has taken great care to provide an authentic setting.

LEFT
Autumn: Vintage Festival (1877)
Oil on canvas. 29$\frac{1}{2}$ x 15in (74.9 x 38cm).
Birmingham Museums and Art Gallery, England.

A dancing maenad, a female follower of the wine god Bacchus and traditionally associated with divine possession and frenzied rites. (See also p. 64 and 70–71.)

OPPOSITE
Strigils and Sponges (1879)
Watercolour. 12$\frac{1}{2}$ x 5$\frac{1}{2}$in (31.8 x 14cm).
The British Museum.

This is a good example of Alma-Tadema's skill in a medium other than oils. Painted when he had decided to abandon the heavy impasto of his earlier style, the work is both light and lively. The fountain was taken from a drawing of a similar one the artist had seen in the Naples Archaeological Museum, and the woman in the foreground is Alma-Tadema's wife, Laura, who often posed for him. On the extreme right is an etching of the same picture.

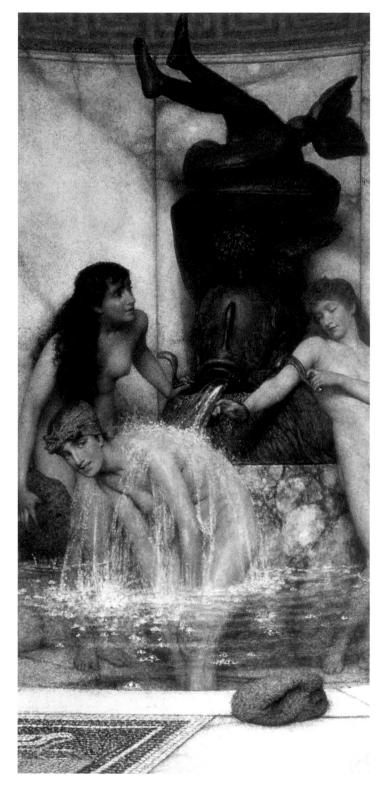
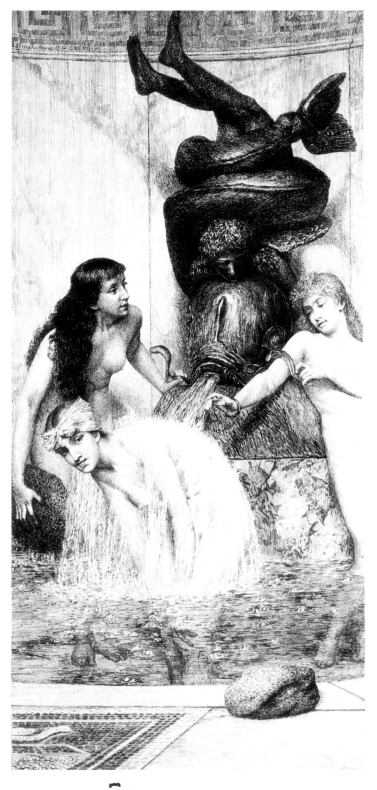

associate of the Royal Academy he undertook to become a visitor (teacher), a post which he regarded as the greatest honour so far bestowed on him.

To Alma-Tadema, the most important feature of his Italian visit was that he was able to rent a studio in Rome and to paint in the brilliant light of the country which was the setting for his new work. Unfortunately, the weather was surprisingly uncooperative and although the Alma-Tademas visited all the important Roman sites, they often did so in the rain. The disappointment of this trip did not discourage a second visit in 1877, during which they again visited the archaeological digs that were taking place in the Naples area.

Thus art depicting classical times, reflecting the everyday lives of Greeks and Romans, became a rival to medievalism, and the biblical and literary subjects espoused by the Pre-Raphaelites. None of these trends pretended to reproduce the

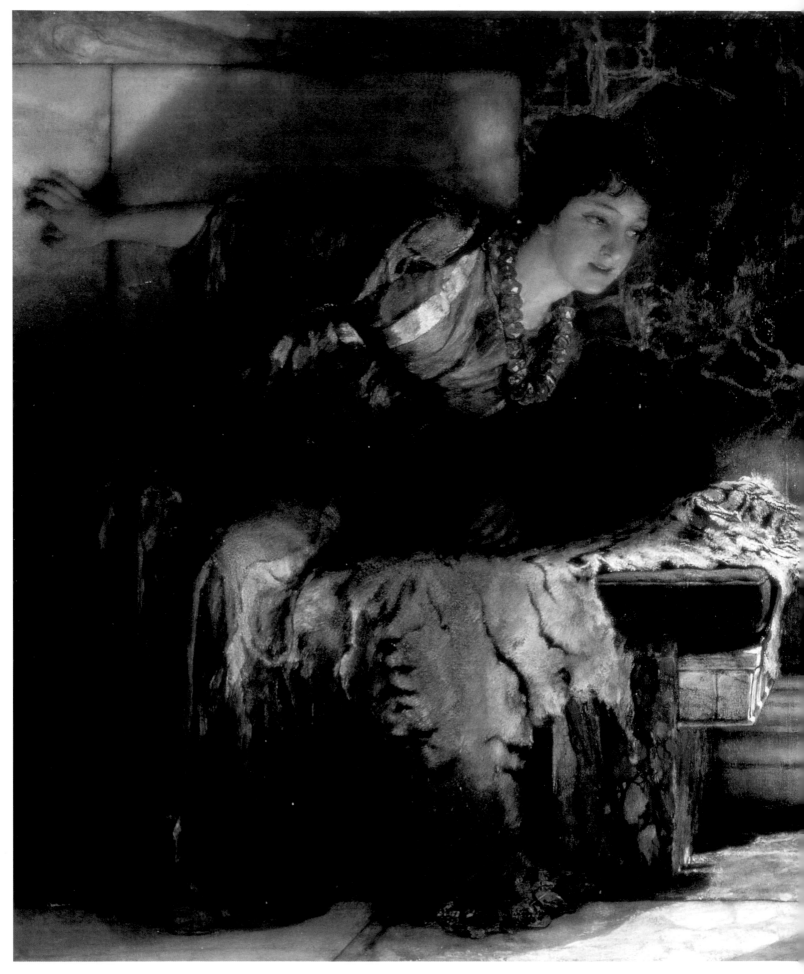

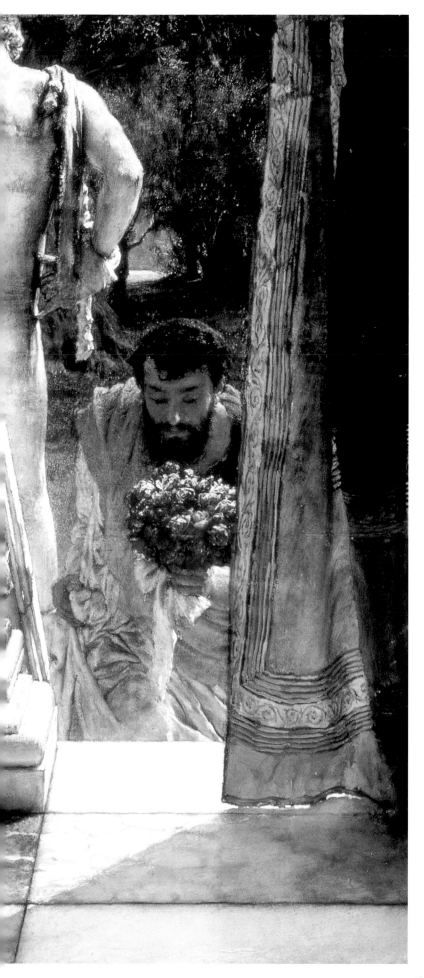

Welcome Footsteps
(1883)
Oil on panel. 16¹/₂ x
21²/₃in (41.9 x 54.8cm).
Private collection.

There were times when
Alma-Tadema's paintings
were less concerned with
historical scenes and
more with the
sentimental aspects of
loving relationships. He
was responding to public
taste, and in this picture
of a woman awaiting a
lover, he is reflecting the
feelings of wives and
lovers whose men were
serving the Empire
overseas. The marble
statue at the entrance
may well be Hercules,
who performed his 12
labours when he was in
the service of Eurystheus,
King of Argos.

source of their inspiration but they became the cult of a
period exploited by artists in search of saleable subjects. Alma-
Tadema, more than other artists of the period, established a
rapport with his audience which made him the most
celebrated artist of his time and a very wealthy man.

There were still some who criticized his work, including
Oscar Wilde, who commented at an exhibition of his work in
the newly founded Grosvenor Gallery that 'his drawings of
men and women are disgraceful'. Wilde did not mean this in
the same way as the Bishop of Carlisle, who had written 'My
mind has been considerably exercised this season by the
exhibition of Alma-Tadema's *Venus...* [There might] be
artistic reasons which justify such public exposure of the
female form, but for a living artist to exhibit a life-size, almost
photographic representation of a beautiful naked woman
strikes my inartistic mind as somewhat, if not very,
mischievous.'

The expressed misgivings of the Bishop and Oscar Wilde
had little effect on the general opinion, expressed by critics
and public alike, that in paintings, Alma-Tadema was the
master of the classical theme. In 1879, when he was made a
full Academician, he seems to have reached the height of his
ambition. But he was not the kind of man to rest on his
laurels and was about to begin a new period in his life's work.

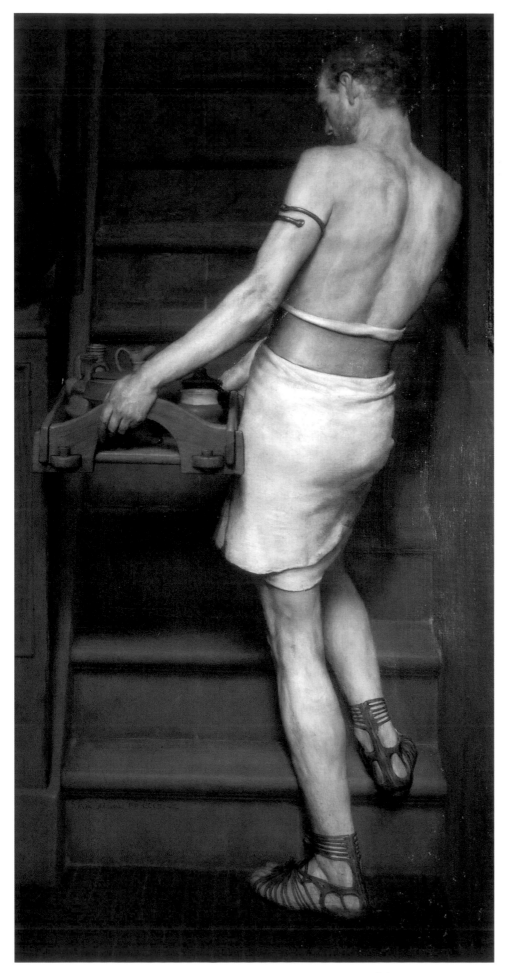

The Roman Potter

(1884)

Oil on canvas. 60¼ x
31½in (153 x 80cm).
Musée d'Orsay, Paris.

This solitary figure is a
fragment of a larger
painting entitled *Hadrian
Visiting a Romano-British
Potter*. Hadrian did a great
deal to improve life while
he was in Britain and his
most famous legacy is
the wall he built to mark
the northern boundary of
England as a defence
against attacks by Picts
and Scots. The British
Museum has a
comprehensive collection
of Roman artefacts found
in Britain.

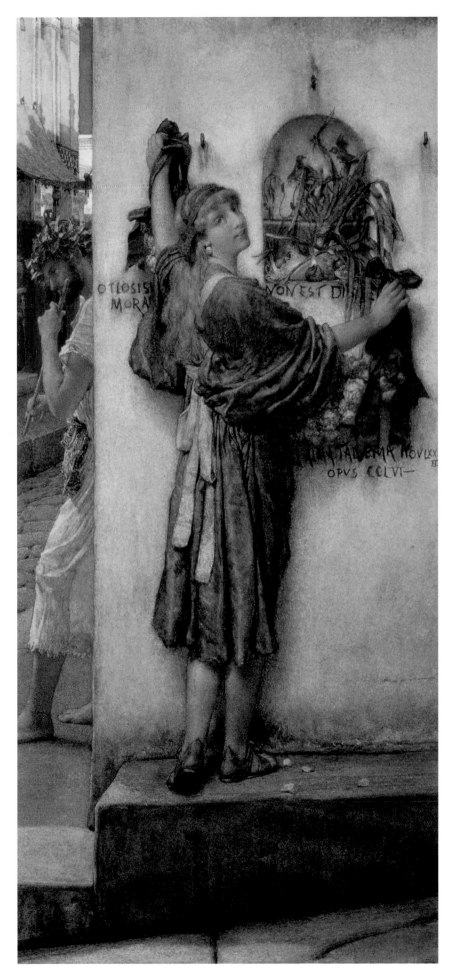

The Street Altar

(1883–84)

Watercolour. 5³/₄ x 5²/₃ in
(14.7 x 14.3cm).

Cecil Higgins Art Gallery,
Bedford, England.

Street shrines and altars
to particular gods were
common in ancient Rome
and their modern
Christian counterparts are
still to be found all over
Italy and Catholic Europe.
Then as now, the object
of veneration is regarded
as both guardian and
intercessor and a source
of consolation in times of
trouble.

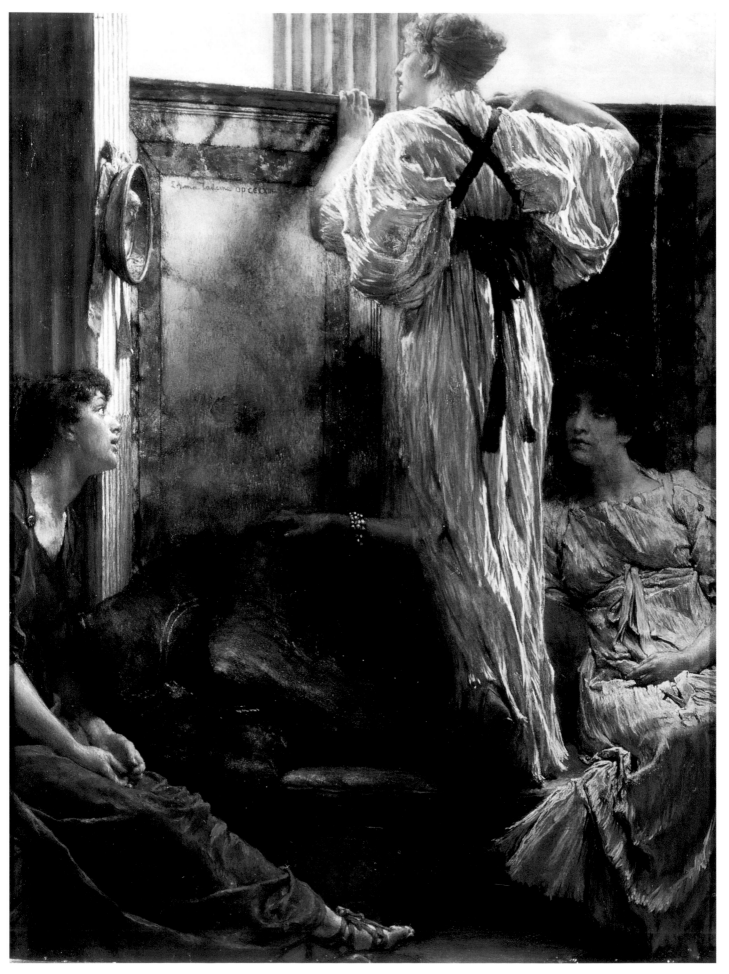

Who Is It? (1884)
Oil on panel. 10$^{1}/_{4}$ x 8$^{1}/_{2}$in
(26.1 x 21.4cm).
Victor Hammer Galleries,
New York.

This picture presents
something of a
conundrum. Is the unseen
visitor a friend,
interrupting a *tête à tête*,
or an intruder? In any
case, the atmosphere of
tension and suspense is
masterfully conveyed and
one can well imagine the
conversation suddenly
tailing off. The screen
suggests that the women
have withdrawn to a
private part of a larger
space, perhaps to gossip
or to show off their latest
puchases.

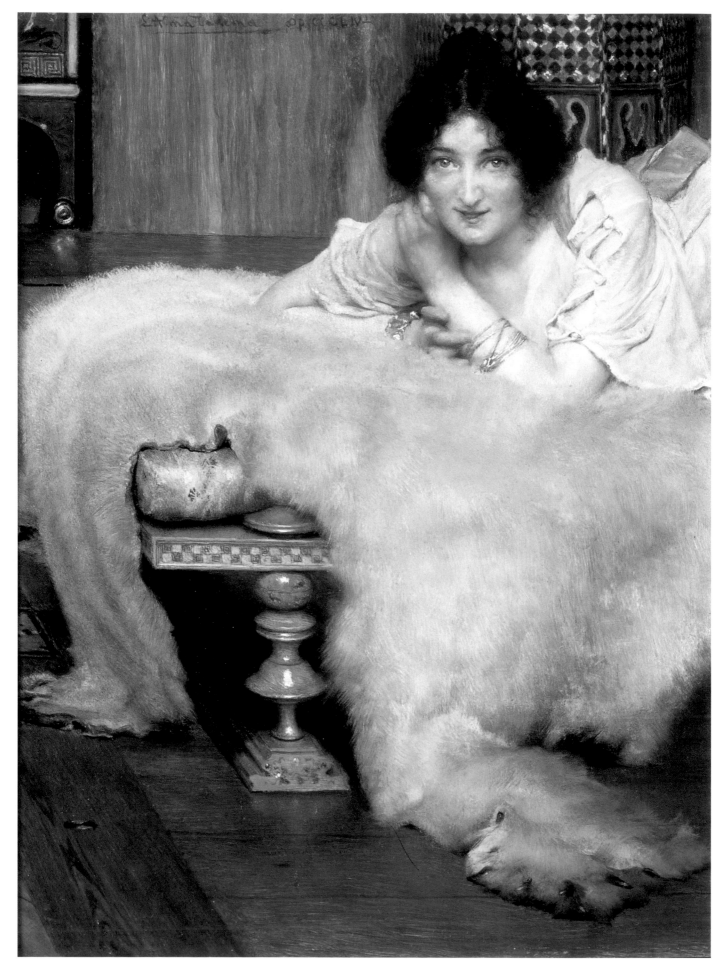

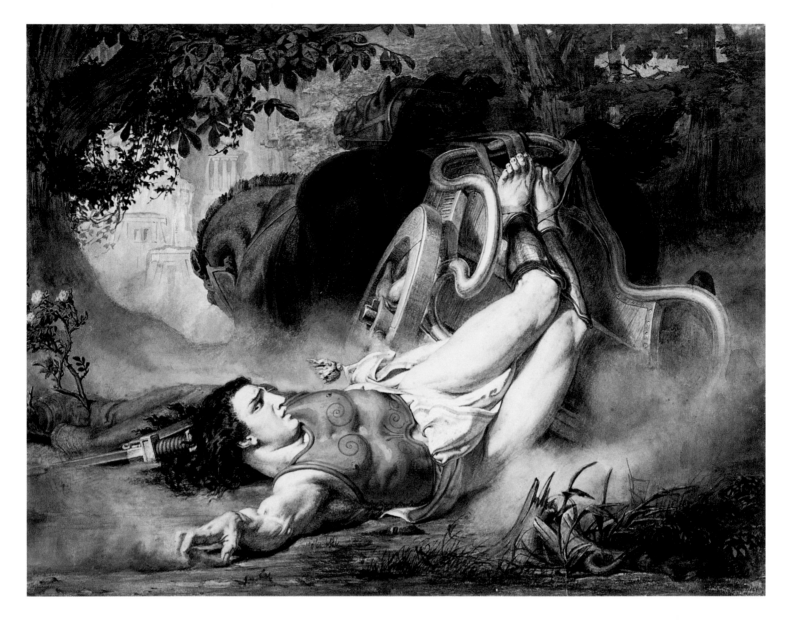

OPPOSITE
A Listener (1899)
Oil on panel. 13³/₄ x
10³/₄in (34.8 x 27.2cm).
Private collection.

The listener of the
painting is luxuriating on
one of Alma-Tadema's
collection of exotic rugs,
possibly made from the
pelt of a polar bear.
Victorians had what is
now regarded as a
politically incorrect
penchant for animal skins,
and for other trophies
garnered from the far-
flung corners of the
Empire. The furniture on
which the rug is spread
was probably designed by
the same artist who, in
the 1880s, produced a set
of furniture for the
American millionaire,
Henry Marquand. It
should also be noted in
passing, however, that it
is unlikely that a Roman
would have ever seen a
polar bear.

ABOVE
The Death of Hippolyte
(1860)
Oil on canvas. 17 x 22¹/₂in
(43.2 x 57.1cm)
Private Collection

Hippolytus was the son of
Theseus by the Amazon
Hippolyte. After her death,
Theseus married Phaedra
who conceived an
overwhelming passion for
Hippolytus who repulsed
her. As a result she hung
herself and left a message
accusing him of seducing
her. When Theseus read
the letter he refused to
believe Hippolytus'
protestations of innocence
and banished him, using
up one of the three
wishes his father
Poseidon had granted him
by demanding his death.
Poseidon sent a sea
monster to frighten
Hippolytus' horses when
he was thrown from his
chariot and dragged to his
death.

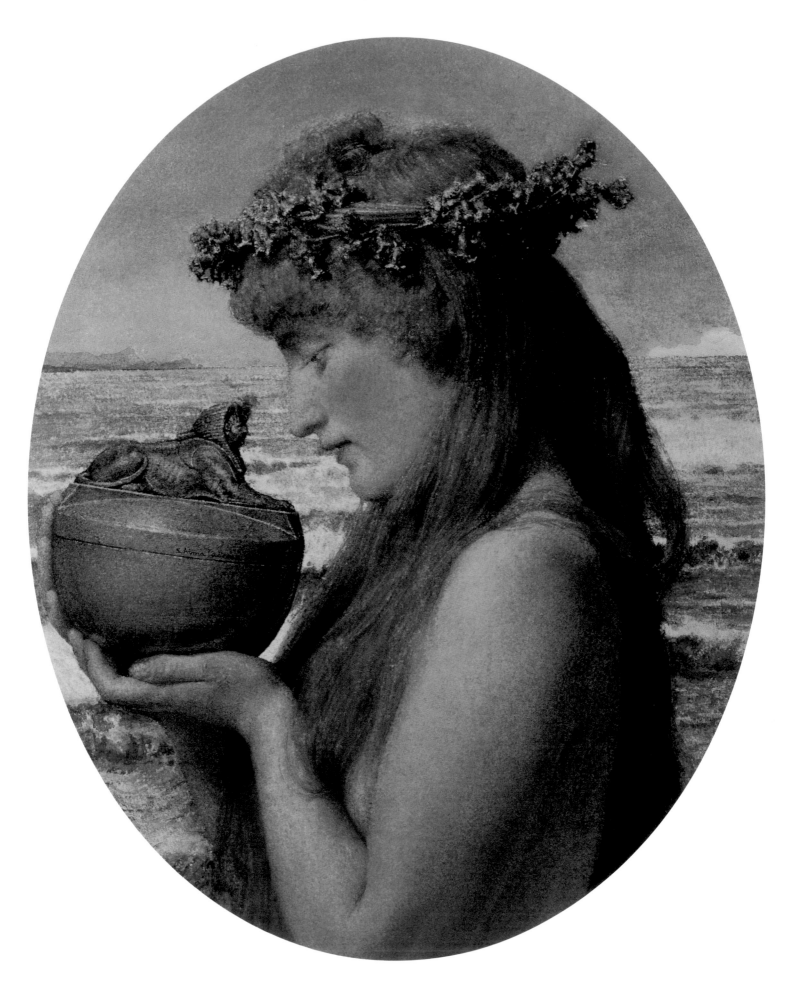

OPPOSITE

Pandora (1881)

Watercolour. 10¹/₄ x 9¹/₂in (26 x 24.3cm).

Trustees of the Royal Watercolour Society, London.

Pandora, in Alma-Tadema's portrayal of her, seems unperturbed by the fact that, having opened the box, she is unleashing all manner of ills upon the human race. Pandora, the first woman, was sent to earth by Zeus with a box filled with evils to counteract the blessings brought to man by Prometheus' gift of fire. The saving grace was that when all the evils had been allowed to escape, Hope remained.

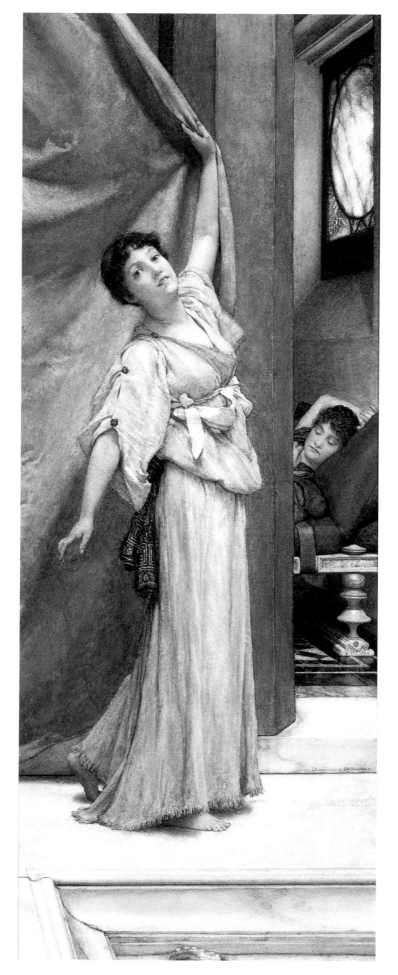

LEFT

Midday Slumbers

Watercolour. Minneapolis Society of Fine Arts.

A servant draws a curtain while a woman reclines on a couch – an ordinary enough domestic scene; but the marble floor suggests that they are at the Roman baths and that the woman is recuperating from treatments and exercises she has just experienced. This may be one of a series of such scenes which Alma-Tadema produced following Frederick Leighton's success in the genre.

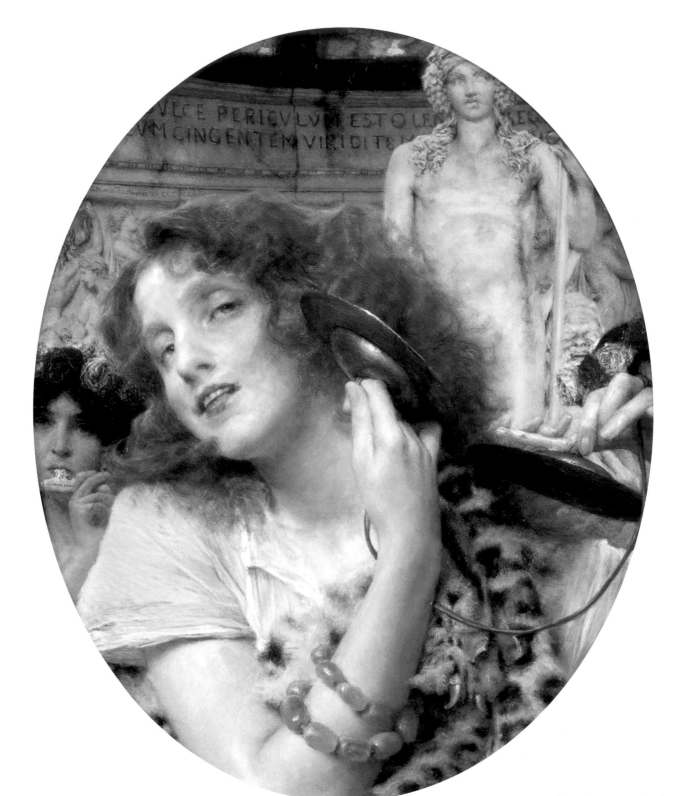

Bacchante (1907)
Oil on canvas. 16$^{1}/_{3}$ x 13$^{1}/_{8}$in (41.5 x 33.5cm). Private collection.

Victorian society was, at least outwardly, highly moral, so the subject may seem slightly anomalous, though not entirely so. Bacchantes were the followers of Bacchus, the Roman god of wine, also known in Greece as Dionysus. He is said to have brought the gift of wine to those who welcomed him on earth; but to those who opposed him he brought madness and intoxication. Bacchantes appeared to belong to the latter group and disported themself in an orgy of drinking and licentiousness before passing out in a stupor. The bacchante in the picture seems to be modelled on Alma-Tadema's wife, though the god Bacchus does not appear to be a self-portrait.

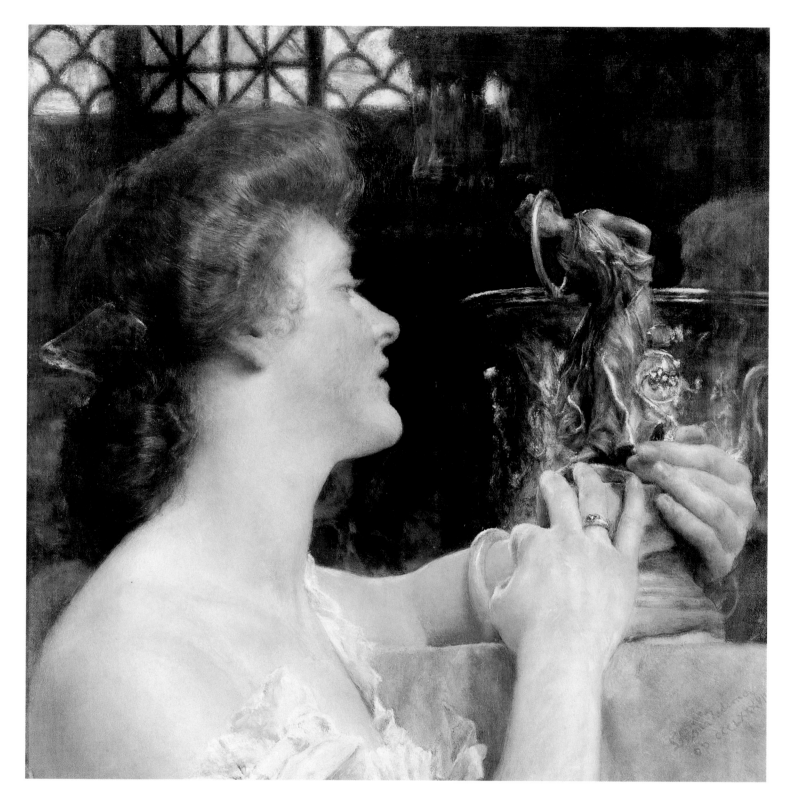

The Golden Hour (1908)
Oil on canvas. 14 x 14in
(35.5 x 35.5cm).
Private collection.

The light coming through
the window suggests that
it is evening and, like

Wordsworth, Alma-Tadema
felt that it was a special
time of day, a moment of
quiet which encouraged
meditation. The young
woman is examining a
small bronze statue, and
may be similar to one the

artist collected on his travels
in Italy, and which revived
memories of other places,
other times. However, the
one in the picture is called
The Hoop Dancer and was
made by the French sculptor
Jean-Louis Gérôme.

THE HISTORY MAKER

There were two main sources that inspired Alma-Tadema's work: one of them was his visit to Italy, where he had immersed himself in the minutiae of Roman life, even to the extent of partaking in an archeological dig especially arranged for him by the curator of the Pompeian museum. This direct contact with the villas in which the Romans had lived and died and the artefacts which they had used, served to bring history vividly alive for him.

The second influence came from Alma-Tadema's Pre-Raphaelite friends, whose use of clear primary colours caused him to distance himself from the dark browns and blacks of his Merovingian and early Roman pictures. Among his new

paintings with an historical context were *Antony and Cleopatra* (p. 78–79) and *On the Way to the Temple*. He also painted the first of a series of pictures of Roman women at their baths. *In the Tepidarium* was no more daring than some of the paintings of Frederick Leighton, now President of the Royal Academy, but it showed a new Alma-Tadema, though the theme did not re-appear until 1886. (see also p. 100–101 and 114)

Three years after becoming an academician, the Grosvenor Gallery offered Alma-Tadema a retrospective show in which he exhibited some 287 of his paintings, many of which had to be borrowed from their owners for the occasion. Putting such a large show together meant a great deal of time and labour for

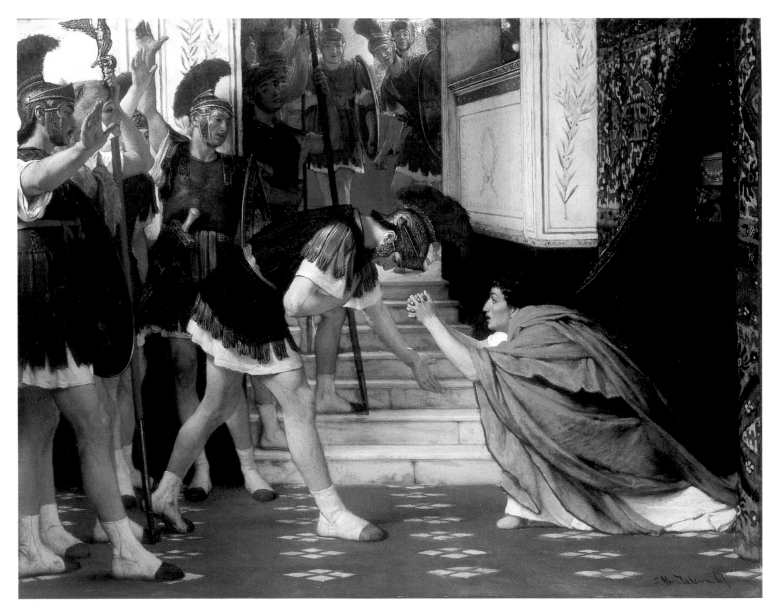

Proclaiming Claudius Emperor (1867)
Oil on panel. 18¹/₂ x 26¹/₃in (46.8 x 67cm). Private collection.

Claudius was the reluctant emperor, elected by the Praetorian guard after the death of Caligula in AD 41. He was a nephew of Tiberius who began promisingly enough but ended up with a persecution mania on the island of Capri. Though not a military man, and interested in more scholarly pursuits, Claudius completed the conquest of Britain and was an able administrator. Alma-Tadema has chosen to record the scene where Claudius is discovered in hiding, trying to avoid being made emperor.

Anacreon Reading His Poems at Lesbia's House (1870)
Oil on panel. 15½ x 19in (39.3 x 48.2cm). Private collection.

This is more likely to be Catullus than Anacreon, which indicates that although Alma Tadema was meticulous when it came to architecture and artefacts, he could be careless when naming the characters in his paintings. Lesbia, or Sappho, was, like Catullus, a great lyric poet; indeed he is thought to have been strongly influenced by her in his own work. The scene is probably Sappho's villa on the island of Lesbos, where she lived in the company of a coterie of girls dedicated to the cult of the goddess Aphrodite. This is probably how the term 'lesbian' arose.

Alma-Tadema who, as a chairman or committee member of numerous art societies, had many other duties to perform. Nevertheless, it was an opportunity that could not be missed and Alma-Tadema reduced his painting output in order to attend to the exhibition.

Two years earlier, Alma-Tadema had bought another house in London, in Grove End Road in St John's Wood, which had once been the home of the artist James Tissot, another of the group of French artists who had come to London after the Franco-Prussian War. After he had bought the house, Alma-Tadema spent some time planning its remodelling and refurbishment, which involved a variety of styles, including Greek, Roman and Japanese. All this took some time and it was not until November 1886 that the Alma-Tadema family was able to take possession.

Two features of the new house with which Alma-Tadema was particularly pleased were his own studio and the one built for Laura, who had developed into a talented painter and would soon be exhibiting at the Royal Academy. There was also a Hall of Panels, which had 45 vertical spaces for paintings, many of which Alma-Tadema had obtained from friends, including Leighton, Poynter and John Singer Sargent, in exchange for his own work.

In this glamorous setting, Alma-Tadema continued to give the lavish parties and musical evenings which had been

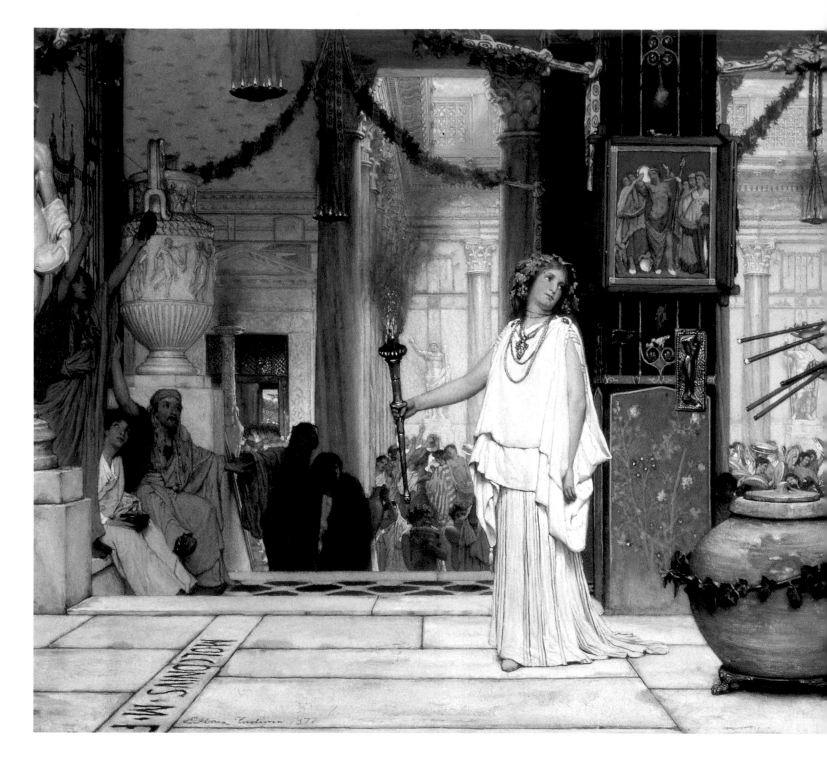

The Vintage Festival
(1871)
Oil on panel. 20 x 47in
(51 x 119cm).
National Gallery of
Victoria, Melbourne.

Alma-Tadema painted this
picture as he was about
to move to London, and it
has all the components of
a *tour de force*, intended
to impress. The complex
composition, with several
depths of perspective, is
full of features designed
to show off the artist's
knowledge of Roman
architecture, dress, art
and artefacts. To the left
of the principle figure, the
priestess of Bacchus,
who is presiding over the
festivities, is a group of
figures who have been
imbibing freely but who
are taking an interest in
the proceedings. To the
right of the priestess is a
group of musicians,
processing past the altar
to the god of wine, while
in the peristyle the
crowds are gathered for
the orgy which is about to
begin. There is a second
version of this painting,
which was the basis for
an engraving.

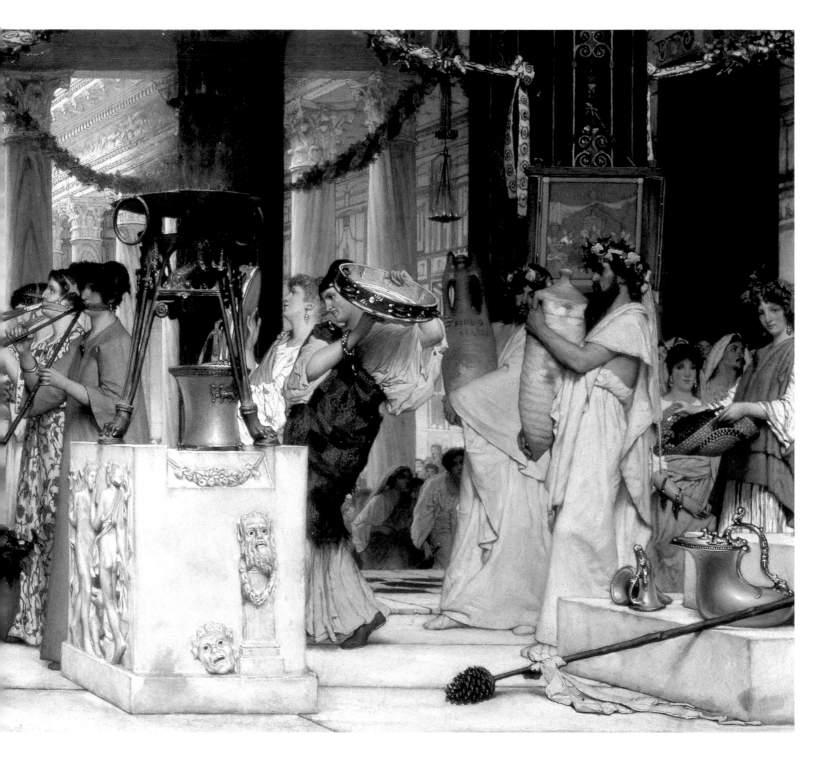

his habit at Townshend House. He was a gregarious man with many friends and the evenings were attended not only by his artist friends and neighbours but also by the cultural élite of London, many of whom had moved into fashionable St John's Wood. George Eliot, Algernon Swinburne, Thomas Huxley and visiting celebrities such as Enrico Caruso, Clara Schumann and Piotr Ilyich Tchaikovsky, all enjoyed the generous hospitality of Laurence Alma-Tadema, whose house was well-established as a cultural focal point for London's intelligentsia.

Not all of these guests, however much they may have liked the artist personally, agreed with his working methods and painting style. One such was John Singer Sargent, who had chosen to move to London from Paris, not so much because of the war as because of the scandal created by one his paintings. This was the notorious *Madame X*, a work that was identifiably that of a society woman with a 'reputation', whom Sargent had painted clad in a daringly low-cut black dress from which, according to the art critic of *Le Figaro*, the slightest struggle would have set her free.

ABOVE
Cleopatra (1875)
Oil on canvas. 21$^1/2$ x
26$^1/4$in (54.6 x 66.7cm).
Art Gallery of New South
Wales, Sydney.

Having failed to defeat
Octavius Caesar and
thereby caused the death
of her lover, Mark Antony,
the future for Cleopatra is
bleak. All she can
envisage is that she is

destined to be exhibited
as a prisoner in a victory
parade in Rome.
Cleopatra therefore
chooses to die by
pressing a venomous asp
to her bosom. The
armband, in the shape of
a serpent, draws the
attention to the meaning
of the painting.

OPPOSITE
**An Audience at
Agrippa's** (1876)
Oil on canvas. 35$^3/4$ x 24in
(90.8 x 60.8cm).
Dick Institute, Kilmarnock,
Scotland.

Agrippa was the Roman
general responsible for
building up the strong
navy which helped
Octavius Caesar to defeat
Antony and Cleopatra's

attempt to split the
Empire at the Battle of
Actium in 31 BC. He was
therefore an important
power in the government
of Rome to whom
requests could be made.
Octavius, who later took
the name of Augustus,
would have chosen the
sons of Agrippa to
succeed him but for the
fact that they died in early
youth.

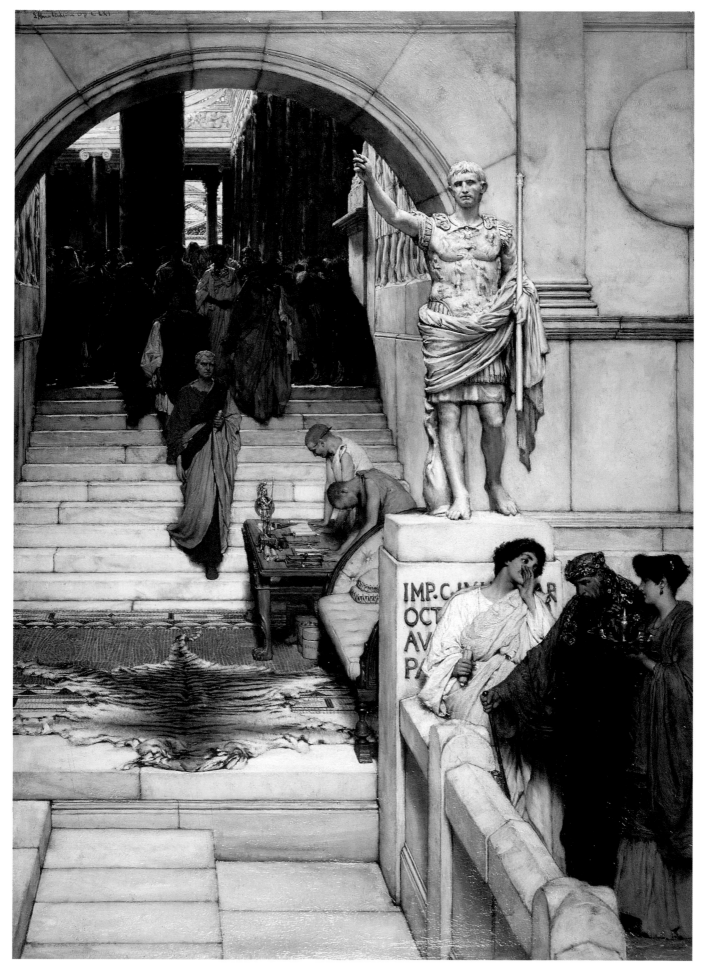

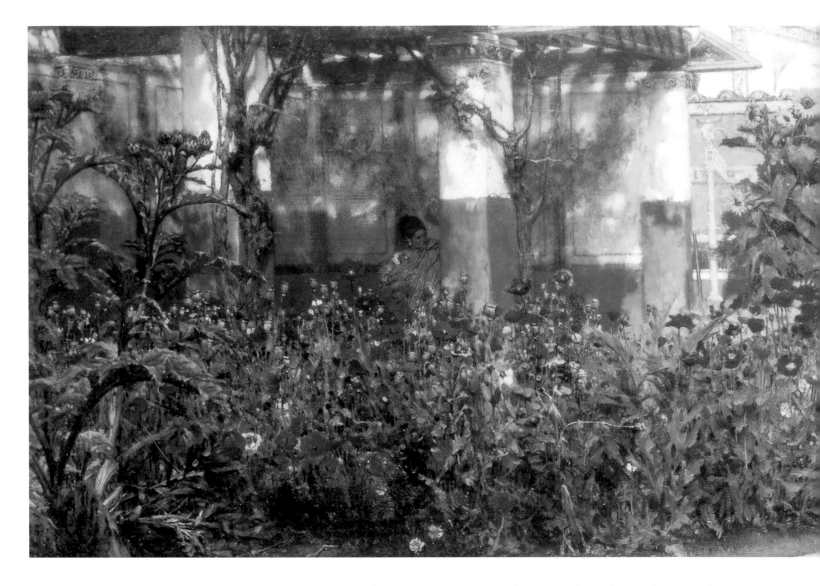

Sargent had been considerably influenced in his own work by Monet, whose opinion was that an artist should paint what he saw before him. Sargent's sympathy with this view led him to feel that Alma-Tadema was a little too concerned with pedantic matters, such as the nature of marble and metallic objects as substances in themselves, and seemingly unaware that their appearance depended on the quality and intensity of the light that fell upon them.

Nevertheless, the men were friends. Sargent painted a portrait of Alma-Tadema (now lost), and Alma-Tadema recommended Sargent to the American millionaire Henry Marquand, who commissioned a portrait that popularized Sargent in the affluent society of Boston, Massachusetts.

In the midst of all this social activity, Alma-Tadema continued to produce many paintings depicting the domestic life of the Greeks and Romans and also – of particular interest to him – portrayals of great events in classical history. For instance, his large picture of 1887, *The Women of Amphissa*

(p. 80–81), records an episode in the war between the Amphissans, who lived near Mount Parnassus, and the people of Phocis. Alma-Tadema's painting shows a troupe of maenads, sacred to the god Dionysus, resting after a night of ritual dancing, the women of Amphissa forming a protective cordon around them to ward off attack by Phocian soldiers.

The following year, Alma-Tadema painted a group of men and women cavorting on the marble floor of a courtyard and covered in rose petals. The title of the work, *The Roses of Heliogabalus* (p. 82–83), refers to the insane Emperor Heliogabalus, who ruled for a few years after the death of Caracalla in AD 218, who invited guests to an orgy and suffocated them by burying them beneath tons of rose petals. For Alma-Tadema, the main problem with the painting, which had been commissioned by Sir John Aird, was to find enough rose petals. Eventually, it was necessary to have them shipped from the south of France on the new Paris-Lyon-Méditerranée train service.

A Roman Garden (1878)
Oil on canvas. 12 x 36½in
(30.5 x 92.7cm).
Ashmolean Museum,
Oxford, England.

Alma-Tadema had an
economical approach to
his work and often used
the same settings,
artefacts and poses in
different paintings. In this
garden scene, the figures
are arranged in much the
same way that the

mother and daughter
would later appear in *The
Parting Kiss* (p.76). In this
picture, which is also
known as *A Hearty
Welcome*, the mother is
thought to be the artist's
wife, Laura, while the
kneeling figure and the
girl being welcomed are
his daughters, Laurence
and Anna. The figure
descending the stairway
may well be Alma-Tadema
himself.

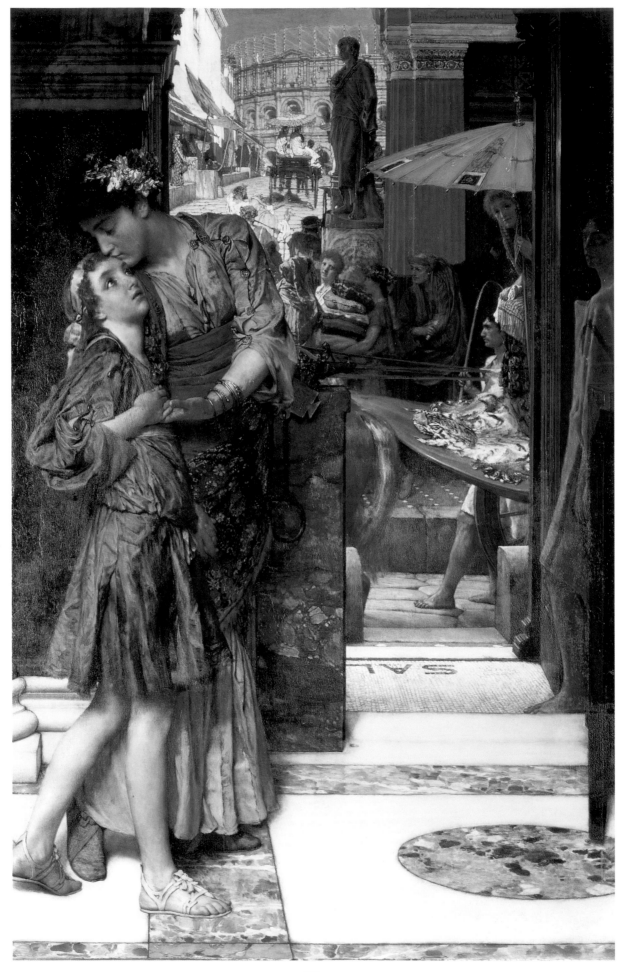

The Parting Kiss (1882)
Oil on panel. 44 1/2 x 29in
(112.5 x 73.5cm).
Private collection.

A mother kisses her
daughter, possibly as she
sets off for work at the
arena, perhaps as an
attendant or waitress at a
food stall. Other members
of the public can be seen
on their way to the

entertainment, which
need not have been a
gladiatorial contest for
there were less
bloodthirsty shows.
Through the doorway can
be seen a servant carrying
cushions to soften the
stone seats of the arena,
and there are a multitude
of booths along the way
selling souvenirs and
snacks.

While painting such large pictures of scenes from Roman
history, Alma-Tadema continued to produce more intimate
domestic scenes, such as *Strigils and Sponges* (p. 53), which
shows three women bathing in a fountain, the central figure
being his wife, Laura. This was probably inspired by artefacts
that he had acquired in Naples, for the women's strigils –
scrapers used by athletes rather than women, to scrape off the
oil with which they anointed their bodies – were often to be
found during archeological digs, and the sponges were a
natural product of the Bay of Naples.

He also painted portraits, including one of his friend the
landscape artist Ernest Waterlow, and one of Frank Millet, a
wealthy American who lived in Broadway in the Cotswolds
and was the centre of an artistic group which included Sargent
and the novelist Henry James.

Alma-Tadema's large paintings with an historical theme
were now replacing the academy paintings based on
mythology and ancient Greek culture that had dominated his
earlier output. His Roman world seemed more real because it
was a reflection of the life of the British: when he painted
Roman women they resembled the English women now seen

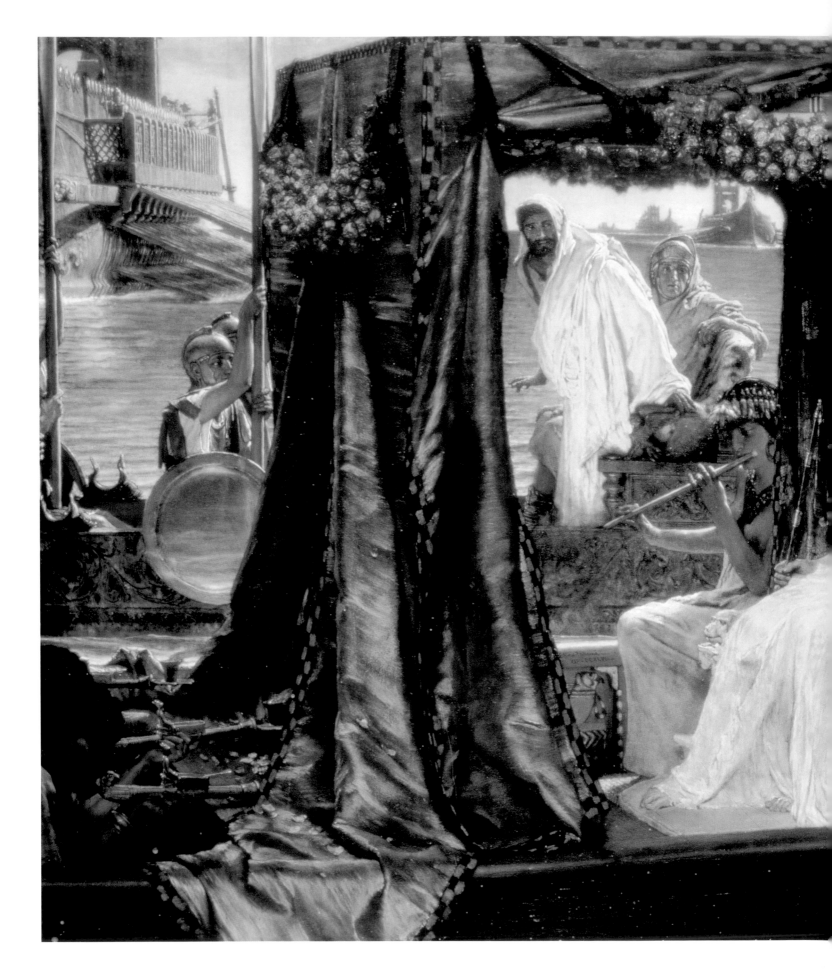

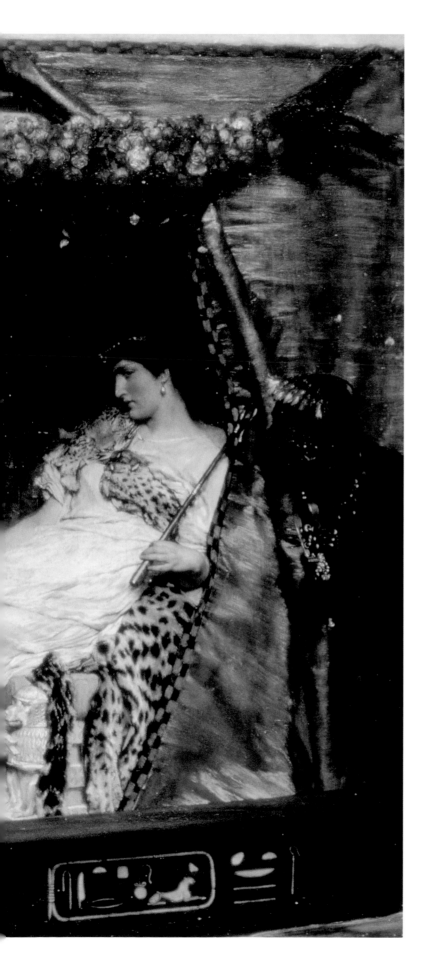

Antony and Cleopatra

(1884)

Oil on canvas. 25³/₄ x 36¹/₃in (65.5 x 92.3cm). Private collection.

Cleopatra, Queen of Egypt, had been the lover of Julius Caesar and had borne him a child, Caesarion, before Caesar was assassinated. After his death, a triumvirate was formed, consisting of Octavius, Lepidus and Mark Antony, which continued to rule Rome. During a visit to the eastern provinces, Antony met Cleopatra and they fell in love, and when the three triumvirs divided the empire between themselves, Antony chose Egypt. However, the Senate declared war on Cleopatra in AD 31, resulting in the Battle of Actium, when Antony was defeated. Antony, humiliated, committed suicide and Cleopatra followed suit soon after. Alma-Tadema paints Cleopatra on her royal barge, awaiting Antony who has disembarked from a trireme which can be glimpsed through the curtains.

shopping in London's new department stores or at social events like Royal Ascot. The processions and rituals of his Roman paintings mirrored major contemporary events, such as the Queen's Golden Jubilee or the bestowal of honours. In contrast, Alma-Tadema's more intimate, domestic pictures, with their themes of love, separation due to overseas duties, and dreams of the future, were as familiar to late 19th-century Britons as they must have been to the Romans.

Towards the end of the century, the new optimistic and more liberal mood that was sweeping Britain was being reflected in Alma-Tadema's work, as in *A Dedication to Bacchus* (p. 84–85), painted in 1889. This is an open-air picture set in a large courtyard overlooking the sea. A young girl is being initiated into the rites of Bacchus, the god of wine and the good life. The high priestess waits to receive her and the gift of a wineskin and her family and friends cheer her as though at a prize-giving. The unlikely success of this theme had been foreseen by Gambart, who had commissioned the painting for Baron J.H.W. von Schroeder, and he asked Alma-Tadema to paint another, smaller copy. This was later sold to the Earl of Carysfort for 5,600 guineas, the original having cost £7,000, the highest prices paid for a painting in the 19th century.

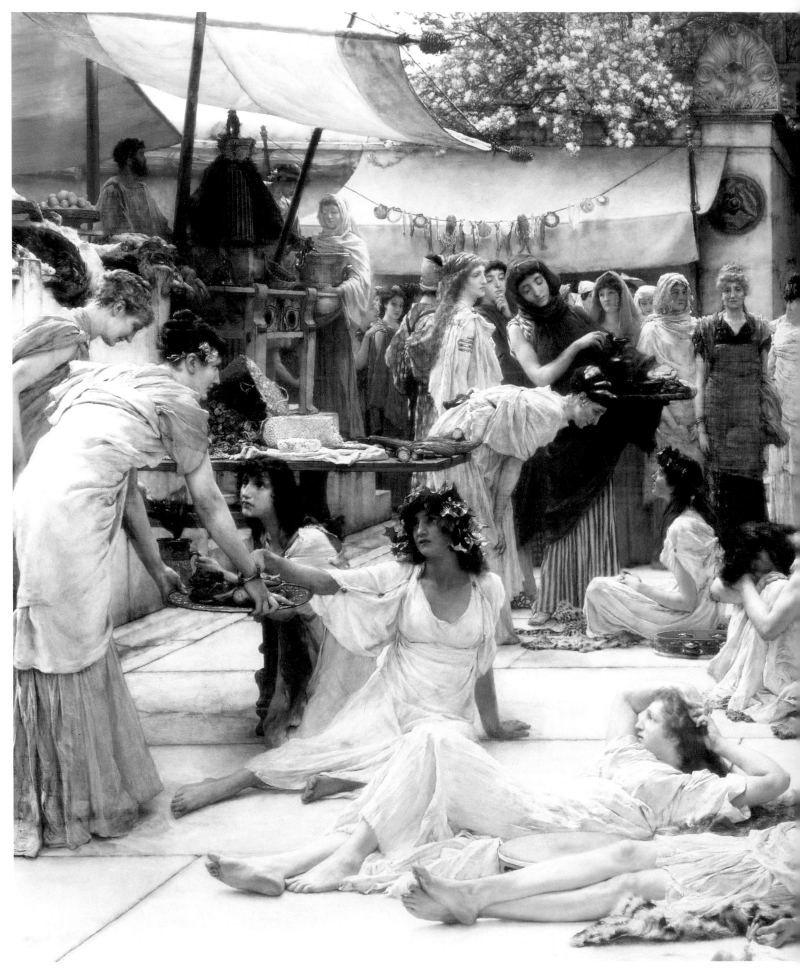

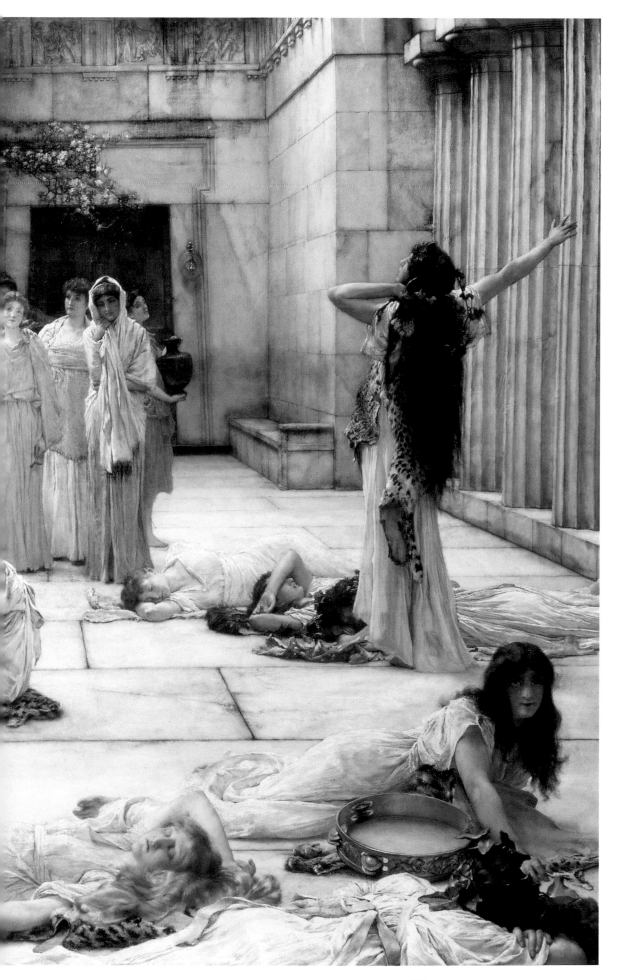

The Women of Amphissa (1887)
Oil on canvas. 48 x 72in (121.8 x 183cm).
The Sterling and Francine Clark Art Museum, Massachusetts.

Flowers and recumbent female figures are often to be found in the Alma-Tadema oeuvre, and evidently found a ready market. The artist's work was always discreet and in good taste, and whatever erotic connotations there may have been never appeared obvious but were left to the imagination of the viewer. In this respect, Alma-Tadema gauged the public values of the Victorians correctly and was rewarded by growing rich on the sales of his work.

The Roses of Heliogabulus (1888)
Oil on canvas. 52 x 84^1/$_8$in (132.1 x 213.7cm). Private collection.

In this picture, Alma-Tadema's love of flowers is given a free rein, but behind the apparently joyful scene is a story of madness and murder. The Emperor Heliogabulus, on an insane whim, decides to asphyxiate his guests by letting down tons of roses onto their heads. Alma-Tadema was not much concerned with the moral implications of the scenes he painted, and though he was criticized for this it did not alter his view that 'seeing the world through rose-tinted spectacles' had its place in the scheme of things.

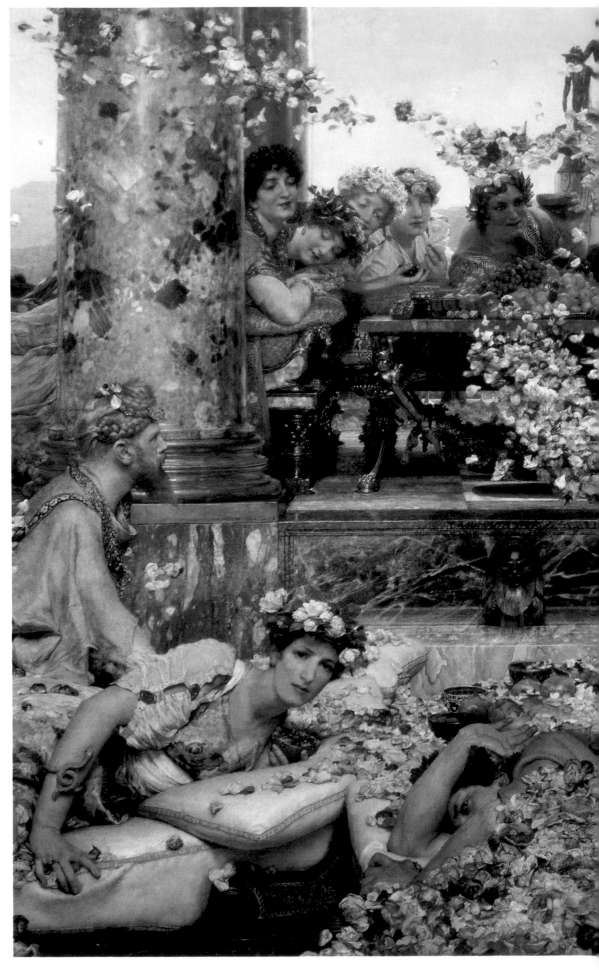

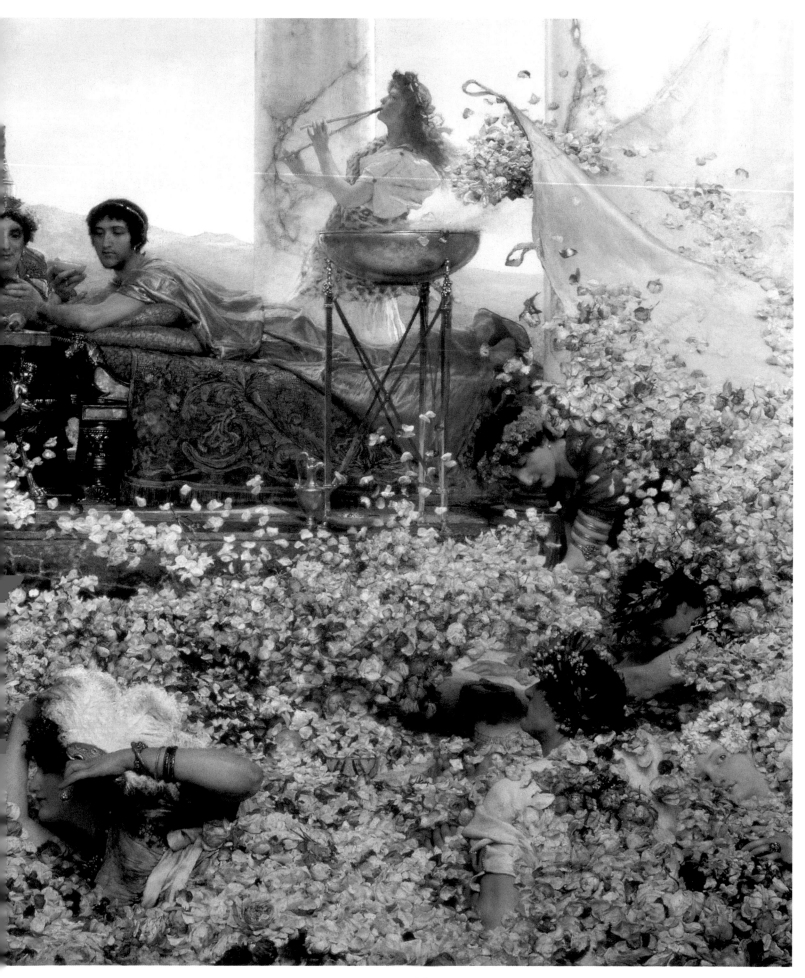

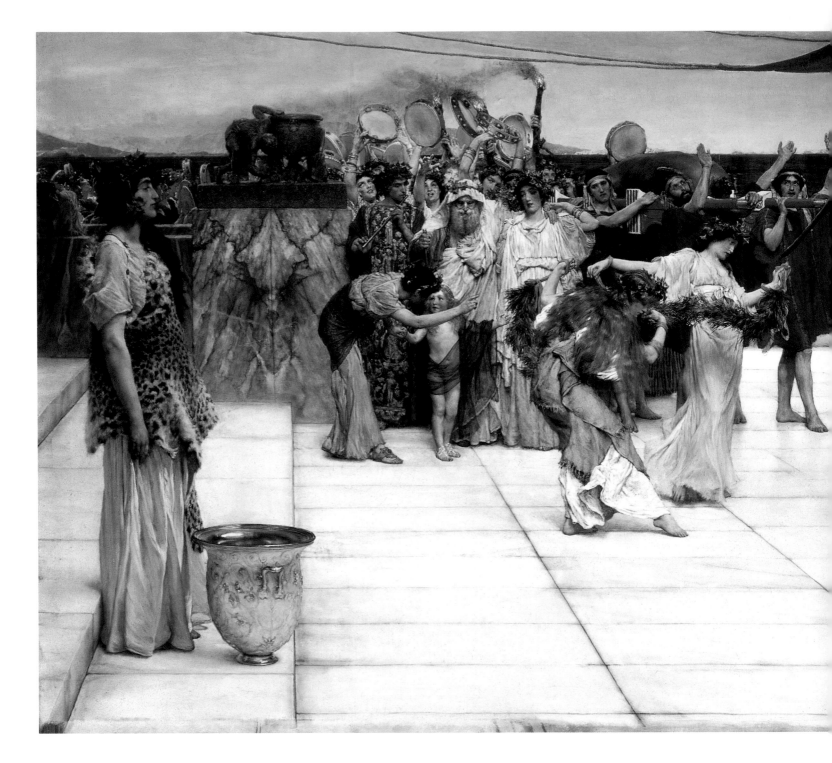

A Dedication to Bacchus
(1889)
Oil on canvas. 30½ x
69¾in (77.5 x 177.2cm).
Hamburger Kunsthalle,
Hamburg.

Dionysus, the Greek god
of wine, was later
absorbed into the Roman

pantheon when he
became known as
Bacchus. In this painting,
a mother arrives with her
young daughter to offer
her up to the Bacchic
rites. Alma-Tadema made
two versions of the
painting, both with
precise architectural

details. In this one,
however, he introduces a
marble frieze illustrating a
battle between Lapiths
and centaurs. The bronze
at centre right of the
picture is the Fumetti
centaur, now in the
Capitoline Museum,
Rome.

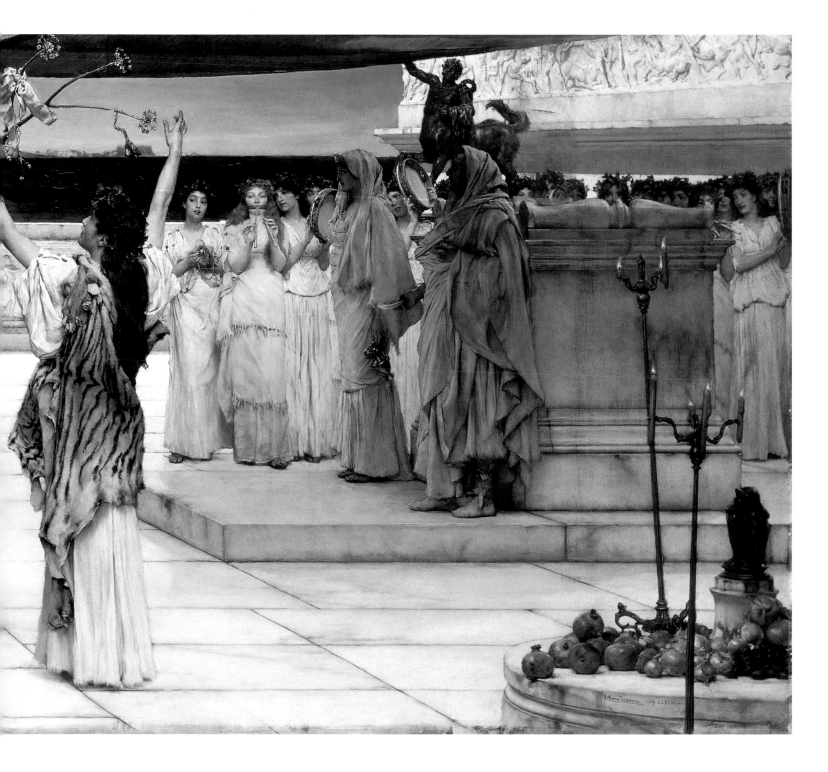

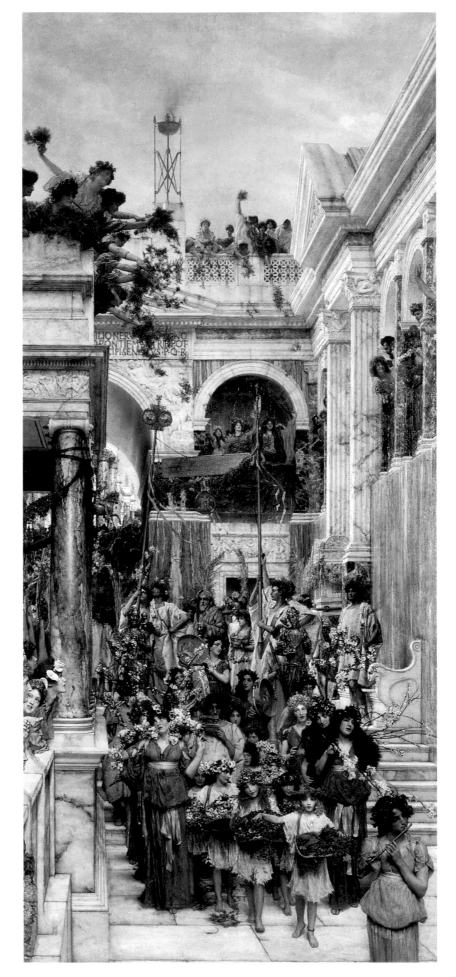

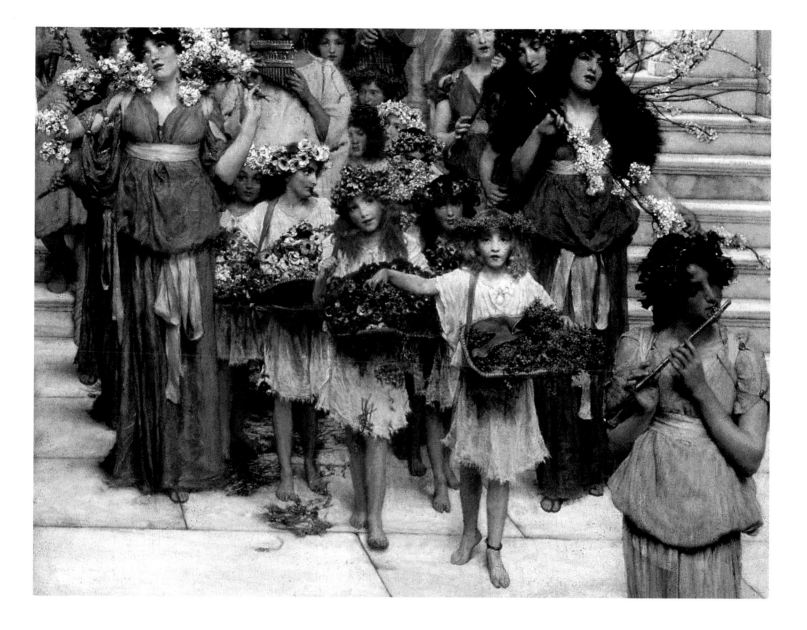

Spring (1894)
Oil on canvas. 70¹/₂ x
31¹/₂in (179.1 x 80cm).
J. Paul Getty Museum,
Malibu.

The festival being
celebrated is the *Cerialia*,
a spring ritual dedicated
to Ceres (the Greek
Demeter), the goddess of
agriculture, in the hope
that she will produce an
abundant crop. Alma-
Tadema has captured the
procession as it surges
through the forum and
has rendered the
architecture of the
temples and arcades with
his usual meticulous
precision.

CHAPTER FOUR
ALL'S RIGHT WITH THE WORLD

The period of settled and comfortable life which preceded the First World War, known in Paris as the *belle époque*, penetrated even staid Victorian Britain and perhaps nudged Alma Tadema into returning to his scenes of women at the Roman baths. The nude of *In the Tepidarium* of 1881 was followed by a women undressing, which he called *The Apodyterium* (p.114), in 1886 and by one of a woman being dressed by a servant, entitled *The Frigidarium* (p. 100–101), in 1890. Discreet references to sexual matters were becoming common in literature and the theatre, so why not in painting where naked women had hitherto been painted with the cold objectivity of marble statues?

Sex was not, in fact, a subject that occupied Alma-Tadema's mind for very long. He was an uxorious man,

devoted to his family, and found in them everything that he desired, as well as support for his own ambitions.

He was proud of his wife's achievements as a painter, to whom his tuition had been invaluable, and did not shirk from impressing on her the principles and techniques by which he worked. A true Victorian, his advice was often offered in the form of maxims such as 'Nothing can be done without taking trouble' or 'You must work hard if you intend to succeed'.

Alma-Tadema taught his wife to paint in the way that he himself painted. First, there was the research of the subject, followed by various studies in charcoal to establish the idea. The final study was for alteration and amendment as necessary and when it seemed satisfactory to the artist was

RIGHT
Sunflowers (1874)
Oil on canvas. 12½ x 5in (31.7 x 12.7cm).
Private collection.

It is doubtful that Alma-Tadema had ever seen Van Gogh's sunflowers but, in any case, his feelings concerning these golden symbols of the sun would hardly have coincided with Van Gogh's. In this painting, the woman is the overriding focus of interest – an elegant Mannerist female expressing a very different emotion from the one that Van Gogh was struggling to convey: the sunflowers in Alma-Tadema's picture are simply there to form a pretty backdrop to the figure.

OPPOSITE
Flora (1877)
Watercolour. 11¾ x 8in (29.8 x 20.3cm).
Private collection

The full title of this picture is *Spring in the Gardens of the Villa Borghese*. It was painted while Alma-Tadema was on holiday in Rome with his wife, Laura, though it was probably finished in his studio at home. The fountain does not in fact belong to the Borghese gardens, and this is not surprising, for the artist often inserted items he had already sketched elsewhere in his travels, in this case in the exedra near Diocletian's palace.

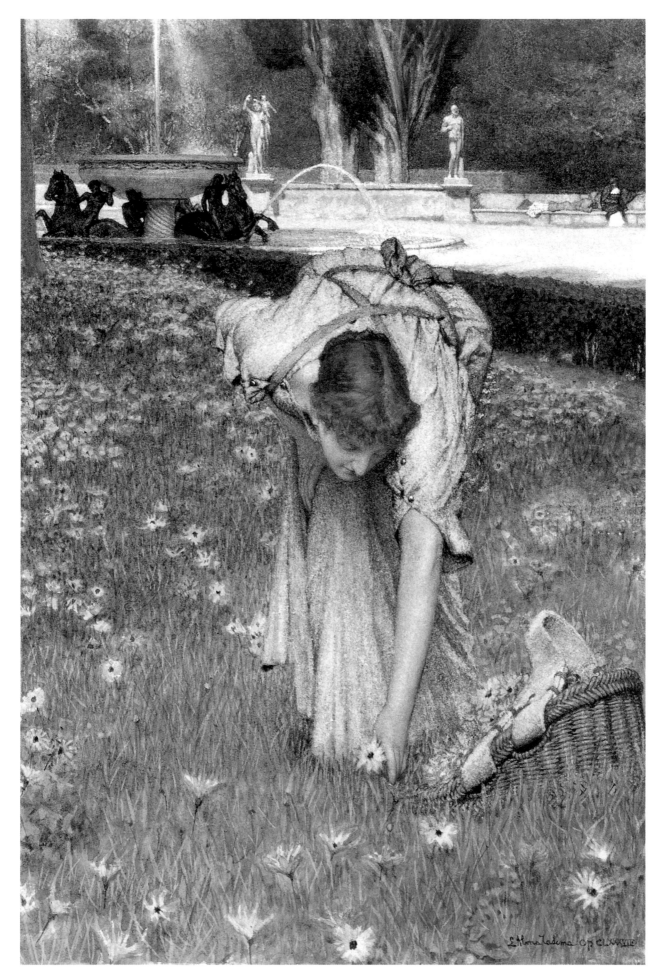

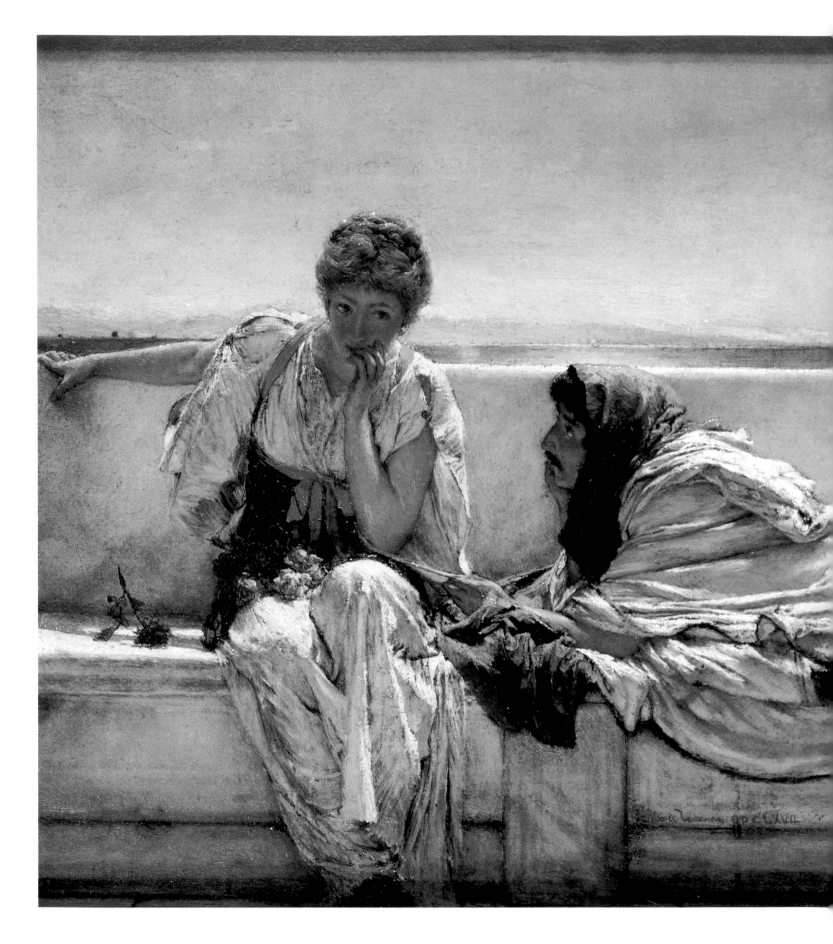

Pleading (1876)

Oil on canvas. 8¹/₂ x 12³/₈in (21.5 x 31.5cm). The Guildhall Art Gallery, London.

Young love, when suitors wonder if they are going to be accepted, and young women try to make up their minds, was a popular subject with the Victorians and therefore with Alma-Tadema. This sentimental drama, set in a sunny clime, was a success with his middle-class audience who were now taking holidays abroad as a matter of course. There is another version of this painting, with the young man bareheaded (p. 106), and it has been suggested that it was inspired by George Ebbers' novella, *Eine Frage*, in which the young man is Phaon and the woman Xanthe.

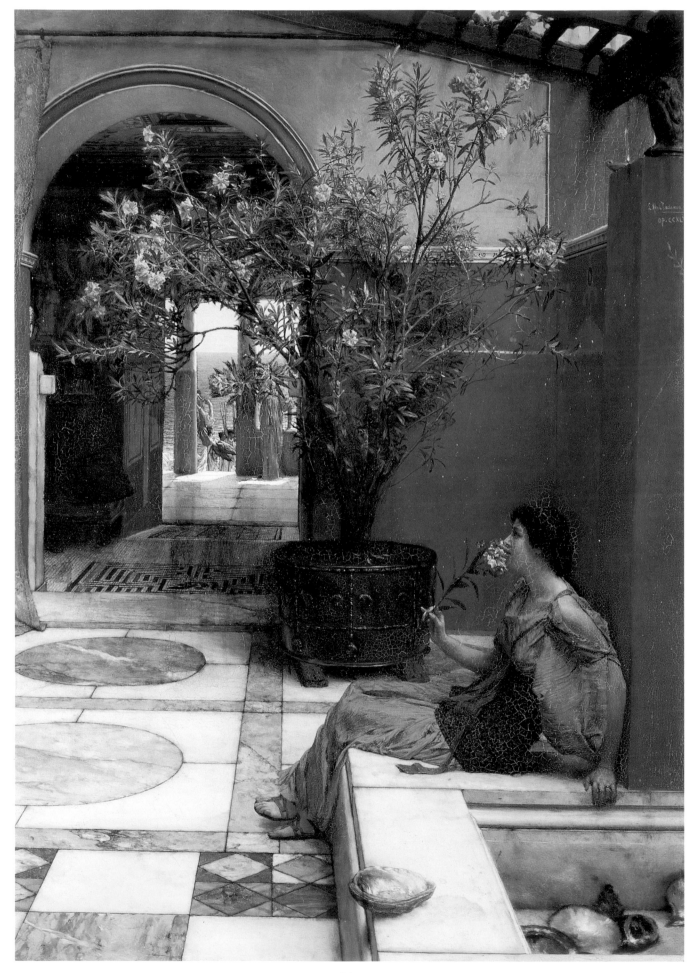

OPPOSITE
An Oleander (1882)
Oil on panel. 36½ x
25½in (92.8 x 64.7cm).
Private collection.

This painting has the
appearance of an actual
location rather than a
scene created in Alma-
Tadema's imagination
from fragments that he
has already recorded in
his sketchbooks. The
marble floor

demonstrates just how
skilful he was at
reproducing this material
in paint while the sea,
glimpsed through a
doorway, gives the
impression of a distant
vista seen from above.
This was the kind of view
Alma-Tadema liked to sit
and contemplate from the
terrace of his hotel high
up on the cliffs of
Sorrento in Italy.

ABOVE
Una Carita (1883)
Oil on panel. 4¼ x 3¼in
(10.8 x 8.3cm).
Private collection.

This is an unusual painting
in that it is evidently the
artist's response to an
actual incident which
stirred his emotions. The
woman is a beggar asking
for alms, which was then
a common phenomenon
in Italy, and particularly in

the poverty-stricken area
around Naples. Alma-
Tadema visited this region
constantly in his search
for authentic Roman
material.

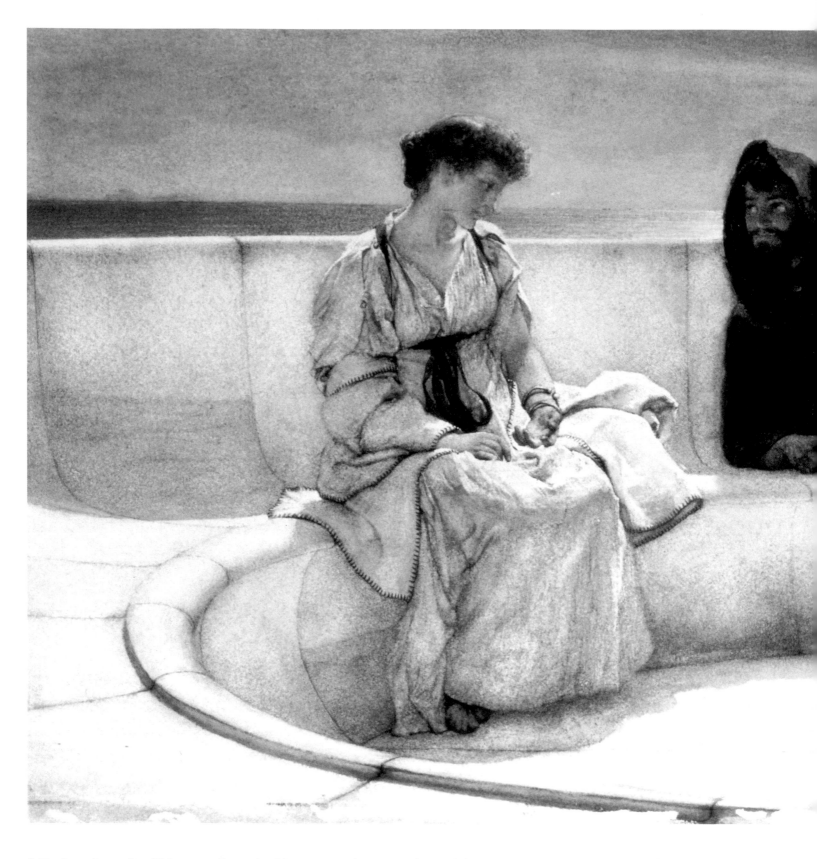

A Declaration – An Old, Old Story (1882)
Watercolour. 8¹/₂ x 18¹/₈in
(21.5 x 46.1cm).
The British Museum,
London.

From the blossom on the
trees at the far side of the
marble balcony, it is clear
that it is springtime. The
young man's cloak
suggests that it is a cool

day and the young
woman's response also
appears to be cool. The
title of the painting is a
little ambiguous: is it love
that the man is declaring?

Alma-Iadema's love of a
good joke may account
for some of his titles
which seem to suggest
more than they say.

94

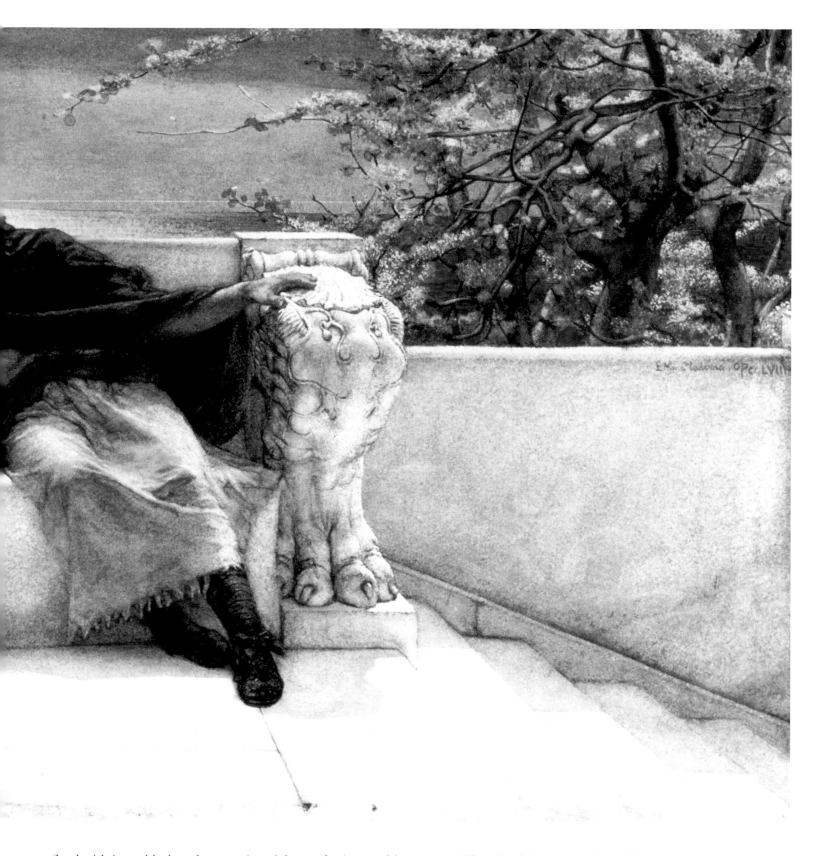

fixed with ivory black and turpentine. A layer of paint would then be used to fill the spaces between the lines and be refined until ready for the final application of paint. There was nothing original about this technique, which derived from the work of the first painters in oils, but the care with which each stage was resolved was Alma-Tadema's own.

What also belonged to Alma-Tadema was his emotional approach to his subject matter. In the case of his historical paintings, emotions were ruled out and an objective account of the story was given. When, however, the subject was of personal relationships, Alma-Tadema succumbed to sentiment, very much in the manner of a popular novel. In

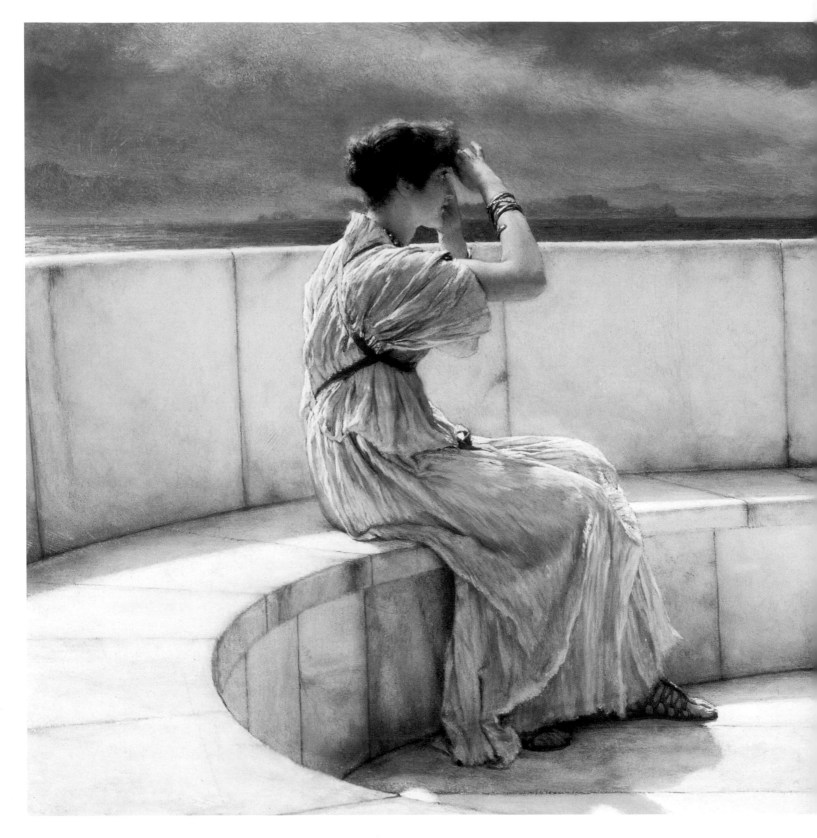

Expectations (1885)
Oil on panel. 8³/₄ x 17³/₄in
(22.2 x 45.1cm).
Private collection.

This painting won a
golden award at the Paris
Exposition Universelle of
1889. It was the year that
Alma-Tadema also
exhibited *The Women of*

Amphissa (p. 80–81) and
marks the high point of
the artist's popularity with
the French people not yet
wholly won over to
Impressionism. The clear

light and diffuse colour
was Alma Tadema's
contribution to the vogue
for sunny paintings and by
introducing the town of
Sorrento, behind the

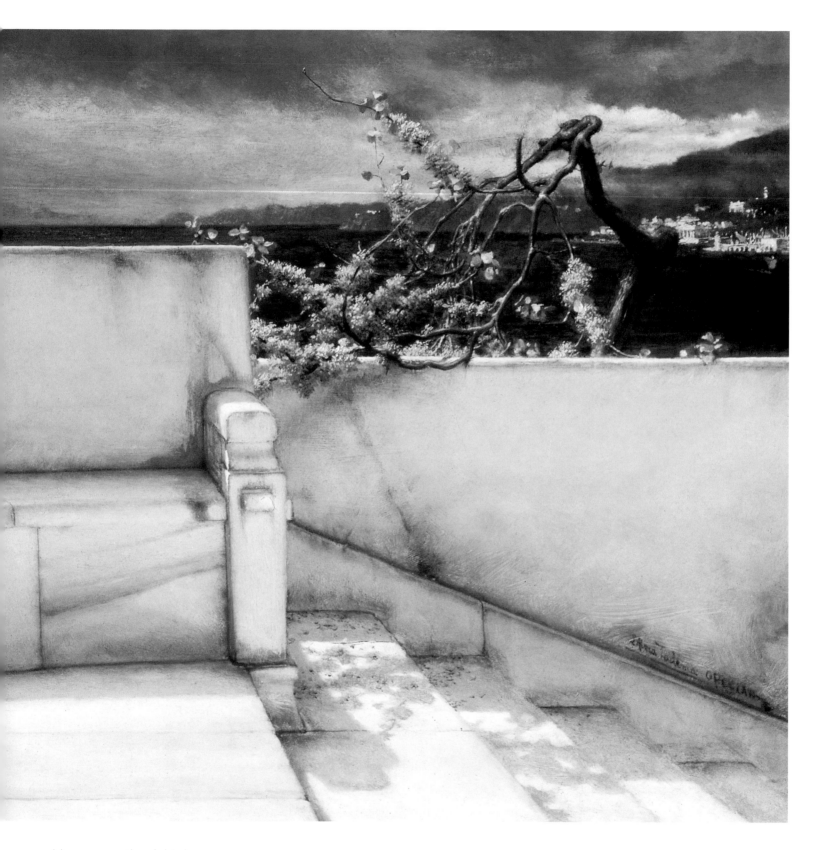

blossom on the right, he
was guaranteed to arouse
happy thoughts and
nostalgic memories of
Italy.

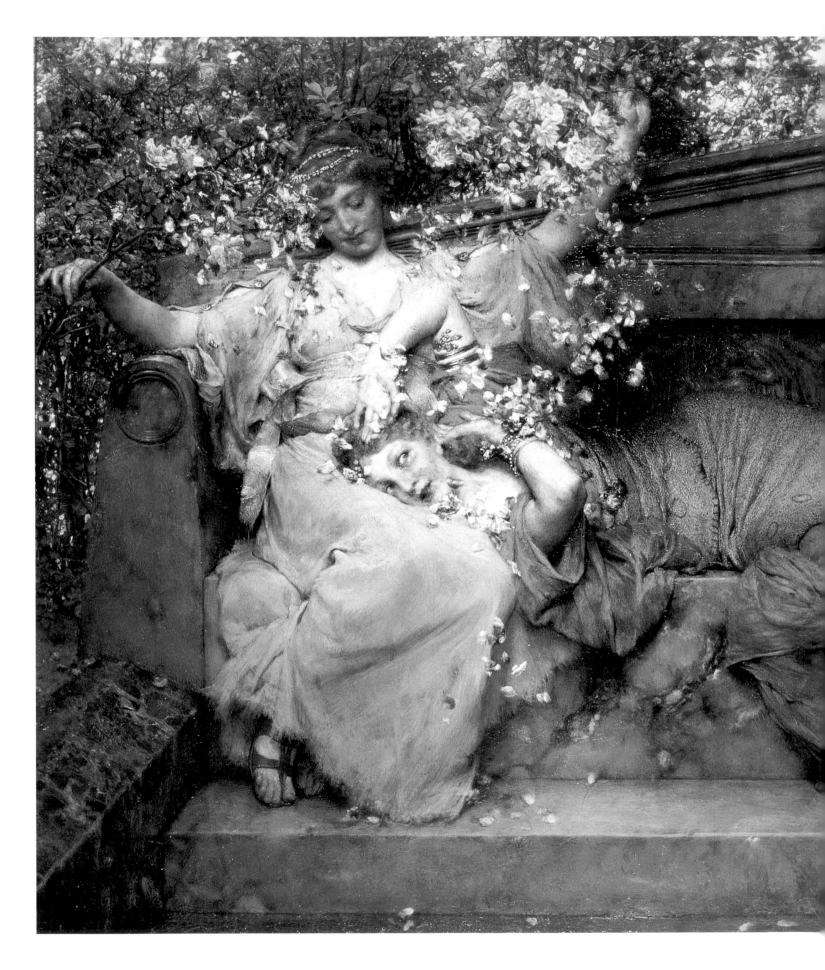

In A Rose Garden (1889)
Oil on canvas. 14³/4 x 19¹/2in (37.5 x 49.5cm). Private collection.

Alma-Tadema loved flowers, not as a horticulturalist but simply because he was an admirer of beauty. Women and flowers continued to entrance him, even in later life, and in painting this picture he has indulged himself to the full. To preserve the Roman context, for which he was now famous, he has introduced a rather obtrusive temple pediment into the background. This painting was first shown in 1890 at the New Gallery, London.

1891 he had painted *An Earthly Paradise* (p. 16–17), which shows a mother leaning over a baby on a couch. It had been inspired by a line from a poem by Swinburne, 'All the Heaven of Heavens in one little child'. What might seem like mawkish sentimentality to modern minds represented true emotion to the comfortable middle classes of the late Victorian period.

Alma-Tadema, very much one of their number, was able to empathize with them so exactly that people found little difficulty in accepting his work and praising its sensitivity. His popularity continued to soar and his paintings, reproduced as cheap engravings for those who could not afford originals, made him ever richer and more famous at all levels of society.

There were many similar sentimental dramas among Alma-Tadema's work of this period. *A Declaration* (p. 94–95) features a young woman sitting on a marble bench looking uncertain, while her lover sits by her side. *Love in Idleness* (p. 102–103) has two young women sitting contemplating their absent lovers. *The Kiss* (104–105) dramatizes the sorrow of parting as a boat arrives to take a mother and daughter home after visiting relatives, while *Unconscious Rivals* (p. 108–109) shows two elegant women exchanging confidences.

Romantic love featured largely in Alma-Tadema's subjects. In his *belle époque* period, the encounters between lovers more often than not take place on wide open-air terraces overlooking the sea. The inspiration for this setting

The Frigidarium (1890)
Oil on canvas. 17³/₄ x
23¹/₂in (45.1 x 59.7cm).
Private collection.

The woman in the
foreground has finished
bathing and is being
helped back into her
clothes by a servant. In
the background, another
woman, wrapped in a
towel, is about to enter
the Frigidarium, or cold
room, another servant
holding back the curtain
for her. Unlike the women
of the Republic, who
worked hard alongside
their men, the women of
the Empire were indolent
and pleasure-seeking and
were not above scheming
to ensure their husbands'
promotion.

was the Bay of Naples, which Alma-Tadema had visited
several times, and in particular the views to be obtained from
the hotels that lined – and still line – the precipitous cliffs
overlooking the Bay of Naples at Sorrento.

In many of the earlier paintings of this period, the woman
is alone on a marble balcony dreaming her dreams, as in
Expectations (p. 96–97), or gossiping with a friend, as in
Whispering Noon (p. 113). In other paintings, groups of
young women are featured, as in *A Coign of Vantage* (p.110),
where they are looking out over a marble balcony high above
the sea at the ships of their lovers returning from duty
overseas. In *The Baths of Caracalla* (p. 116), they are lolling
about, abandoned and overcome with *ennui*.

In 1896, Alma-Tadema entered his 60s, a milestone that
was celebrated with a banquet in his honour at which the
guests of honour were Sargent and Burne-Jones. Every artist
of repute was present, as well as many of the important
patrons of the art world. The enormous birthday cake with its
60 candles seemed to delight the high-spirited Alma-Tadema
as much as the fact that he had just been nominated for a
knighthood in the Queen's Birthday Honours list.

The birthday was an opportunity to gather the family
together, his elder daughter Laurence, who was a budding
writer and travelled a great deal, arriving from Russia with her
friend Eleonora Duse. Laurence was still unmarried and it was

Love in Idleness (1891)
Watercolour. 32¹/₂ x
65¹/₄in (82.6 x 165.7cm).
The Laing Art Gallery,
Newcastle upon Tyne,
England.

Like so many young
women in Alma-Tadema's
paintings, these two have
no idea what to do with
themselves and are idling
their time away in
sporadic conversation.
Although the sea is
temptingly close, it would
have been indiscreet to lie
about on a beach and
frolicking in the sea
without the proper
accoutrements of a
bathing machine and lady
attendant would have
been out of the question.
The quotation in the title,
from the Odes of Horace,
asks Venus to bring on
'cupid glowing warm' and
'graces and nymphs
unzoned and free'.

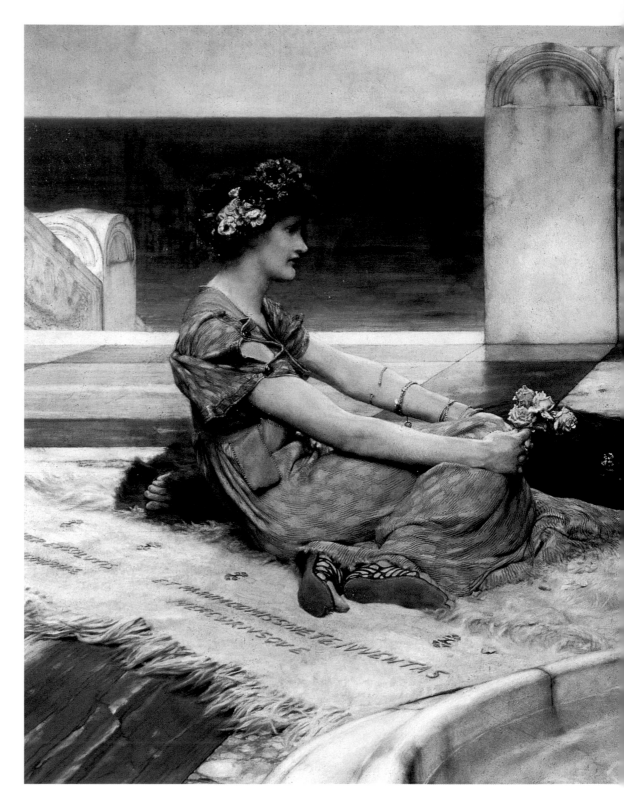

rumoured that she never would be for she had fallen in love
with the Polish pianist Ignaz Paderewski while her father was
painting his portrait, and she would not contemplate
marrying anyone but him. Anna was in London but remained
close to her mother whose health had been deteriorating
since she had had an attack of erysipelas which, in the days
before antibiotics, was difficult to cure. Laura's sister Ellen
was still close to the family, but her husband's revelation that

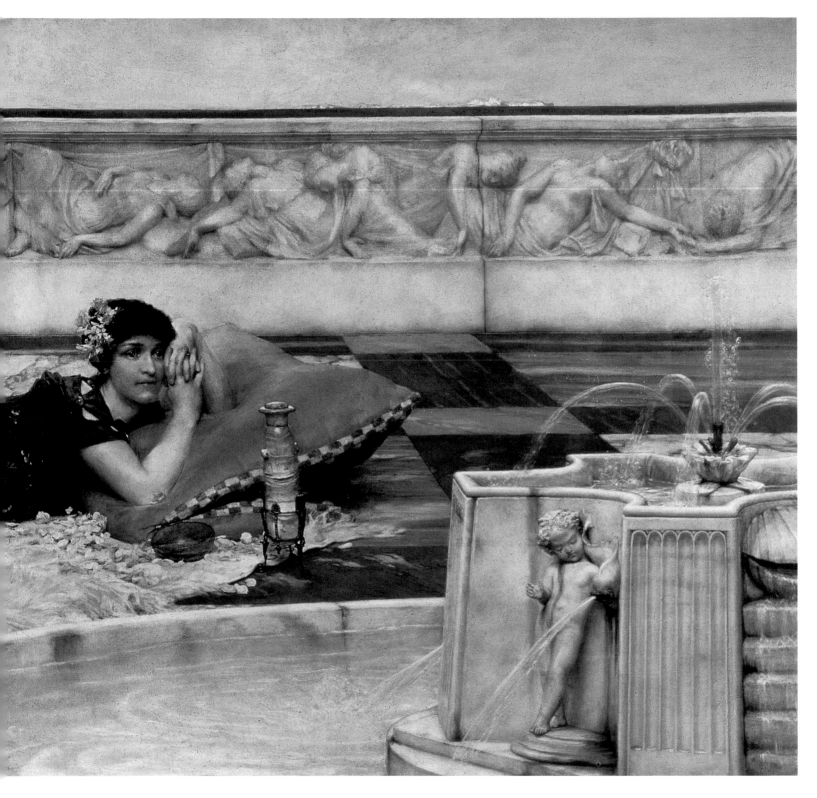

he was homosexual had caused much heartache in the family.

Sir Laurence Alma-Tadema, with his usual energy and exuberance, had embarked on yet another new departure at the beginning of the 1890s. The great actor-manager, Sir Herbert Beerbohm Tree, had asked him to design a set and costumes for his production of *Hypatia* at the Haymarket Theatre in London. Tree was delighted with Alma-Tadema's first offerings for the theatre; he spoke in particularly glowing

terms of a scene in which Hypatia, a philosopher, addresses a school which, he said, was just like a painting by Alma-Tadema.

Sir Henry Irving, for whom Alma-Tadema had designed a set for *Coriolanus,* had then asked him to make sketches for scenery for *Cymbeline* and *Julius Caesar,* though this latter production was not staged until 1898, and then by Tree. It was an instant success, George Bernard Shaw noting that it

The Kiss (1891)
Oil on panel. 18 x 24¾in
(45.7 x 62.9cm).
The Maas Gallery,
London.

The unfamiliar background
is the result of a visit
made by Alma-Tadema to
his friend George Ebbers
at his house on the
Starnberger See, near
Munich. The marble

terrace has certainly come
from the artist's store of
sketches of Roman
architecture, and the
women bear a
resemblance to his family
and models that he had
used before. The quality
of the light and *gemütlich*
ambience ensured that it
would be a success at the
Royal Academy show in
1891.

was Alma-Tadema who was the hero of the evening, ' though
the stage carpenters seemed intent on spoiling the show.' *Julius
Caesar* ran for five months and, although Alma-Tadema's
scenery brought him further praise, he admitted that he had
been exhausted by the new venture.

'It has been suggested,' he wrote, 'that I found these
matters pleasant relaxation. It was harder work than painting …
At the dress rehearsal of *Julius Caesar* at His Majesty's I was at
the theatre from seven in the evening until three the next
morning … But I considerably enjoyed the experience and this
was, I think, to a large extent due to the fact that our actors
and actresses are a particularly nice people to get on with.'

His theatrical work did not prevent Alma-Tadema from
continuing with his own painting. While working on the *Julius
Caesar* designs, he produced *Watching and Waiting*, which was
based on a poem by Tennyson, and *Her Eyes are With Her
Thoughts and These are Far Away (p. 115)*. This was inspired by
a canto in Byron's *Childe Harold*, which recounts the fate of a
Dacian wife whose husband has been taken prisoner by the
Romans and sent to the arena to be 'butchered to make a
Roman holiday'.

Some time before, Laura had written to refuse an invitation
from their friends, the Ebbers, to spend a holiday at their villa
in Tutzing, in Bavaria, because her husband was so busy; he
had not become less so as the 20th century opened. He was a

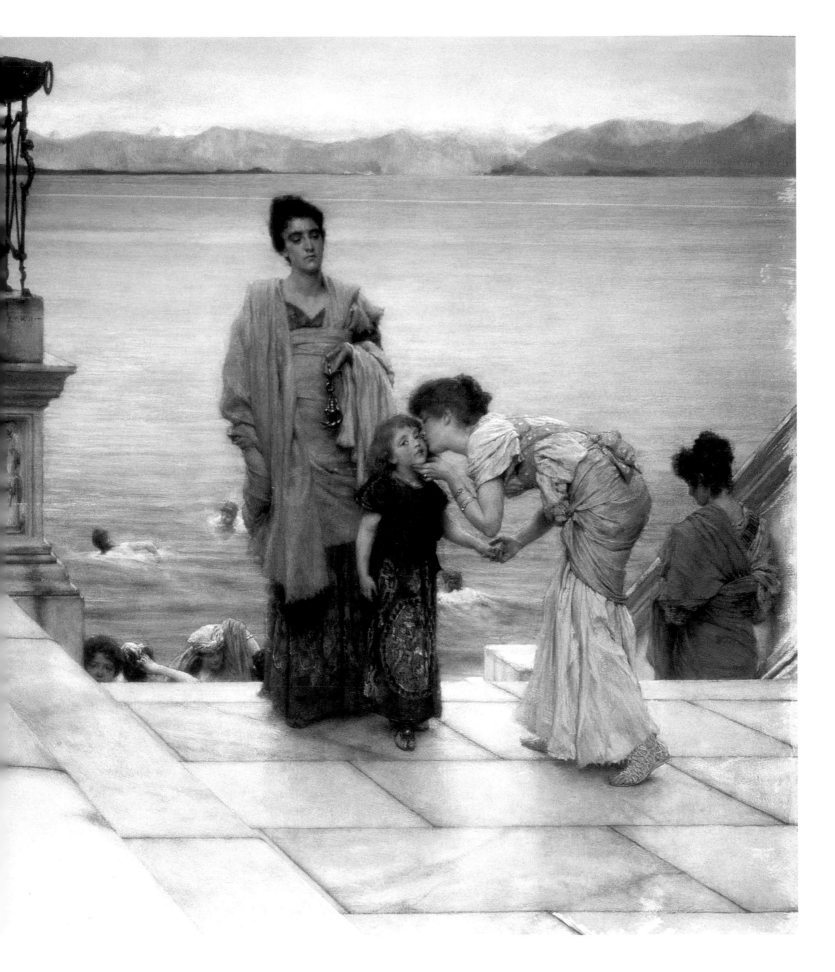

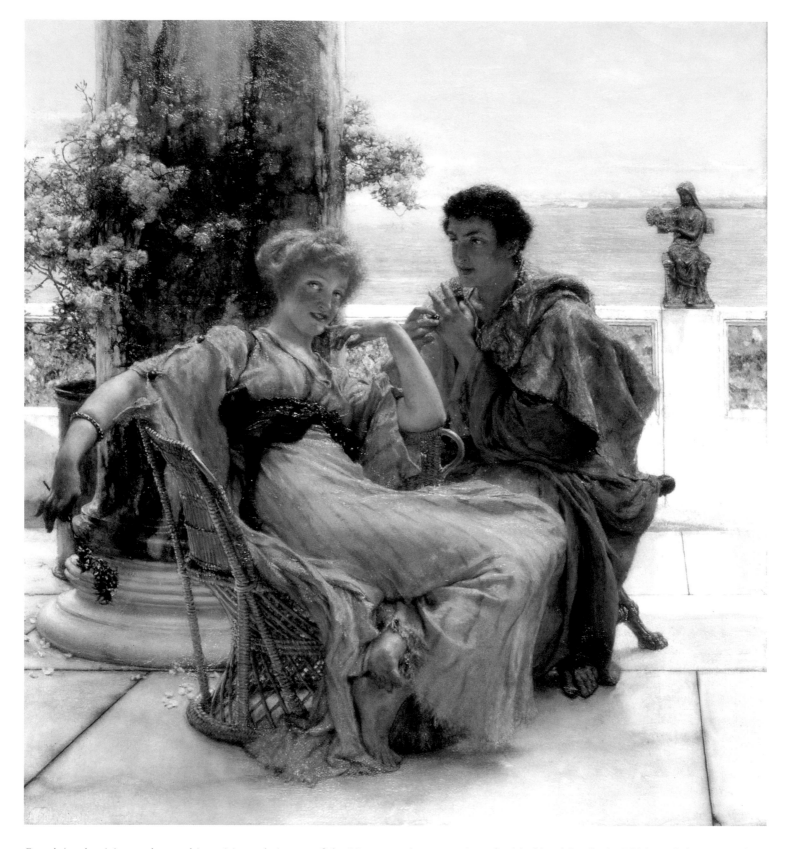

Royal Academician and a teaching visitor, chairman of the New Gallery, on the selection committee of the Grosvenor Gallery, President of the Royal Society of Artists in Birmingham, and a member of innumerable other societies, all of which entailed specific duties.

His was besieged by social occasions, which included the banquet given for his friend Rodin in 1902, and the coronation banquet of King Edward VII, to which he had contributed the decorative plan. He had presented the new king with a watercolour entitled *The Crown*, and on a visit to Sandringham, had already given Queen Alexandra another entitled *Impatient*.

Busy though he was when Sir John Aird, the engineer in

Courtship – The Proposal (1892)
Oil on canvas. 15$\frac{1}{2}$ x 14in (39.2 x 35.5cm).
The Royal Pavilion Libraries and Museums, Brighton & Hove, England.

The young Roman is putting his case to his beloved much as a young Victorian would have done in Alma-Tadema's time. The artist always insisted that though times and fashions might change, the essential exchanges between human beings remained the same. The setting of balcony and sea was one of Alma-Tadema's trademarks, as are the flowers encircling the column.

charge of the construction of the Asyût and Aswan dams on the upper Nile, invited himself and Laura on a six-week trip to Egypt in 1902, he accepted eagerly. He had planned to visit Egypt ten years earlier but had been prevented from doing so by pressure of work. This time he had a particular reason for going as Aird had asked him to paint a picture with an Egyptian theme: of the three subjects that Alma-Tadema had been offered, he chose *The Finding of Moses* (p. 128–129).

Alma-Tadema set about painting this subject in his usual meticulous way. It was, he decided, to be a large painting in the style of his historical paintings of Roman events. He made copious notes as he travelled up the Nile on one of Mr Thomas Cook's steamers, some of which he transcribed into a letter to Edwin Austin Abbey, the American he had often encountered at Broadway in the Cotswolds.

'Egypt is funny,' he wrote. 'The first impression of the people, at least for a day or two, was that I was at Beerbohm Tree's theatre and that they were all the supers [that is, extras] from one of his oriental plays, say Herod ... It was funny never to see a woman in the streets of Cairo ... all men ... and then, these magenta sunsets. Too absurd.'

The highlight of the trip was the inauguration of the dams. This was a very formal affair with all the pageantry of an imperial event: the British authorities in plumed hats and

Unconscious Rivals

(1893)

Oil on canvas. 17³/₄ x 24³/₄in (45.1 x 62.8cm). Bristol City Museum and Art Gallery, England.

The two elegant women in the large, well appointed room with semi-circular barrel vaulting, which looks out onto the city, are exchanging confidences, perhaps the intimate ones that will make them rivals for the same man. A figure of Cupid on a marble pillar suggests what is on their minds. The complex scene took Alma-Tadema two years to complete and the barrel vaulting was added later.

gold braid, accompanied by armed forces in dress uniforms, and Egyptians in flowing robes and scarlet fezzes. The guest list – which included the young Winston Churchill – were all in formal attire.

'Fancy standing in the sun in a chimney pot [top hat] and black frock coat for a few hours; it's enough to play the deuce with my system. Assuan was all bunting and seeing it from the other side of the Nile with all the red flags in the sunshine and transparency, looked like a huge poppy field. It was so cheery.'

This was the ebullient Alma-Tadema enjoying himself and when his painting, *The Finding of Moses*, was in progress, some of this spirit seemed to permeate it. In March 1903, Alma-Tadema received a call from Buckingham Palace announcing that the King and Queen intended to visit his studio. Though unfinished, the Egyptian picture evidently attracted their attention, though nothing was said at the time. The painting, for which Sir John Aird had paid the huge sum of £5,250, was eventually finished in 1904 and exhibited at the Royal Academy. The Roman numeral on it, beside the artist's signature, was Opus CCCLXXVII (377). A year later, Alma-Tadema received the Order of Merit, an honour in the personal gift of the sovereign.

The Finding of Moses was a tour de force in the style of his earlier Roman historical epics and was not only a

A Coign of Vantage

(1895)

Oil on panel. 25¹/₄ x 17¹/₂in (64 x 44.5cm). Private collection.

This painting, with its vertiginous perspective, is probably Alma-Tadema's most successful work, and its popularity has endured. The three women are looking out over a marble parapet at returning Roman triremes, which undoubtedly bear their husbands or lovers. The situation would have struck a similar chord in the hearts of Victorian women whose loved ones were serving the Empire on the high seas. A similar painting, entitled *God Speed*, evokes the drama of a departure.

commemoration of Sir John Aird's work on the Nile dams, but also a symbol of British rule in Egypt. The painting shows the baby Moses being brought back to the Pharaoh's palace, borne on a cradle held aloft by slaves. On the far bank, crowds of Egyptians have turned out to witness the event. On the seat of the palanquin, which carries the Pharaoh's daughter, are hieroglyphs representing the words 'Life' and 'Dominion'.

This was Alma-Tadema's return to great epic painting and he had put all his skill and dedication into it. It had taken so long that Laura had joked that it was no longer the finding of a baby Moses but of a two-year-old, who could have walked to the Pharaoh's palace.

Alma-Tadema had now decided to reduce his workload. Many of his paintings were still circulating in exhibitions in Europe and America, and he had committed himself to producing one large canvas for the annual Royal Academy show. A more leisurely life would enable him to devote himself to his family, travel, and to the many calls on his time by the various societies of which he was a member, selection committee judge or chairman. His fame and stature in the international world of art also made him eligible to represent Britain abroad, as he did in 1904, attending the St Louis World Fair. He enjoyed the social side of an artist's life and the public functions at which he could wear the decorations

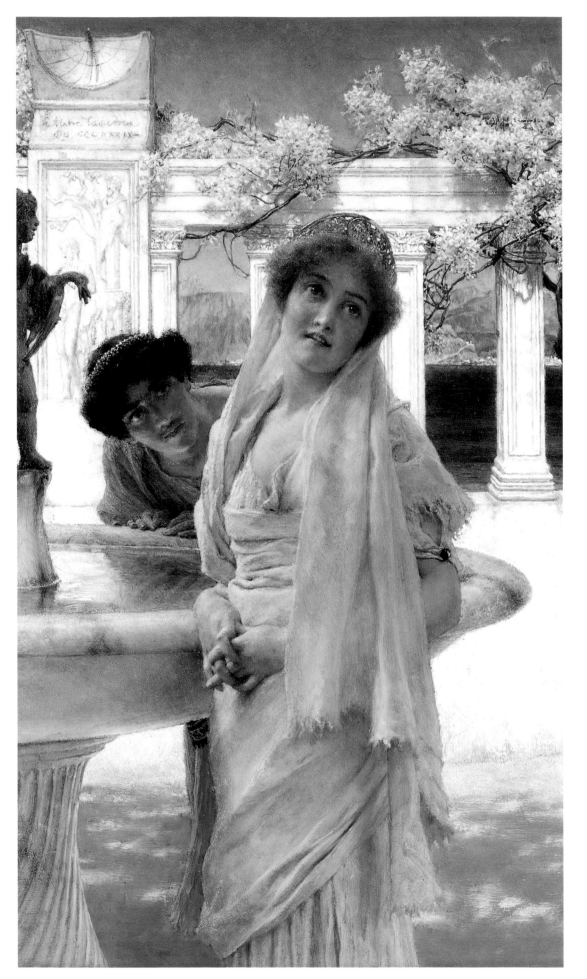

A Difference of Opinion
(1896)
Oil on panel. 15 x 9in
(38.1 x 22.9cm).
Private collection.

The delicate English rose
and the dark-eyed
Mediterranean are a
recurrent theme for Alma-
Tadema's Roman lovers,
here engaged in a lover's
tiff which the girl seems
almost to be enjoying:
perhaps she is testing the
degree of his devotion.
The two make a pretty
picture in the shimmering
heat of noon, posed
against wisteria-clad
columns with the
ubiquitous fountain and its
bronze statue of a boy
holding a goose.

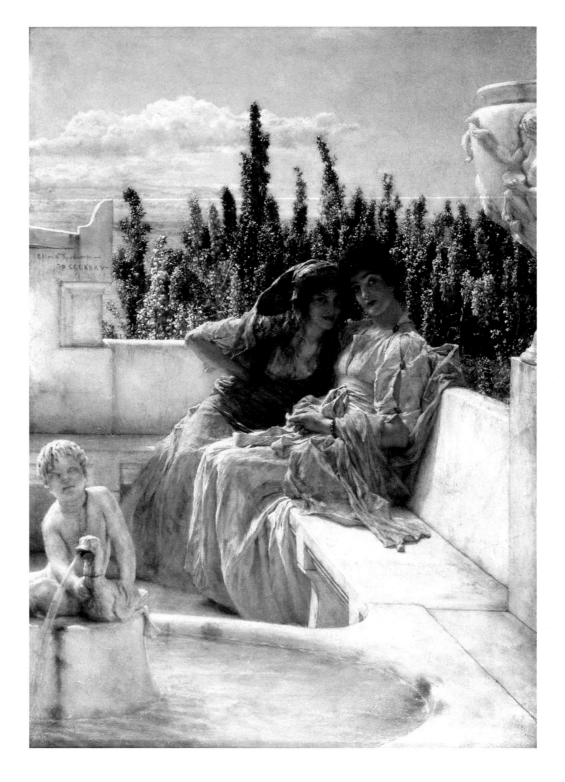

Whispering Noon (1896)
Oil on canvas. 22 x 15¹/₂in
(56 x 39.3cm).
Private collection.

Two women gossiping on
a marble balcony in the
heat of the day are being
kept cool by water
trickling into a basin on
which the statue of a boy
with a duck is posed. The
atmosphere is one of
calm repose reminiscent
of a warm spring day in
England rather than the
oppressive heat of a
southern afternoon.

Likewise, the women
seem more like English
ladies than Roman
matrons: no doubt this
was intended to make the
picture more acceptable to
potential British buyers.

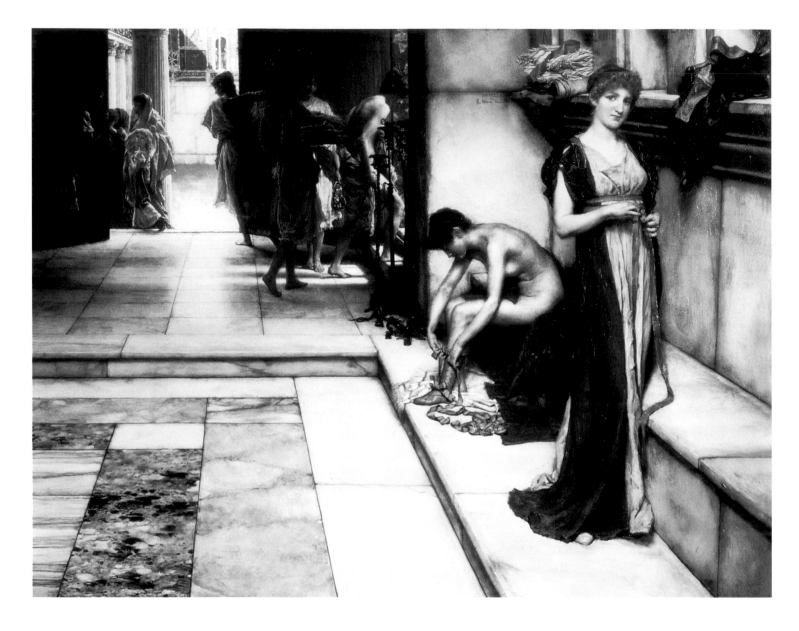

awarded to him by various countries and societies. This small pleasure had not been allowed him in England until the accession of King Edward VII.

When Ernest Gambart, the man who had recognized Alma-Tadema's potential at the start of his career died, his collection of paintings was sold and Alma-Tadema's *A Dedication to Bacchus* (p. 84–85) realized £5,800 – a considerable sum for a painting at that time.

In 1906, Alma-Tadema celebrated his 70th birthday and received yet another honour, a Royal Gold Medal on the recommendation of the Institute of British Architects for his part in the study of Roman architecture and its reconstructions in theatrical sets such as *Coriolanus*.

His apotheosis cut little ice with the new avant-garde of art, which was reacting against what it saw as the 'out-moded culture of the Victorian age'. One of the leaders of the new

wave was Roger Fry, who was about to organize the first post-Impressionist exhibition in London. As he set out to launch Cézanne, Van Gogh and others of their generation onto the British scene he commented, 'How long will it take to disinfect the Order of Merit of Alma-Tadema's scented soap?'

The battle was on between old and new and would be waged throughout the inter-war years, 1920–1939, for the British were reluctant to embrace a foreign cultural influence in their self-assured and stable world. For them a painting like *Ask Me No More* (p. 132–133), showing a shy young woman attempting to deflect her lover's attentions, reflected a human situation with elegance and refinement, whereas a painting such as Manet's *Bar aux Folies Bergères* extolled the common and vulgar aspects of life.

Though he painted the kind of picture that was soon to

OPPOSITE
The Apodyterium (1886)
Oil on panel. 17¹/₂ x
23¹/₂in (44.4 x 59.7cm).
Private collection.

Both Frederick Leighton
and Alma-Tadema
produced a group of
paintings showing Roman
women at the baths.
These were discreet and
inoffensive though

inevitably possessed
some erotic content. The
women here are in the
disrobing room while in
the background others are
about to enter the bath.
The large expanse of
marble floor shows where
the artist's true interest
lay and demonstrates the
skill which led him to be
called the king of marble.

BELOW
**Her Eyes Are With Her
Thoughts and They Are
Far Away** (1897)
Oil on canvas. 9 x 15in
(22.9 x 38.2cm).
Private collection.

Romantic dreams were
the main preoccupation of
the affluent and idle
young women of the

Victorian and Edwardian
eras. The idea of a career
was unseemly, and an
army of domestic
servants robbed them of
an occupation still further.
However, according to the
artist, this woman's
thoughts are with her
husband who is a captive
destined for the Roman
gladiatorial arena.

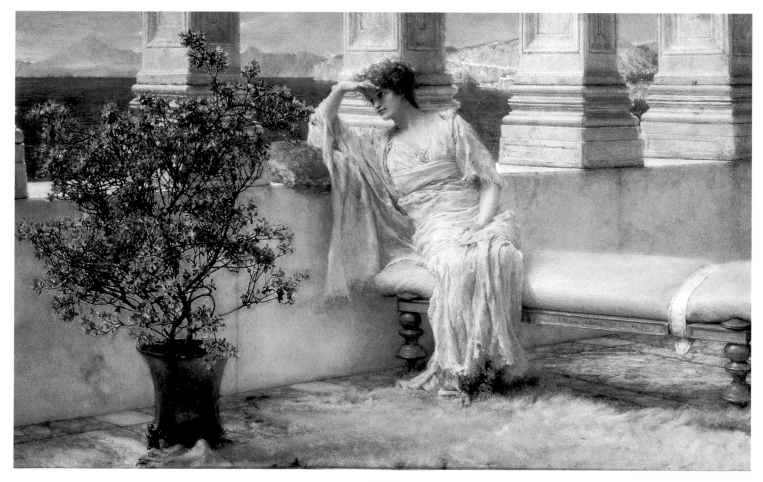

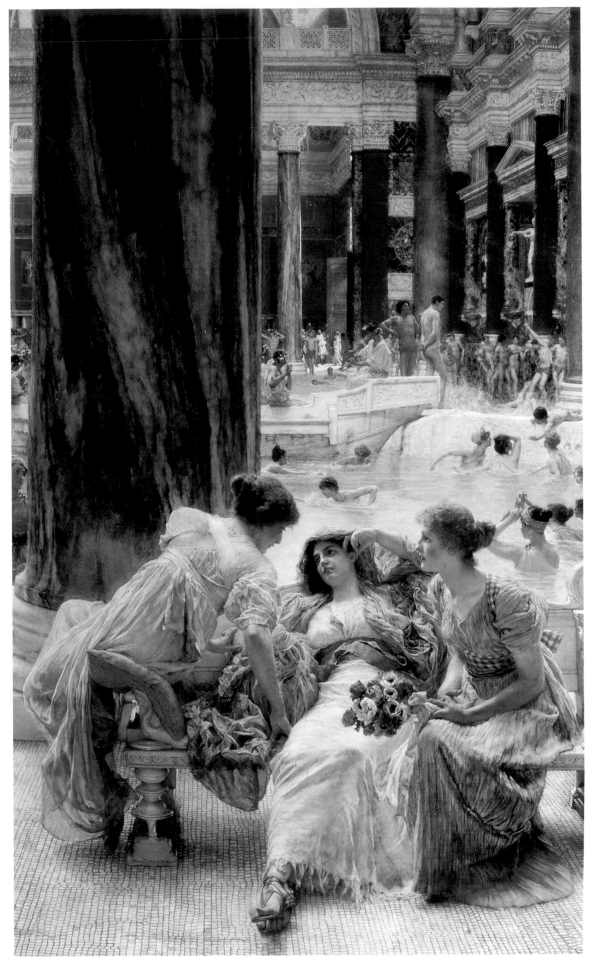

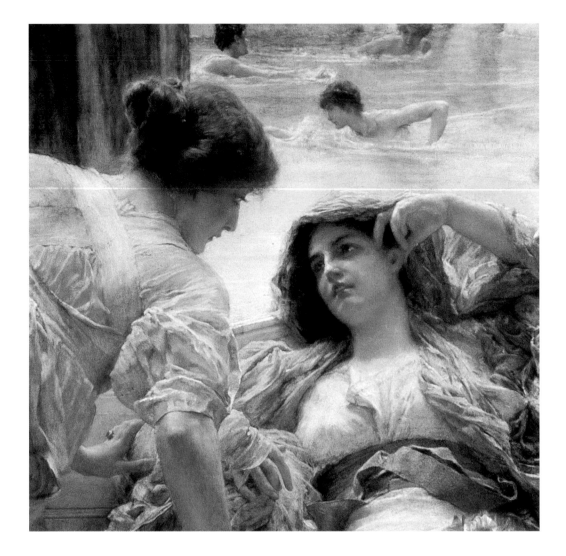

The Baths of Caracalla
(1899)
Oil on canvas. 60 x 37¹/₂in
(152.4 x 95.3cm).
Private collection.

The Baths of Caracalla were the most sumptuous in the Rome of AD 212 and could accommodate 1,600 bathers at a time, in separate areas for men and women. (Mixed bathing was not practised in Europe until the late 19th century.) Roman baths, as well as being a place for ablutions, were also social meeting places, as is clear from this painting with its three young women idly chatting in the foreground, while others disport themselves in the great marble pools beyond.

RIGHT

The Flag of Truce (1900)

Oil on panel. (17½ x 8¾in (44.5 x 22.2cm).

Private collection.

This painting was Alma-Tadema's contribution to the Boer wars, a conflict which aroused deep passion in British hearts unaccustomed to being repulsed by foreign troops – and non-professional ones at that. When the last war ended in 1902, the artist offered the painting to the War Artists Fund at an exhibition opened by Princess Louise, Duchess of Argyll, a daughter of Queen Victoria.

OPPOSITE

The Year's at the Spring, All's Right with the World (1902)

Oil on panel. 13½ x 9½in (34.2 x 24.1cm).

Private collection.

When he painted this picture, the artist must have agreed wholeheartedly with the quotation, taken from Robert Browning's *Pippa Passes*, for he had recently been knighted and was considered one of the most eminent painters of his time. The advancing forces of the rebels against post-Impressionism, among them Matisse, at that time carried no weight in the world of serious academic art, and were ignored by almost everybody.

become unfashionable, Alma-Tadema was not blind to other avenues of expression and had himself flirted with Impressionism in 1876 with his painting of a man in a solar topee reading a book in a hay field, entitled *Ninety-Four Degrees in the Shade*. There had also been several portraits in the Impressionist style, such as *Mrs McWhirter*, shown in Manchester in 1889. But as a practical craftsman he knew what his métier was and did not intend relinquishing it to engage in alternative theories.

His sympathy with other painters who were ploughing new furrows through establishment art led Alma-Tadema to contribute to a statue of Whistler after his death in London. The memorial, which was to be sculpted by Rodin, was to be erected in Chelsea where Whistler had had his studio, later inhabited by Sargent. Unfortunately, the project did not receive enough support and had to be abandoned. Thus London was deprived of an original work by the great French sculptor.

Meanwhile, Alma-Tadema carried on with the work in which he excelled and, now over 70 years old, responded to a commission from Sir Charles Wakefield in 1907 for a large work with a Roman theme. The work was *Entry to the Colosseum*, a companion piece to *Caracalla and Geta* (p. 124–125), which he had painted earlier in the same year. The latter had been another grand work, Alma-Tadema's last to depict a specific historical event, and shows the Emperor

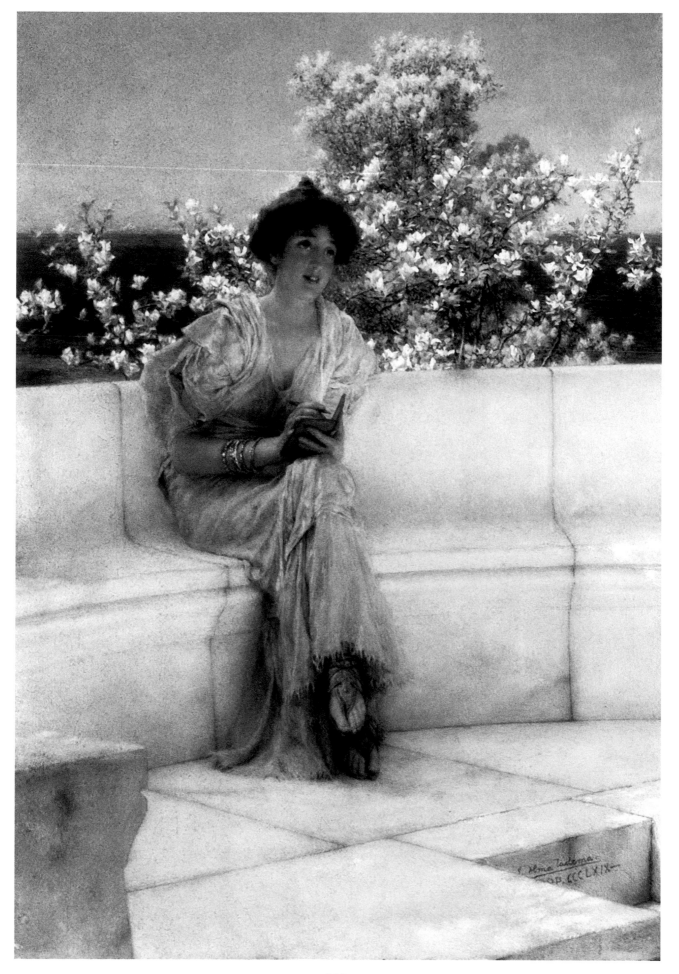

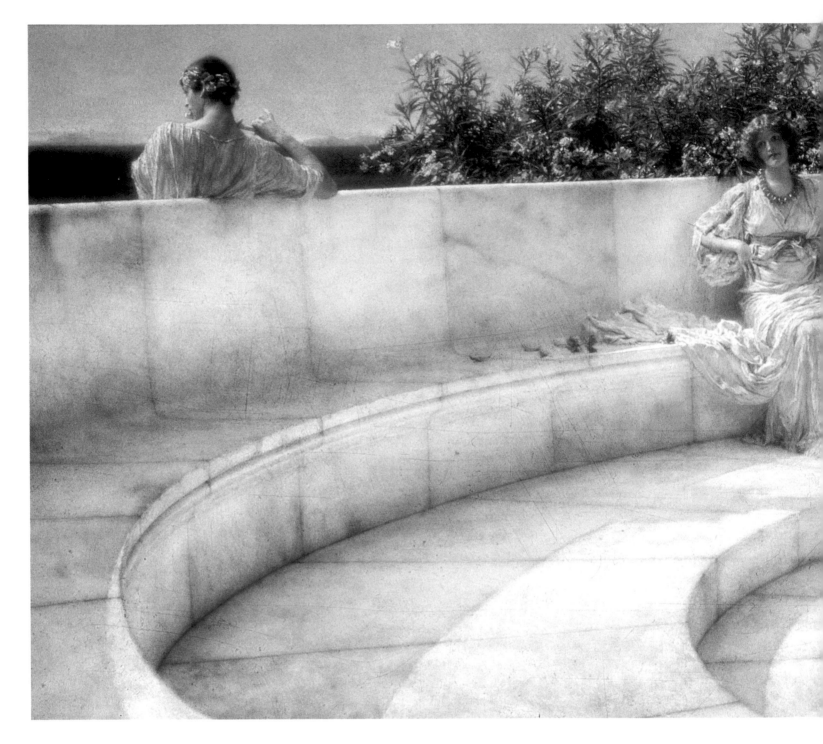

Under the Roof of Blue Ionian Weather (1901)
Oil on panel. 21³/₄ x 47¹/₂in (55.3 x 120.7cm). Private collection.

The poet Shelley wrote the words of the title as part of a letter to a friend, and certainly knew how to enjoy his travels in Europe, as did Byron. Perhaps Alma-Tadema had his own travels in mind when he painted this picture, which took two years to complete and was a resounding success, especially as people were now taking annual holidays in different parts of Europe.

120

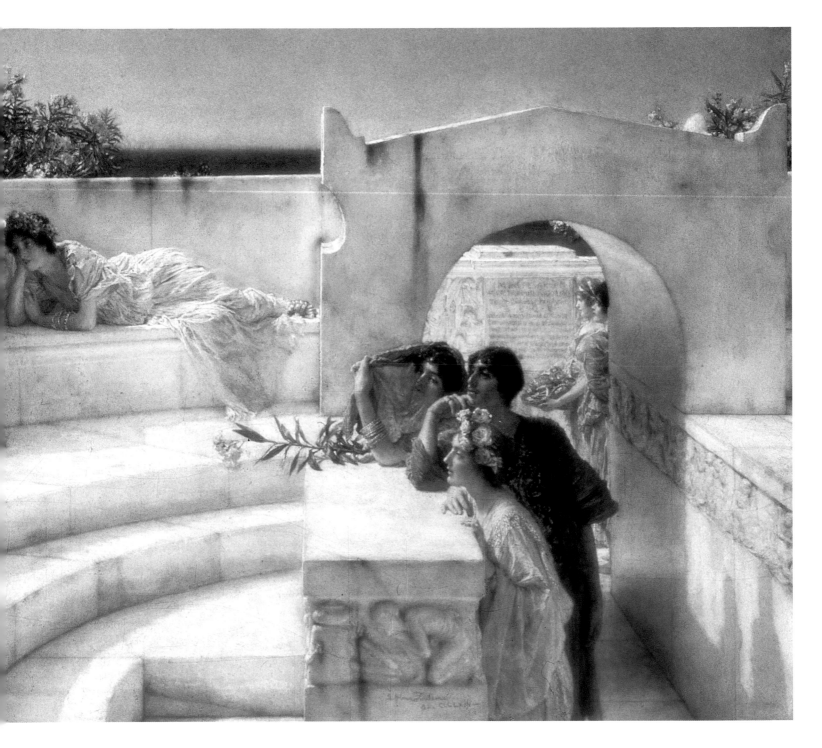

Septimius Severus at the colosseum during the presentation of his son Caracalla as the future emperor. Septimius Severus sits facing the milling crowd beneath a canopy of flowers encircling marble columns while his second wife, Julia, by his side, passes a secret note to an ally who is a supporter of her own son's claim to the imperial title. All was in vain, however, for Geta was soon murdered at the orders of Caracalla.

This was the last and most ambitious of Alma-Tadema's large-scale works and he now returned to his scenes of domestic bliss and mild eroticism. In 1907 he painted a bathing scene in the style of Leighton with two naked women, their bodies veiled by the water. In the background other women are undressing or being massaged. The whole scene prompted the critic Walter Paul to comment at the Royal Academy show that Alma-Tadema had made a strange transition from Victorian opulence to the risqué and the immodest.

Alma-Tadema's only concern was that the picture lacked finish and he requested the president and council of the Academy to let him finish it on the varnishing days before the exhibition was opened to the public. This was permitted and, perhaps to Alma-Tadema's surprise, was followed up by a bid

for the painting out of the funds of the Chantry Bequest.

The year 1909 was a successful one for Laura Alma-Tadema for she had a work, *Sigh No More Ladies*, accepted by the Royal Academy. It was her last exhibition, for she died that August, leaving Alma-Tadema depressed but not inactive, for he and his daughters now began to organize a memorial exhibition at the Fine Art Society in 1910.

Alma-Tadema produced one important oil painting in 1910, *The Voice of Spring* (p. 136–137), the subject being a woman, looking like Laura, sitting alone in a spacious marble exedra. There is the corner of a pool visible in the foreground of the picture and a glimpse of the sea beyond. In the distance, behind the woman, children are dancing and playing and there is a bouquet of flowers on the seat. The whole effect is one of infinite space and eternal youth: though he did not comment on his work it is not difficult to imagine its significance. Two other paintings in the same idiom were *Summer Offering* (p. 138) and *When Flowers Return* (p. 140–141), in which the heads of two young women appear amid bouquets of flowers while a third face appears buried among the flowers, almost indistinguishable but with a remarkable likeness to Laura.

Alma-Tadema now began what was to be his last work for the Royal Academy's summer exhibition. It was to be entitled *Preparation at the Colosseum*, but it was never finished for, on doctor's orders, he went with his daughter Anna to Wiesbaden in Germany for a cure. He died there on 25 June 1912. His body was brought back to London and buried in St Paul's Cathedral, next to his friends William Holman Hunt, Landseer, Leighton and Millais.

His death brought to the fore those who were actively seeking to demolish the reputation of the art of the previous century, among them Roger Fry, Lytton Strachey and Edward Wadsworth, all banner carriers for the Bloomsbury Group. But there were defenders too, among them George Bernard Shaw, William Blake Richmond and John Collier.

It was the end of an era that had begun with the accession of Queen Victoria in 1837 and the unrivalled supremacy of Britain as an industrial and military power. In the arts, J.M.W. Turner, the supreme genius of romantic art, was dying and his place was being taken by the Pre-Raphaelite Brotherhood, a nobly intentioned group of

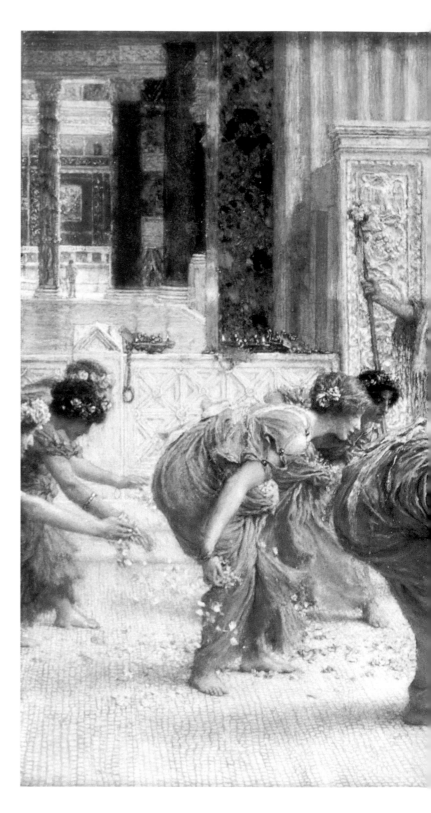

Caracalla (1902)
Oil on panel. 9¼ x 15½in
(23.5 x 39.5cm).
Private collection.

Marcus Aurelius
Antoninus Caracalla, an
army general, succeeded

his father as emperor in
AD 211 when he returned
to Rome and assassinated
his brother Geta to
become sole ruler against
his father's wishes. Alma-
Tadema has chosen to
show him the year he

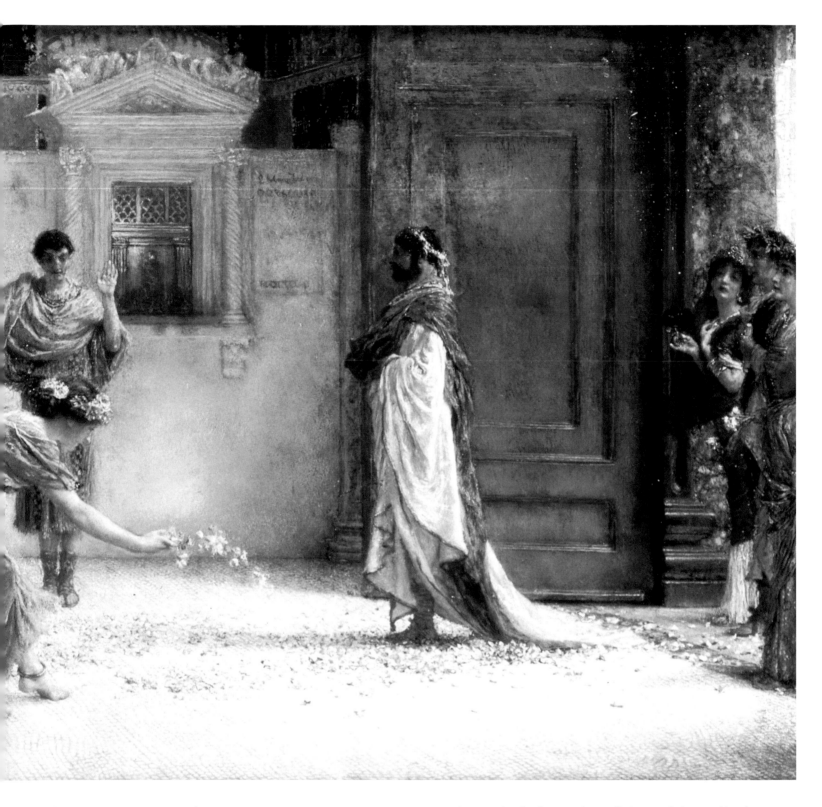

became emperor, entering the Senate through the great bronze doors. Alma-Tadema followed this with a much larger canvas in 1907 (p.124–125), which shows Caracalla being declared emperor.

painters who had turned to religion and the medieval past for inspiration. Alma-Tadema had instead embraced the Romans, whose empire seemed to parallel Britain's own.

Like his fellow painters of Roman themes, Alma-Tadema had prospered while the cult of things Roman lasted, but even during his lifetime there had been strong artistic trends in other directions, particularly for art that reflected the true reality of people's lives.

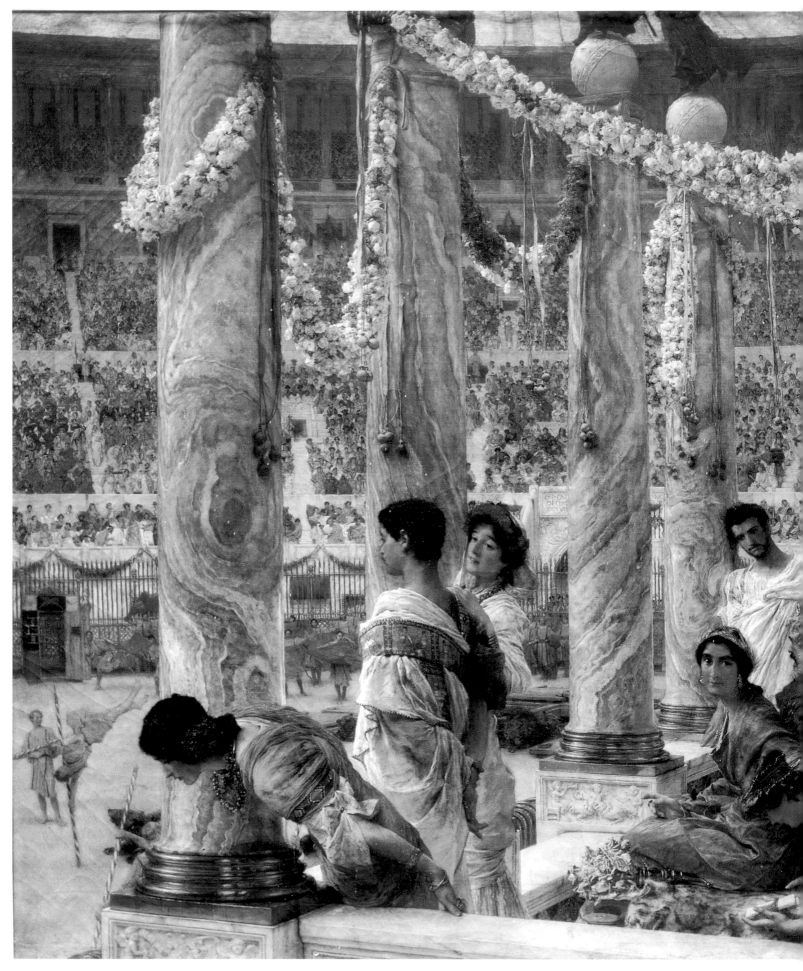

Caracalla and Geta

(1907)

Oil on panel. 48¹/₂ x 60¹/₂in (123.2 x 153.7cm). Private collection.

This picture shows Caracalla standing and his father, Septimius Severus, seated behind him, on the occasion of his receiving the title Antoninus Caesar. Also in the picture is his half-brother, Geta, whom Septimius Severus had designated co-ruler of the Empire. The woman passing a note to a servant is Geta's mother who is scheming to get her own son elected as emperor. She did not succeed, however, for Caracalla had his brother assassinated in order to ensure his sole rule.

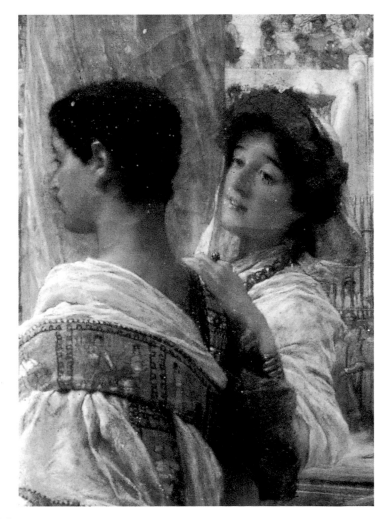

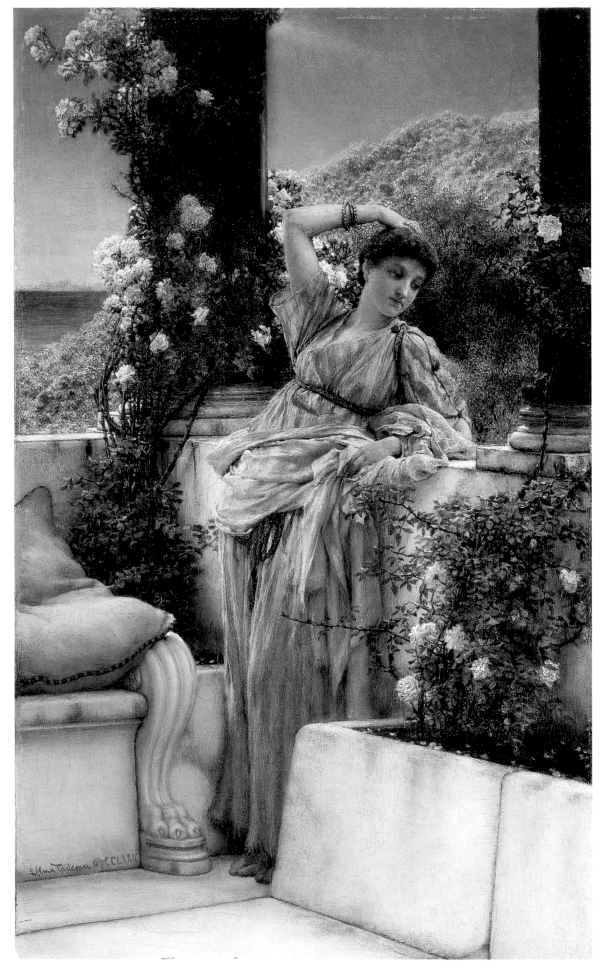

Rose of All Roses (1885)
Oil on panel. 15^1/$_4$ x 9^1/$_4$in
(38.7 x 23.5cm).
Private collection.

In his later years, Alma-Tadema painted a number of pictures of women surrounded by flowers, with daffodils representing spring and new life and roses the maturity of summer. Each symbolized, as did women, the vital spirit of life eternal.

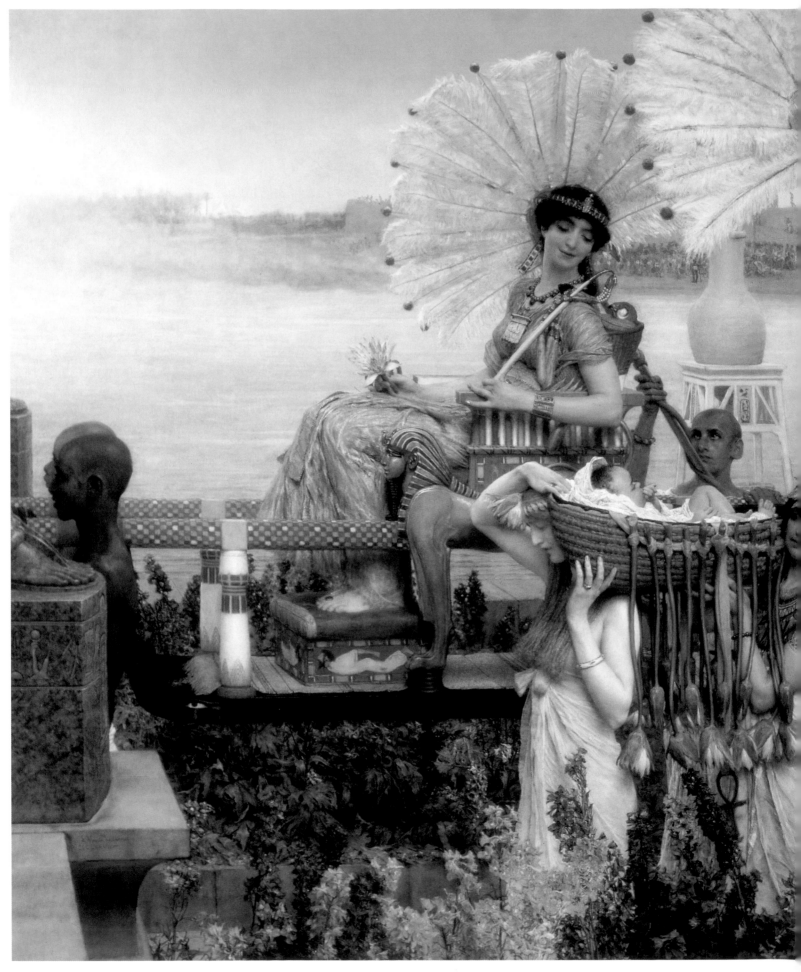

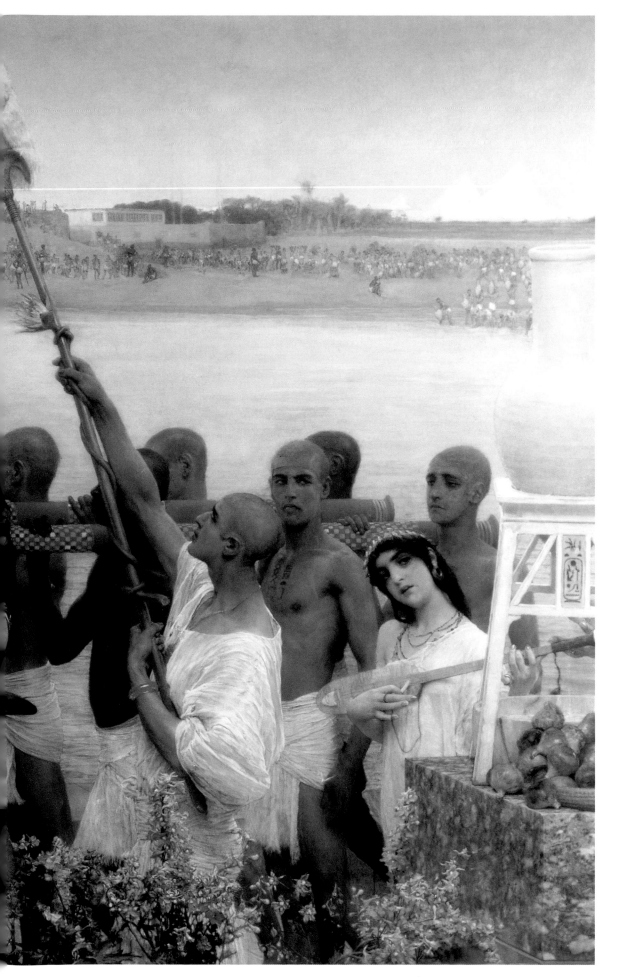

The Finding of Moses
(1904)
Oil on canvas. 54⅛ x 84in
(137.5 x 213.4cm).
Private collection.

By now, Alma-Tadema
was painting fewer large
canvases, so he was
happy to oblige Sir John
Aird when he and his wife
were invited on a trip to
Egypt for the opening of
the Aswan Dam which Sir
John had built. Sir John
wanted a souvenir of the
event and agreed to pay
Alma-Tadema £5,250 for a
picture. Though the
subject may have seemed
a little strange for a
celebration of the opening
of a modern engineering
enterprise, Alma-Tadema
introduced an appropriate
hieroglyphic reference,
'Life' and 'Dominion', on
Pharoah's daughter's
palenquin.

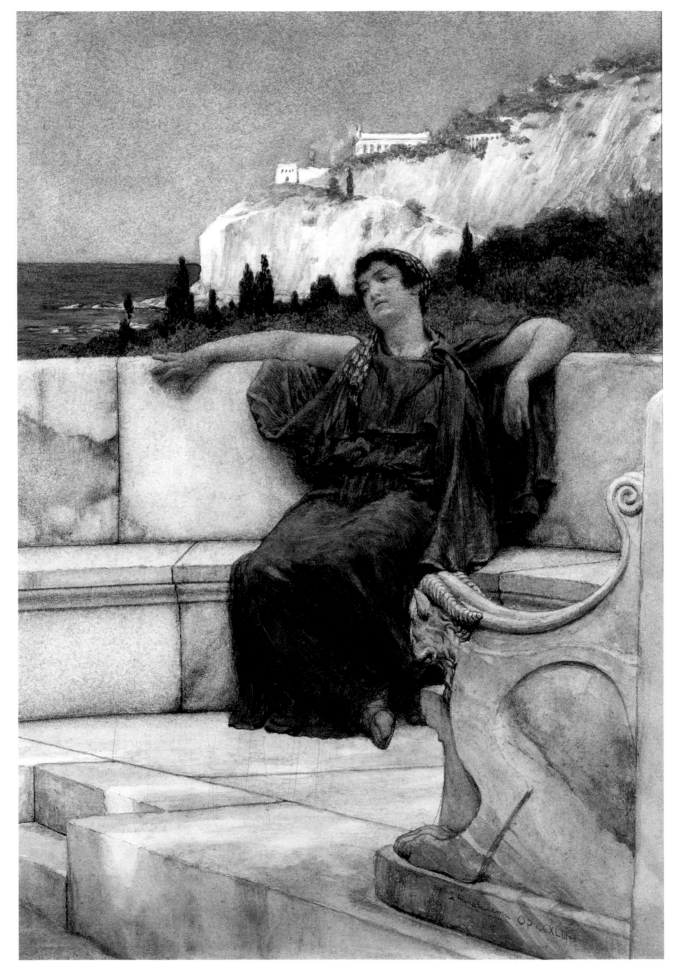

Dolce Far Niente (1882)
Oil on panel. 9¹/₄ x 6¹/₂in
(23.5 x 16.6cm).
The Maas Gallery,
London.

The Italian phrase,
expressing the pleasure
of simply doing nothing,
was more often used in
England in criticism of the
indolence of the people of
the South. Alma-Tadema
evidently meant it in its
truer, kindlier sense. The
woman, leaning back
against the cool marble, is
no doubt reflecting the
artist's own feelings of
escaping from his busy
life to a peaceful Sorrento
cliff-top retreat.

Realistic social art did not have the same cachet as that of the Classicists, but Alma-Tadema still managed to find an appreciative audience, willing to pay high prices for his work, among those who prided themselves on their sensitivity towards high art.

A new life began for populist art when it was combined with aestheticism. A realistic picture of a cobbler painted in an academic way was one thing, easily appreciated and requiring little deep thought on the part of the viewer, but when painted according to the new laws of aesthetics, it was something else. The idea of art, not as realistic reproduction, but as a entity in itself, was propounded by the critic Walter Pater and practised by James McNeill Whistler, who turned the banks of the grubby Thames or down-market Chelsea into scenes of mystery and haunting beauty.

The notion of art for art's sake meant that an exact representation of the subject, with the exacting detail that had been so admired in the 19th century, was now an obsolete way of working. What was important about painting now was the ability of the artist to convey feelings and ideas, and that the viewer should have the aesthetic sensibility and knowledge of technique to understand what the painting was all about.

The new parameters of art appreciation in Britain created a whole new realm of aesthetic appreciation which appealed

Ask Me No More (1906)
Oil on canvas. 31½ x 45½in
(80 x 115.6cm). Private
collection.

The predilections of the affluent
middle classes of the period
were set firmly towards bathos
and saccharine emotions which
writers like Oscar Wilde
attempted to expose for their
sentimentality and hypocrisy.
However, Alma-Tadema was
firmly at one with his public on
that score, and this painting is
based on a rather mawkish
poem of Tennyson:

*Ask me no more: thy fate and
 mine are sealed;
I strove against the stream,
 and all in vain;
Let the great river take me to
 the main:
No more, dear love, for at a
 touch I yield.*

However, Alma-Tadema is now
using the lighter, clearer colours
that would characterize his
open-air scenes from now on.

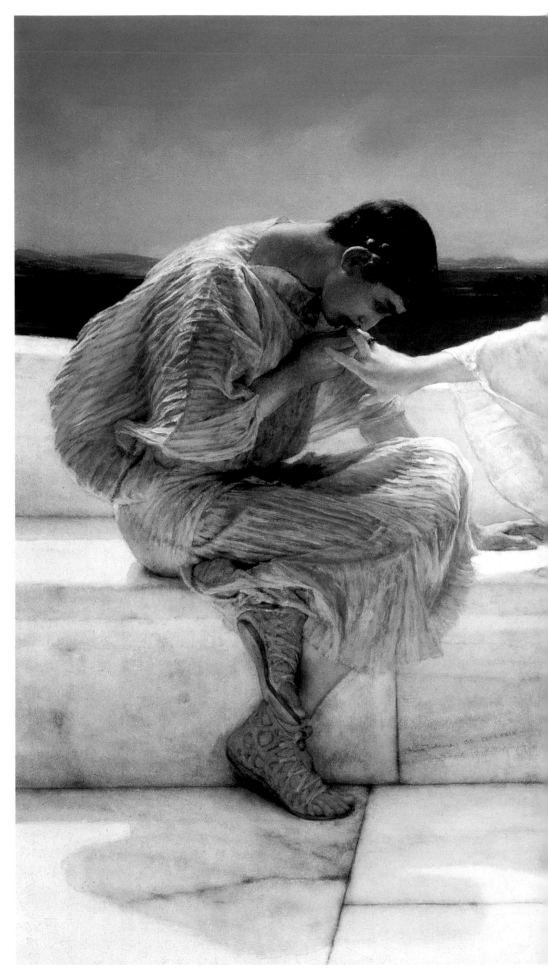

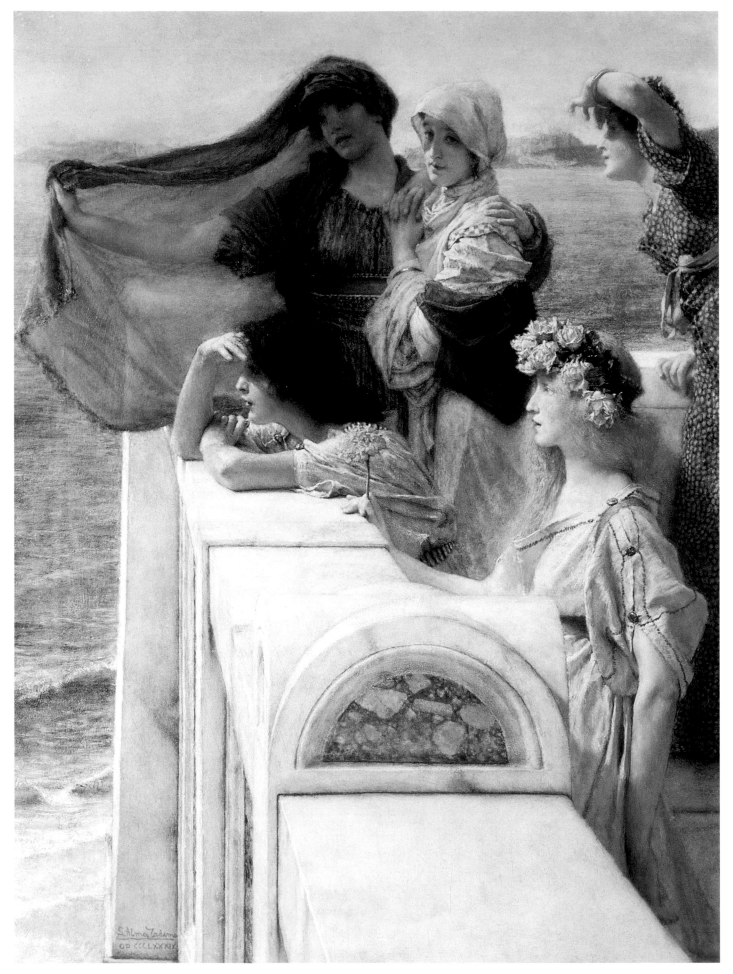

At Aphrodite's Cradle
(1908)
Oil on panel. 19¹/₂ x 15in
(49.5 x 38.1cm).
Private collection.

This is a reworking of an
earlier painting of 1903
and refers to Aphrodite's
cradle (the sea) from
which she emerged at
Paphos, Cyprus. The
women are waiting for
their husbands or lovers
to return from overseas
and are invoking
Aphrodite's help.
According to an ode from
Horace, which inspired
the painting, they hope
their men will return with
Mercury, i.e. with money
or merchandise.

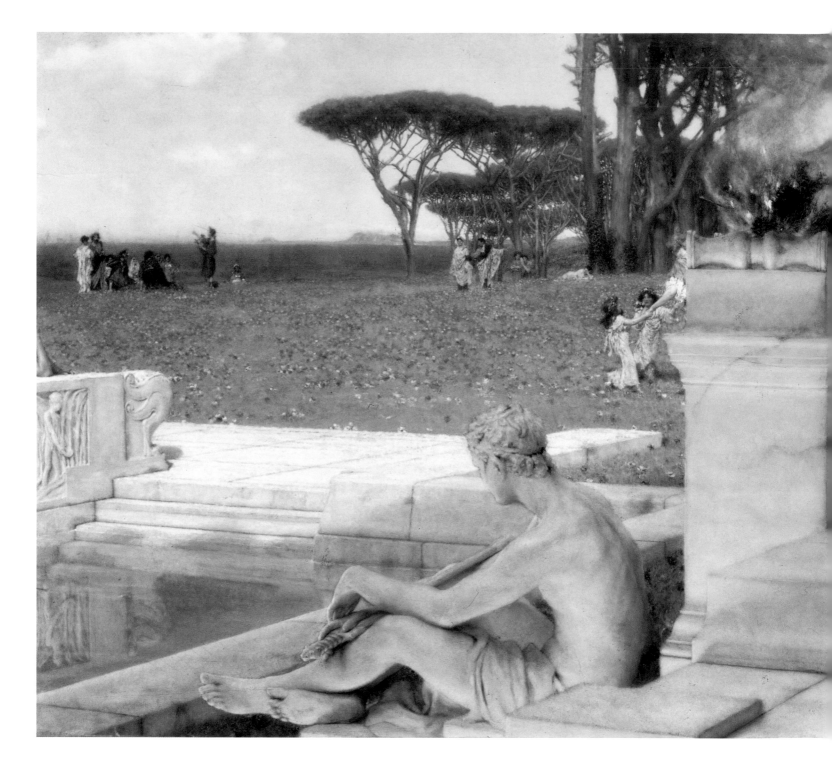

The Voice of Spring
(1910)
Oil on panel. 19¹/₈ x
45¹/₄in (48.6 x 114.9cm).
Private collection.

The woman sitting alone
on the vast marble terrace
was painted the year after
the artist's wife, Laura,
died. The painting seems
therefore to be a
memorial to her. A fire
burns on a pillar in the
centre of the picture, a
symbol of eternal life,
while children dance in
the background in a
representation of the
continuance of life.

to a wide public, including those who favoured such subjects as people on beaches, or at the races, or glimpses of domestic interiors, and to those who could appreciate the subtle colour changes which produced certain pictorial effects, or the distortions in drawing or the handling of the brushwork.

In such an artistic world, there was little room for the precise naturalism of Alma-Tadema and his preoccupation with the veracity of detail. The painters who now began to attract the public's attention used a loose, flamboyant, technique and sought to establish a personal identity by the character of their work. Among these were Augustus John, Wilson Steer and Walter Sickert – men with a bohemian aura about them – who painted the subjects that pleased them. They represented the new generation of Edwardians who, taking their lead from their king, were rejecting the constraints of Victorian values.

By the end of his life, Alma-Tadema was no longer the favourite artist of the day. In 1913, when the Royal Academy mounted a memorial exhibition, only 17,000 people attended, half the number who had visited his shows in his

Summer Offering (1911)
Watercolour. 14 x 20¹⁄₂in
(35.5 x 52.1cm).
Private collection.

This painting of a pretty girl holding a potful of white roses, with more in her hair, is typical of Alma-Tadema's late style and, according to one critic, was more suitable for adorning boxes of chocolates. Such images were very popular in some quarters of society, however, until cosy sentimentality eventually gave way to the harsh realities of trench warfare.

lifetime. The rejection of Alma-Tadema, which continued after the Great War, was part of a general revulsion for the values of the Victorians and Edwardians, though it was not entirely the end of his influence in the arts. The great new art form of the 20th century, the cinema, liked his style: Cecil B. De Mille used the Roman paintings of Alma-Tadema and Edward Poynter as inspiration for the sets of his Roman epics in the heyday of the silent screen.

In the world of art, however, the prices of paintings by Alma-Tadema and his friends nose-dived. Some were sold for a few hundred pounds and it was rumoured that at least one painting was bought for its gilded frame. More recently, however, those same paintings have come to be more highly valued as Alma-Tadema's impeccable technique, and the historical importance of his work as examples of Victorian high art, gains more appreciation. One of his works recently sold for £1.5 million at auction.

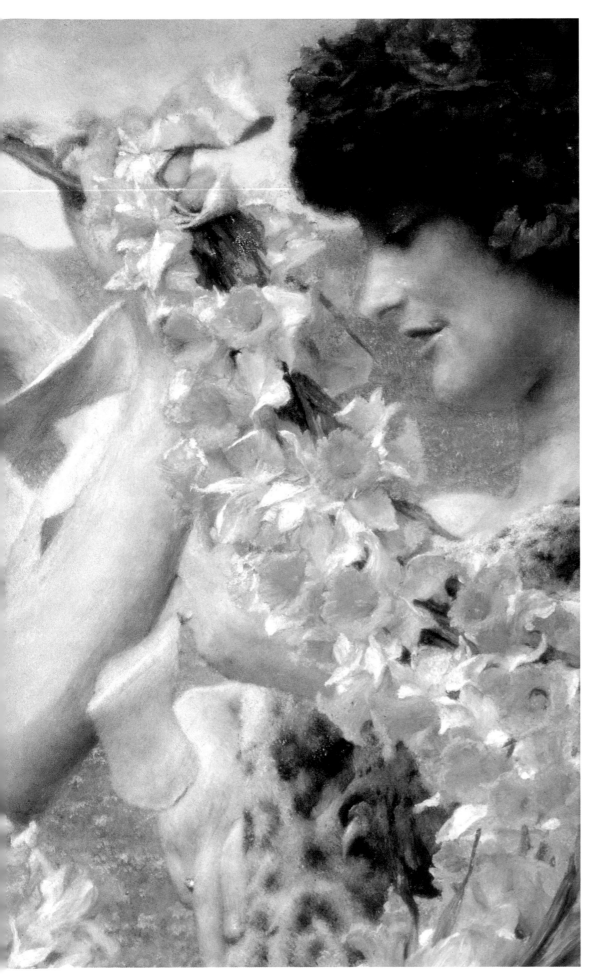

When Flowers Return

(1911)
Oil on canvas. 14 x 20$\frac{1}{2}$in
(35.5 x 52.1cm).
Private collection.

This picture of young
women holding aloft
garlands of daffodils, was
painted the year before
Alma-Tadema died, and
has a poignancy which
suggests that he knew
his days were numbered.
Behind the woman on the
left, almost invisible
beneath the flowers, is a
face that is probably a
memory of his wife, who
had died in 1909. Though
many of his paintings may
have been awash with
sentimentality, Alma-
Tadema had a deep and
loving regard for his
family.

Summer Offering (1911)
Oil on panel. 14 x 20½in
(35.5 x 52.1cm).
Private collection

Like *The Finding of
Moses* (p. 128–129), this
painting was
commissioned by Sir
John Aird, but Alma-
Tadema may have
intended it as a personal
tribute to his own wife
who had recently died.
The red-haired woman is
Marion Tattershall, his
favourite model, who had
similar hair colour to his
wife Laura, and the two
younger women may
represent his daughters,
Laurence and Anna.

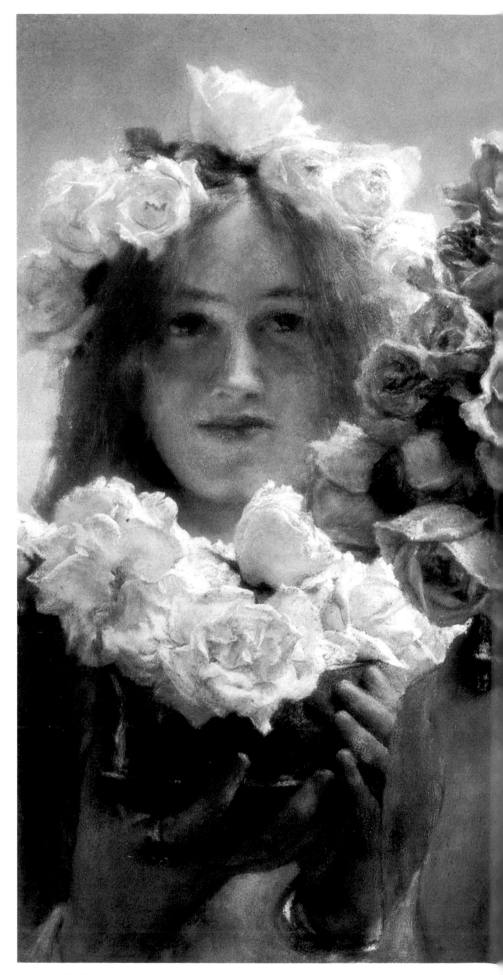

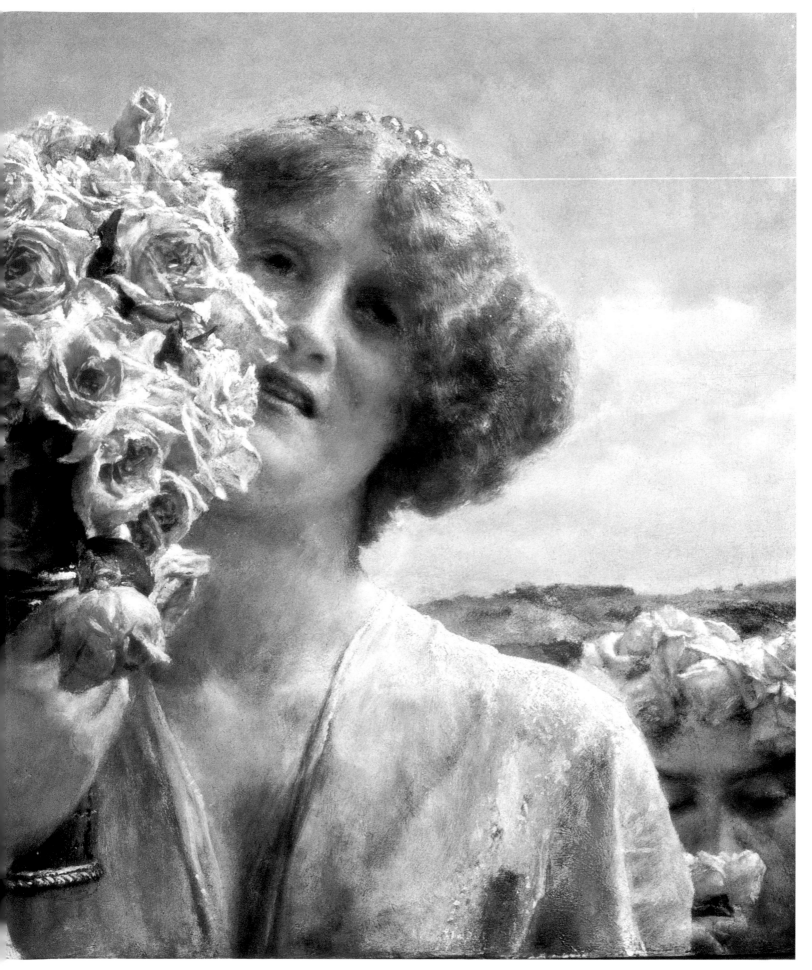